SEASONAL LANDSCAPES

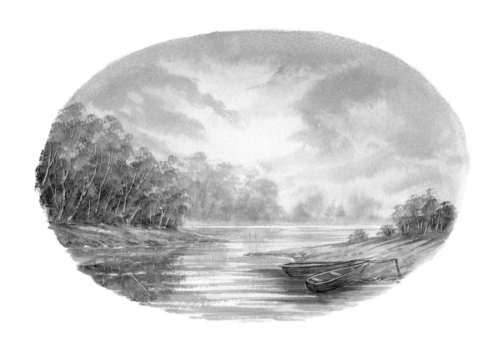

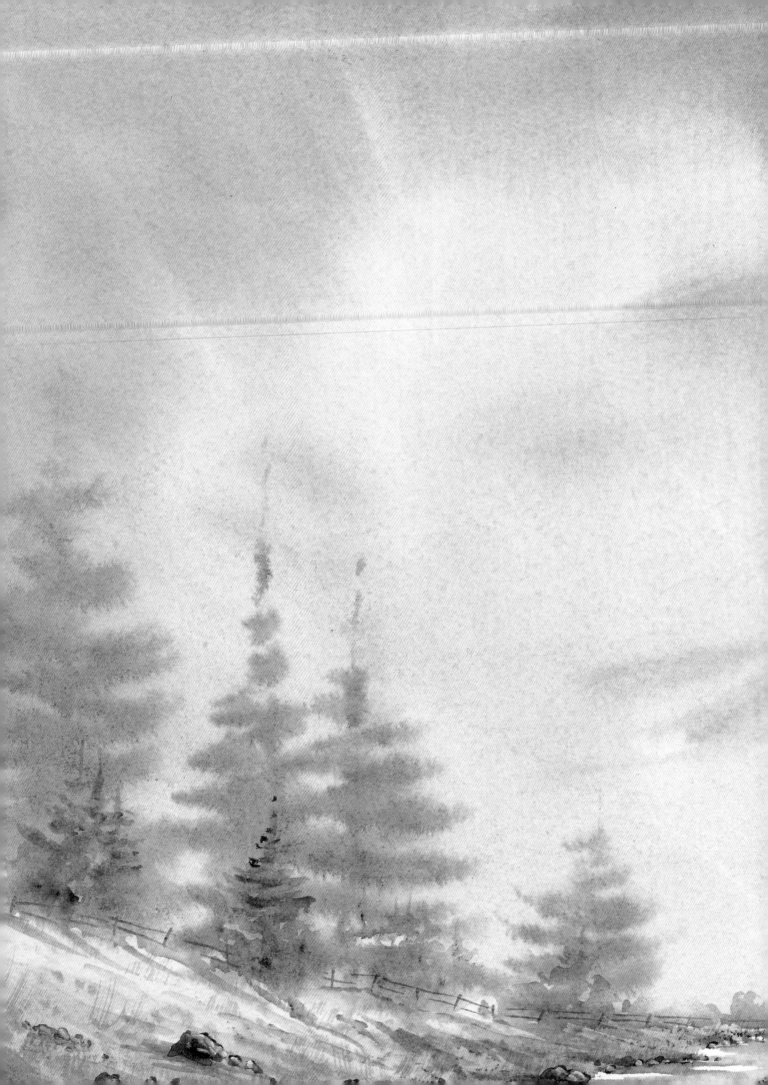

SEASONAL LANDSCAPES

Painting Watercolours with Acrylics

Keith H. Fenwick

*How to paint successful landscapes
stage-by-stage to finished painting*

AURUM PRESS

First published in Great Britain 1999
by Aurum Press Ltd
25 Bedford Avenue, London WC1B 3AT

A catalogue record for this book is available from the British Library.

ISBN 1 85410 478 0

2–4–6–8–10–9–7–5–3–1
2000—2002—2003—2001—1999

Designed by Don Macpherson

Printed in Hong Kong/China
by South China Printing Co (1988) Ltd

WHY USE ACRYLICS?

Acrylics are the most versatile of watercolours and are the paints of the future. They are the ideal starter medium, their properties being sympathetic to beginners, and allow more experienced painters to develop their painting techniques without being restricted by the limitations of traditional watercolours. In fact, anything one can accomplish with traditional watercolours can be accomplished more easily and with better results using acrylics. Listed below are some of the specific advantages of acrylics:

1. ACRYLICS DO NOT REQUIRE SPECIAL TECHNIQUES. As acrylic and traditional watercolours are both water-based paints, one can adjust easily to the new medium, or, in fact, combine the two.

2. ACRYLIC WATERCOLOURS ARE PARTICULARLY SUITED TO TRANSPARENT TECHNIQUES. Any number of thin washes may be super-imposed without muddying the colour. This means intricate effects and textures can be created without a loss of brilliance. (Traditional watercolours can lose up to 30 per cent of their colour when dry.)

3. ACRYLICS ARE ROBUST. When the paint is wet, it can be easily removed; however, when it is dry, it can be over-painted without disturbing the under-painting. This enables the less-experienced to experiment and thus improve their technique much more easily. Moreover, acrylics do not yellow with age.

4. ACRYLICS ARE VERSATILE. It is possible to work from light to dark, as with traditional watercolours, but also to work from dark to light. Thus, creating atmosphere and mood is much simplified and colour harmony can be achieved easily.

5. ACRYLICS ARE FLEXIBLE. There is a wide range of media that can be added to the paint to obtain different textures, finishes and creative effects, thus extending the range of the artist.

6. WITH ACRYLICS IT IS EASIER TO ADD DETAIL. As sequential layers of paint will not sink into the under-painting and become lost, the acrylic medium allows the painting of soft, transparent scenes, atmosphere and detail – even impasto, as in oil painting. It is particularly useful when applying glazes to rocks, tree bark, skies and lake or beach shores, or when adding depth to woodland, etc.

7. ACRYLICS ARE MUCH BETTER VALUE. The traditional watercolour tube contains 5 ml of paint, whereas for a similar cost the tube of acrylic watercolour contains 59 ml – an important consideration.

If I had to choose only one medium with which to paint, I wouldn't hesitate to choose acrylics. Look at the paintings in this book and judge for yourself: do try acrylics – I promise you won't be disappointed.

CONTENTS

INTRODUCTION

This book is about painting landscapes employing traditional watercolour techniques but using acrylic paint. It is aimed both at the novice (most of the techniques associated with watercolours will be demonstrated) and at the experienced painter. Whether I am successful or not in convincing you that acrylics have many advantages over traditional watercolours, this book is still for you.

As I spend my life painting with both traditional and acrylic watercolours, I find myself in an excellent position to compare the two. I often hear comments such as: acrylics are too bright, they dry too quickly, they ruin your brushes and they require a special palette. When I ask what specific difficulties the sceptic experienced whilst using acrylics, the usual reply is, 'Oh! I haven't used them, but someone told me.' Once they see me painting, the comments change to: 'I never knew acrylics could be used like that;' or, 'I didn't realize you were using acrylics.' I often carry two paintings around with me, one painted with traditional watercolours and the other with acrylics, and I defy anyone to tell the difference by simply looking.

When using watercolour techniques with acrylic paints, I work in exactly the same manner as I would with traditional watercolours. I don't notice any difference, except that I can extend the range of techniques I'm able to use. I have been using the same type of brushes and a normal palette for twenty years. I simply cover my palette with clingfilm (plastic wrap). Let me assure you that acrylics are the most versatile paints you will ever use, enabling you to produce effects difficult to achieve with ordinary watercolour. I would ask you to forget any nonsense you may have heard about acrylics, to keep an open mind and judge for yourself.

Quite apart from the type of paint used is the question of technique. When I first started to paint, there weren't any videos available of an artist at work, and the colleges were more interested in academic qualifications or the history of art than in teaching landscape painting. What I needed was a book which actually *showed* me how to paint, not a collection of paintings which, with my limited skills at that time, appeared to be beyond my reach.

This book has been a passion of mine for some time and is my attempt to address that need. You will find its format and content different to that of other books. The aim has been to overcome the myths and nonsense and to show you 'how it's done': to save you many years of frustration by teaching you specific, practical techniques that I have learned during many hours of practice and experimentation. By working through numerous demonstrations and exercises, commencing with simple landscapes and leading you stage-by-stage to more detailed works, your confidence will grow and you'll take great pleasure in creating and hanging your paintings. If you are currently using traditional watercolours, you'll find that most techniques are the same for acrylic watercolours, and you will discover for yourself the many advantages of acrylics which will facilitate your development as an artist.

I welcome the opportunity to show you the techniques and approach I have developed over the years and thank my editor, Sheila Murphy, for believing in me and giving me the opportunity to produce this book. I quote my catchphrase: ANYONE CAN PAINT – LET ME SHOW YOU HOW! I hope, by means of this publication, to prove it to you.

PORTRAIT OF THE ARTIST

My childhood was spent exploring acres of woodland, swimming in rivers, climbing trees and studying all aspects of nature. I was born in the rural town of Spennymoor, close to the city of Durham, in the north-east of England. Like most boys living in a rural area, I went potato picking and harvesting on the local farms. I can still remember the call of the corncrake, now virtually extinct due to modern farming methods, except for a few places in Ireland. I also remember my mother and me sketching on our weekly trips to the countryside. My early ambition was to train as a draughtsman.

A long time has passed since those days. I served an engineering apprenticeship, became a designer draughtsman in charge of the drawing office, eventually progressing to production and works management with several international companies. Having obtained an honours degree and several professional qualifications, I entered the further education system, eventually taking early retirement as associate principal/director for site development and publicity from one of the UK's largest colleges of further education. Through all these years, one of my hobbies which kept me sane was my love of sketching and painting.

I'm now fortunate enough to spend my life doing what I love: landscape painting. This involves me running fifteen painting holidays, numerous workshops, seminars and demonstrations to forty art societies and at fifteen major fine art exhibitions each year. I find great satisfaction in encouraging all those who've always wanted to paint but lack the confidence to 'have a go', and in helping more experienced painters to develop their skills further. I lead a hectic but wonderful lifestyle and consider myself privileged to be able to teach people to paint through my demonstrations and teaching videos.

SO YOU THINK YOU CAN'T PAINT

When I'm outdoors sitting by a river or lake painting, regardless of the stage the painting has reached, I'm often approached by admiring members of the public, who say things such as, 'Aren't you lucky? I've always wanted to paint;' or, 'I wish I had the gift.' This is irresistible to me and I can't help painting a simple 'doodle' just to show them how easy it can be. You see, I don't believe it's a gift or an ability to become inspired; to me it's more perspiration than inspiration. I believe that if you really wish to achieve anything worthwhile in life and are prepared to work hard, you will reach an acceptable standard. When I was an apprentice, I had a tough supervisor who used to tell me, 'Achievers never quit and quitters never achieve,' and I've adopted this as my philosophy in life.

I can honestly tell you that complete beginners on my courses, who have never held a brush before, sometimes produce better work at the end of the course than some who've been painting fifteen years.

WHY PAINT AT ALL?

Learning to paint is fun and it's easier than you think. There's a painter in all of us just waiting to jump out. Once you commence painting, you'll appreciate more fully the creations of man and the wonders of nature. You'll see things in a completely different way: the sky, the structure of trees, the variety of colours in the landscape, the textures of bark or the form of a rock. (Why not join your local art society? The local library should be able to put you in touch and you'll be able to watch the many demonstrations organized by such groups. You will also be able to join in on field trips and not feel alone when you're learning to paint.) Perhaps more important, the sense of satisfaction that your creative urges are being fulfilled cannot be described: it must be experienced to fully appreciate. Even if you never reach 'masterclass', you'll find that painting opens up a new world. It will change your life – ask any artist. Enjoy yourself. I wish you well on your new journey – who knows, you may soon be selling your paintings.

STARTING OUT

When starting out, most of us discover that the painting of tree foliage is a major problem; the second problem is skies, which need to be painted in less than two minutes; and running water is a close third in level of difficulty. This is why you will find I have spent more time dealing with these elements in the book. I'm going to show you how to paint each element in the landscape, how to compose your painting and how to produce landscapes that you'll be proud to show your friends.

The demonstration on pages 12–13 shows how easy it can be to produce a simple landscape, but for best effect it's important to learn the basic techniques first, such as how to mix colours, how to draw, and the importance of using the brushes effectively and choosing the correct paper.

I've never been one to recommend the purchase of small, inferior brushes or student quality paints and papers. When you're learning to paint you'll have to overcome enough problems mastering new techniques without the

additional problems encountered by using materials, particularly papers, that are unsatisfactory for the job. By this I don't mean you need to purchase expensive sable brushes, as the modern brushes made from man-made fibres mixed with sable will work just as well, but above all else, experience has taught me the value of high-quality paper. Reference to page 28 will provide an explanation of the materials I use and why.

What I'm unable to do is practise for you, but through this book I can show you 'how it's done'.

Art comes in all shapes and forms, and, like all artists, you will eventually develop your own style. You don't have to concern yourself with this, it will come naturally. We are all influenced by painters whose work we like, but with time and experience you'll find your natural style will show through.

In fact, when you're learning to paint there's nothing wrong with studying the work of artists you admire. The great masters before us did just that. I have spent many hours in national galleries attempting to analyse great works of art, trying to determine from the width and the direction of brush strokes the size and type of brush the artist used to create a particular effect.

I have endeavoured to cover all aspects of watercolour painting in this book. You can do it if you really want to, it's not as difficult as you think.

Painting is for everyone – you can do it!

WHAT MAKES A SUCCESSFUL PAINTING?

There's an old saying that beauty is in the eye of the beholder and indeed this is true: we all see and appreciate things differently. Paintings come in all forms and styles. It would be a boring world if they didn't. There are, however, basic design considerations that must be incorporated into your composition if your painting is to work. We all like to produce paintings that our friends or potential purchasers will admire, but a well-designed painting doesn't just happen.

Painting is easy, but like learning to swim or play tennis, you must learn the basic techniques and the principles of design and then practise until you've mastered them, until they become second nature. They are the foundation of any successful painting.

Considerations such as contrast, counterchange, tone (value), colour harmony, gradation, variation and balance are all important to success. Most of these principles are just common sense anyway, and I will explain each aspect in the appropriate section of the book. (Don't be put off or concerned about the chart on the opposite page. Think of it as a handy check list to which you can refer.)

When you make a mistake, and we all do, it's important to understand why to prevent it happening again. It's vital to spend more time observing and studying your subject, together with thinking through your approach, than actually painting. When I've completed a painting, I usually spend time looking at it over a two-week period before making changes I consider necessary (such as adding figures or animals to indicate scale or applying glazes to add warmth).

It's not just a matter of producing a topographical study of the landscape either: you have to immerse yourself in it if you're going to capture atmosphere and mood. There's no substitute for painting outdoors, being able to feel the wind on your face, smell the country-side, feel the texture of that stone wall, listen to the sound of running water and of birds singing. Soak in the atmosphere, imagine your landscape in all seasons and try to develop a feeling for it.

It's unlikely that you will ever be really content with the results of your endeavours – you'll probably feel that you could have done better. All artists do. You'll experience moments of great joy and moments of total frustration. The main thing is to keep painting: learn from your mistakes and your work will improve.

HOW TO USE THIS BOOK

This book has been written to meet the needs of both the beginner and the more experienced painter and to facilitate progression from simple doodles to paintings of greater complexity.

This book is different to other books. If you are new to painting, I will be starting you off with simple exercises in the section entitled '**Keep it Simple**'. I suggest you refer to pages 12–13 to see how easy it can be, then to pages 28–29 to determine what materials you will need. After that, work your way through the book from page 30 to page 95, mastering each exercise before progressing further. Once you have done that, have a go at the stage-by-stage demonstrations, starting with the one on pages 12–13, then proceeding to those on pages 16–27. Then, work your way sequentially through the rest of the book.

For the more experienced painter who is having difficulty with painting specific elements in the landscape, I suggest you work through the appropriate lessons and tackle the demonstrations that appeal to you, referring in particular to sections which cover the principles of design. As a further useful exercise, why not paint a particular demonstration in a season different to the one portrayed?

As your skills grow, progress to the section entitled '**Painting in More Detail**'. When you experience difficulty painting any of the elements in the landscape, such as trees, mountains, skies or water, you will be able to refer to the appropriate techniques demonstrated earlier in the text.

Have a quick look through the pages of this book and don't worry, I'm going to make it easy for you.

I hope you find this book both stimulating and beneficial to your future development. Don't forget that there's a video available to complement this book. And above all, enjoy yourself: anyone can paint – let me show you how.

Good luck with your painting!

WHAT MAKES A SUCCESSFUL PAINTING?

SKILLS	PAGE
Achieving unity	107
Drawing	48
Indicating life	94
Indicating scale	94, 95
Measurement	48, 50
Observation	44
Planning	44
Simplification	44

TECHNIQUES	PAGE
Basic brushwork	30
Colour mixing	35, 109
Dry-brush	32, 77
Glazing	77, 107
Lifting colour	65
Washes	65, 77
Wet-in-wet	64, 65
Wet-on-dry	74

ELEMENTS	PAGE
Boats	112
Buildings	91
Foreground	88
Mountains	84
Rocks	81
Skies	64
Trees	70
Water	78

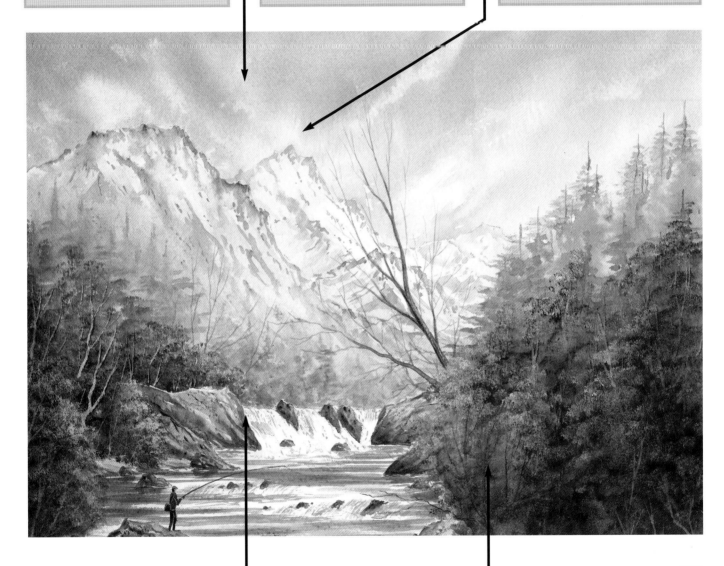

DESIGN	PAGE
Alternation	125
Atmosphere	98
Balance	110
Colour harmony	45, 107
Composition	46

DESIGN	PAGE
Contrast	45
Counterchange	45, 54
Focal point	46
Gradation	45, 54
Perspective	51

DESIGN	PAGE
Recession	52
Scale	94
Texture	73, 110
Tonal values	54
Variation	45, 54

IT'S NOT AS DIFFICULT AS YOU THINK

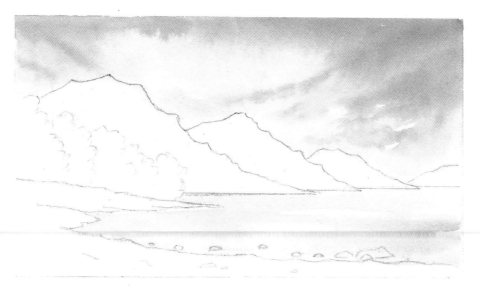

FIRST STAGE

For this 25x18cm (10"x7") painting, use 300gsm (140lb) artist's quality rough watercolour paper. Lightly draw in the water line approximately one third of the way up, using a 4B pencil. Sketch in the mountains, making each peak smaller than the one before. All you are doing is drawing a series of letter Ms.

Apply a weak Raw Sienna wash to the sky area with a hake brush or large round brush. While this wash is still wet, paint in the water and some clouds, using a Payne's Gray/Cerulean Blue mix. Allow to dry, or use a hairdryer to speed up the process.

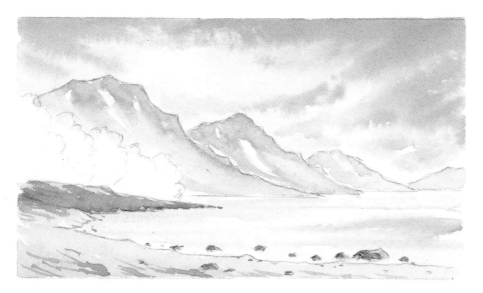

SECOND STAGE

Load the round brush with a Payne's Gray/Cerulean Blue mix of a darker tone than that used for the water and paint in the first mountain, working downwards from the peak with brush strokes following the profile of the mountain. Each receding mountain should be lighter in tone – add more water and a little Alizarin Crimson to the mix to achieve a sense of recession.

Paint the land projecting into the lake in a variety of greens made from Cerulean Blue and Raw Sienna. The land is simply the letter V on its side.

Paint the foreground lake shore in various tones of Raw Sienna in the shape of a letter C. Paint in a few rocks with Burnt Umber.

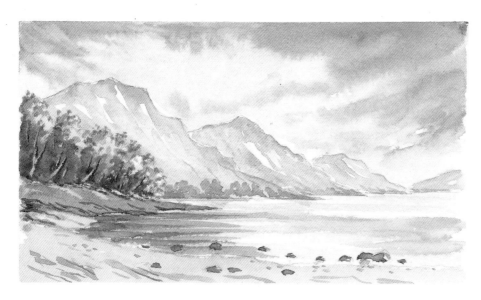

THIRD STAGE

Using a round brush and three tones of green made from Payne's Gray and light yellow, dab or stipple in the trees.

When the paint is half dry, scratch in some tree structure with a knife, cocktail stick or thumbnail. Add shadows at the water's edge using Payne's Gray with a little Alizarin Crimson. Dab in the distant trees using a weak Payne's Gray mix.

FOURTH STAGE

Here I've added the fence, in Payne's Gray/Burnt Umber, and given more definition to the mountain peaks, using a rigger brush.

A Burnt Sienna wash has been applied over parts of the foreground shore to add colour and variation. I've also added some texture with the rigger brush.

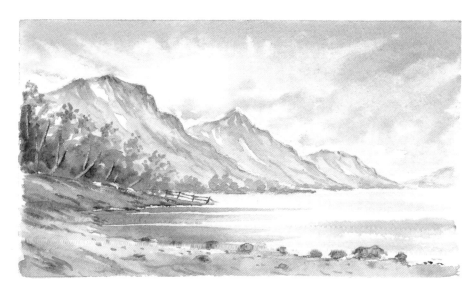

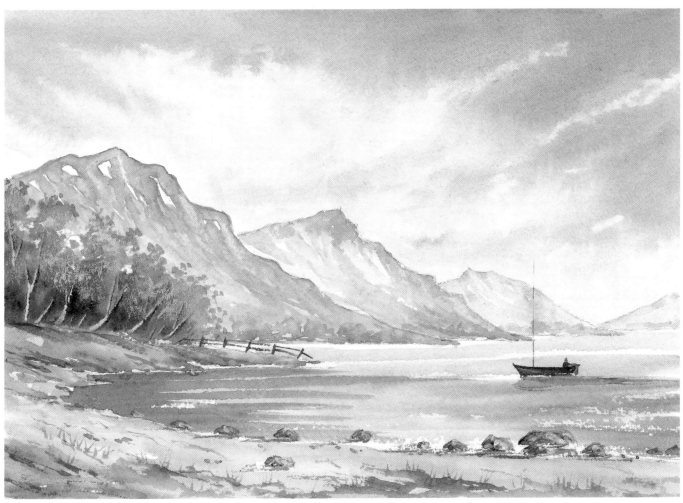

FINAL STAGE

Now the painting needs to be brought together by adding a little warmth here and there.

First, wet parts of the sky area and wash them over with Raw Sienna. Add some of this same wash to the base of the foreground mountain, to the shore line and to the water. The boat, which I painted at the end using the rigger brush, is optional.

Congratulations! You have just completed your first painting!

STAGE-BY-STAGE TO FINISHED PAINTING

Demonstration 1
Painted in 19 mins
Pages 16–17

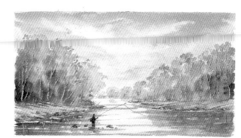

Demonstration 2
Painted in 24 mins
Pages 18–19

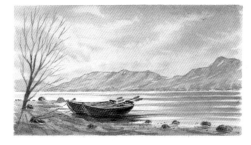

Demonstration 3
Painted in 23 mins
Pages 20–21

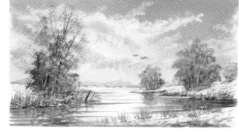

Demonstration 4
Painted in 21 mins
Pages 22–23

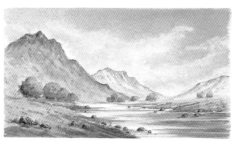

Demonstration 5
Painted in 26 mins
Pages 24–25

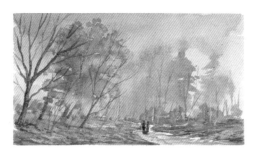

Demonstration 6
Painted in 28 mins
Pages 26–27

KEEP IT SIMPLE

Demonstrations you will see in this book

In 'Keep it Simple' I will show you how to paint a wide range of what I call my 'doodles'. They are the kind of simple sketches I produce in less than 30 minutes outdoors or as demonstrations at fine art shows. Although relatively simple, they are useful for learning a wide range of techniques which, once mastered, will allow you to progress to landscapes of increasing difficulty.

Forget your inhibitions and have a go. Yes, you will make lots of mistakes, we all do, but if you learn from them, your attempts will soon improve.

Don't paint too large when you're learning: 35x25cm (14"x10") is about right. (If you paint much larger your mistakes will appear to be larger.) Have some watercolour paper remnants alongside your painting so you can practise your techniques and check your colours and tones before applying paint. I have indicated how long it normally takes me to complete these 'doodles', but I don't expect you to be as proficient at this point in your development. Follow the stage-by-stage demonstrations, referring to the appropriate lessons in the book for advice on painting particular elements, such as trees, water, etc.

You can do it!

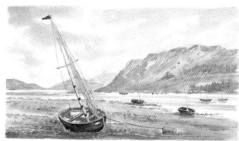

Demonstration 7
Painted in 32 mins
Pages 112–113

PAINTING IN MORE DETAIL

Some of the more advanced exercises

Having worked through the stage-by-stage demonstrations in 'Keep it Simple' and the lessons covering the techniques for painting the elements in the landscape, you should be better equipped to tackle the more advanced landscapes in 'Painting in More Detail'.

Demonstration 8
Painted in 41 mins
Pages 114–115

Don't attempt to copy exactly: you won't be able to anyway, as water-colours have a habit of behaving differently depending on the wetness of paint on your brush in relation to the wetness or dryness of your under-painting. That's what makes watercolours so immensely exciting: interesting – but unplanned for – shapes and textures sometimes occur which add variety to your work.

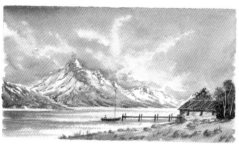

Demonstration 9
Painted in 40 mins
Pages 116–117

A recommended size for these paint-ings would be 46x31cm (18"x12"). Your confidence and technique should have developed sufficiently to allow you to work in this larger size.

If you are unsure about a particular stage in the painting, refer back to the relevant section in the book for help and guidance and practise your techniques prior to applying paint. Don't worry if you don't get it right first time, it happens to us all. You'll get it right eventually.

Demonstration 10
Painted in 39 mins
Pages 118–119

Practice makes perfect!

Demonstration 11
Painted in 29 mins
Pages 120–121

Demonstration 12
Painted in 44 mins
Pages 122–123

KEEP IT SIMPLE DEMONSTRATION 1: PAINTING AN EVENING SCENE

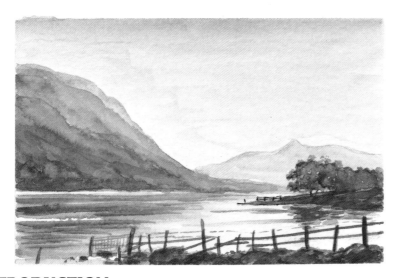

FACT FILE

MATERIALS

Brushes:
 Hake, Rigger, Size 16 round

Paper:
 300gsm (140lb) Winsor &
 Newton artist's quality, rough

CONSIDERATIONS

1. Keep the sky simple.

2. Shape your mountains,
 don't paint them as curves.

3. Distant mountains should be
 lighter in tone.

4. In the water area, leave some
 white paper unpainted.

INTRODUCTION

This evening scene looking across Buttermere Lake is simple to paint and only four colours are needed. Loweswater, Crummock Water and Buttermere are three lakes in the English Lake District, all within a few miles of each other. In the evening, the lakes are very peaceful and it's a lovely time to paint, with few distractions apart from a handful of walkers and passing sheep. The tonal study was painted using a dark-brown, water-soluble crayon.

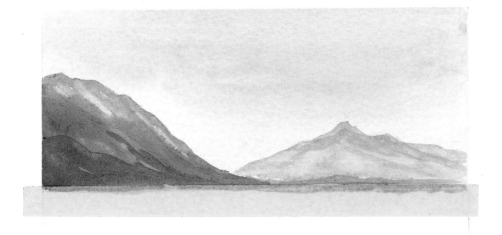

FIRST STAGE

Cut a piece of masking tape and stretch it across the paper approximately one third of the way up the painting. This is our water line. Press down on the top edge of the tape only. Then, using a pale wash of Alizarin Crimson/Payne's Gray/Cerulean Blue to produce a soft violet sky, paint down to the level of the tape with the large hake. Dry the area using a hair dryer. Using a stronger mix of the same colours, paint the mountains; a lighter tone should be used for the right-hand, distant mountains than for the left-hand, middle-distance mountains. Use the size 16 round brush to add texture and tonal variations. I did not draw the scene prior to applying paint, but this is optional.

SECOND STAGE

When dry, slowly remove the masking tape to reveal a level water line. If this is done carefully and a good quality, rough-surfaced watercolour paper used, the paper should not tear. To paint the water, use a pale wash of Payne's Gray/Cerulean Blue with a little Alizarin Crimson added, making horizontal strokes with the side of the size 16 round brush. Notice that some of the paper has been left uncovered. Once dry, apply darker tones of the same wash to add variety to the water and to represent reflections from the middle-distance mountains.

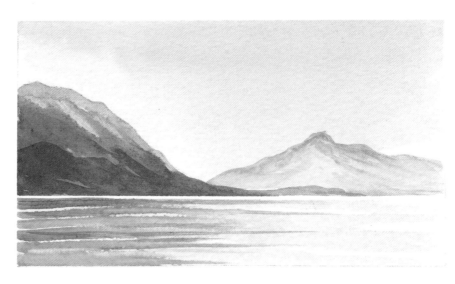

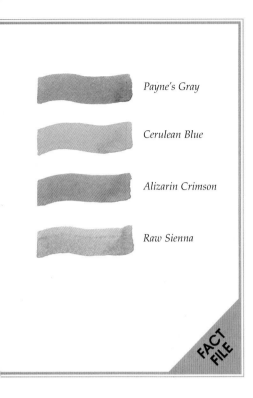

Payne's Gray

Cerulean Blue

Alizarin Crimson

Raw Sienna

FACT FILE

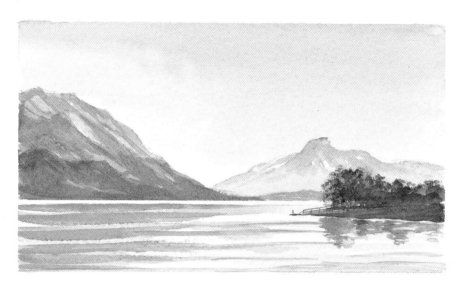

THIRD STAGE

Use a darker tone made from Payne's Gray with a little Alizarin Crimson for the land projecting into the lake. When dry, paint the trees and their reflections with the size 16 brush, using a dabbing action for the group of trees followed by horizontal strokes to represent their reflections.

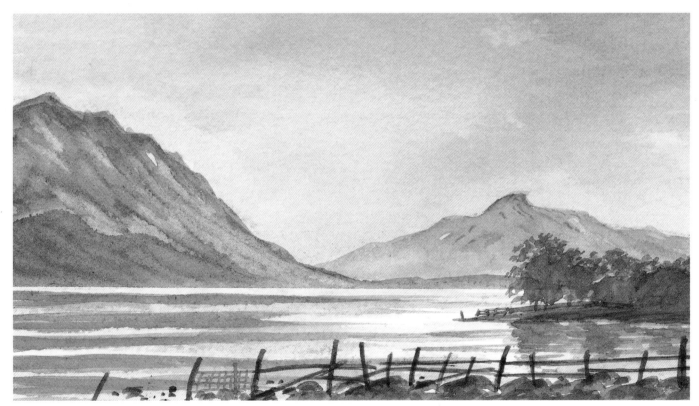

FINAL STAGE

Wet the whole of the sky area with clean water and paint cloud formations using a Payne's Gray/Cerulean Blue mix with a little Alizarin Crimson added. Use a darker mix of the same colours to paint the foreground rocks (with the round brush) and the fence (with the rigger). Dry the paper. To add warmth, apply a Raw Sienna glaze to the whole painting using the hake, leaving some white paper in the water uncovered. (A glaze is a small amount of paint, in this case Raw Sienna, mixed with lots of water and applied over a dry under-painting.)

DEMONSTRATION 2: PAINTING A RIVER SCENE

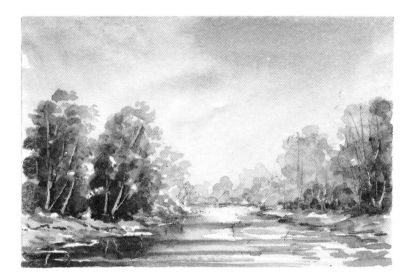

FACT FILE

MATERIALS

Brushes:
Hake, Rigger, Size 16 round

Paper:
300gsm (140lb) Winsor &
Newton artist's quality, rough

CONSIDERATIONS

1. Use a variety of colours and
 tones to make your trees inter-
 esting, working from light to
 dark.

2. Apply a glaze to warm up or
 add sparkle to your painting.

3. Ensure river strokes are
 horizontal – water does not run
 up hills.

4. Don't paint your fisherman too
 large and don't position him in
 the centre of the painting.

INTRODUCTION

The site of this scene on the River Wear
was my playground as a boy. I thought
it would make a pleasant landscape to
practise painting trees.

Before starting to paint, I used a
water-soluble crayon to complete a
tonal study. Such tonal studies should
be completed quickly; they're an impor-
tant means of establishing your lights
and darks.

FIRST STAGE

Having used your tonal study to think
about your approach before applying
colour, now take the water-soluble cray-
on and draw the basic outline. The
distant water line is approximately one
third of the way up the painting. Paint
in the sky by wetting the area with a
pale Raw Sienna wash and, whilst still
wet, adding the clouds using a drier mix
of Payne's Gray/Cerulean Blue. (A drier
or stiffer mix is the opposite of a glaze:
more colour, less water.) Use the hake to
paint the sky and then use tissues to
soften the cloud edges. Leave to dry.

SECOND STAGE

Paint the river banks by wetting the area
with a Cadmium Yellow/Hooker's
Green mix, and, when half dry, add
shadows and texture using a drier,
deeper-toned mix of the same colours.
Allow to dry.

Cut some masking tape and position
it to cover the bank areas to prevent sur-
plus paint running down when you
paint the trees. Employ the pecking
technique described on page 72 to paint
the trees using various mixes of
Hooker's Green/Raw Sienna/Cad-
mium Yellow. Add some Burnt Sienna to
the left-hand trees to indicate depth,
and, when the paint is half dry, scratch
in the structure of the trees.

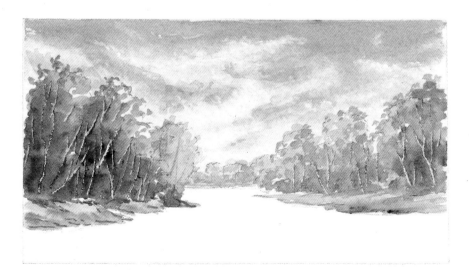

Payne's Gray

Cerulean Blue

Alizarin Crimson

Raw Sienna

Burnt Sienna

Burnt Umber

Cadmium Yellow

Hooker's Green

FACT FILE

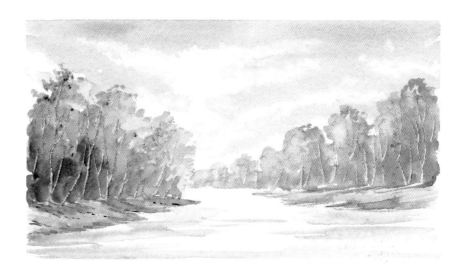

THIRD STAGE

Paint the water with horizontal strokes using the size 16 round brush and a pale wash of Payne's Gray/Cerulean Blue with a little Alizarin Crimson added. Start your strokes from the river banks, moving toward the centre of the river and leaving areas of white paper uncovered. Link the two sides of the bank together with two or three horizontal strokes.

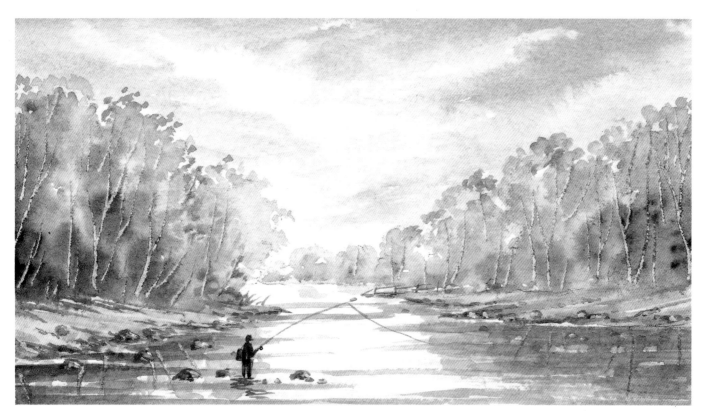

FINAL STAGE

Paint the tree reflections making horizontal strokes with the round brush, leaving some white paper showing through. Use a mixture of Hooker's Green/Burnt Umber, and scratch in some tree structure reflections.

To complete this 'doodle', add a few rocks using Burnt Umber. You can paint the fisherman using the rigger and add some sparkle by applying a Raw Sienna glaze to selected areas. Notice this is the opposite of what was done in the previous demonstration: there an overall glaze was used; here specific areas were selected for highlighting.

DEMONSTRATION 3: PAINTING BOATS

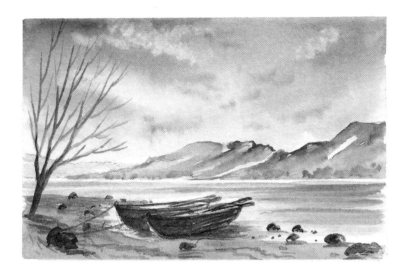

INTRODUCTION

This is a scene typical of those I come across when walking along a lake shore and I purposely have kept it simple for you. It will give you the opportunity to practise drawing boats and a tree structure in autumn, when the leaves have fallen. Refer to page 48 for examples of boats and page 77 for winter trees. It's important to produce your quick tonal study first.

FACT FILE

MATERIALS

Brushes:
 Hake, Rigger, Size 16 round,
 1" flat

Paper:
 300gsm (140lb) Arches
 Fontenay, artist's quality rough

CONSIDERATIONS

1. Firmly press only the top edge of the masking tape down and remove it slowly.

2. If you make a mistake drawing the boats with a water-soluble crayon, don't rub out with an eraser – wet the area and wipe off with a tissue.

3. Don't forget to add the shadows under the boat and the rocks.

FIRST STAGE

Position a piece of masking tape approximately one third of the way up the painting to represent the water line. Draw in the mountain shapes using a water-soluble crayon or pencil. Wet the paper with a pale Raw Sienna wash down to the level of the tape. Paint the clouds using the hake and a less-wet mix of Payne's Gray/Cerulean Blue with a little Alizarin Crimson added. Use tissues to create some shape in the sky. Leave to dry. Paint the mountains with darker tones of the same mix, leaving areas of Raw Sienna to show through.

SECOND STAGE

When dry, carefully remove the tape. Draw the shape of the shore line, adding a few rocks. Paint the water in a lighter tone of the mix used for the mountains, making horizontal strokes with the round brush. Allow to dry. Paint some mountain reflections using darker tones. Allow to dry. Using the hake or the 1" flat, paint the lake shore with a Raw Sienna wash. When half dry, paint some shadows using the mix which was used for the mountains.

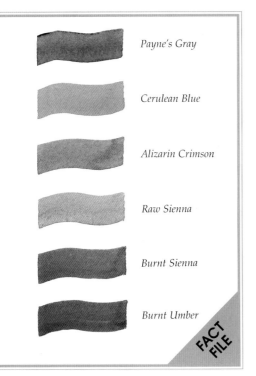

Payne's Gray

Cerulean Blue

Alizarin Crimson

Raw Sienna

Burnt Sienna

Burnt Umber

FACT FILE

THIRD STAGE

When the painting is completely dry, paint in the rocks with some Burnt Umber, using the corner of the 1" flat or the pointed brush. Using the rigger, paint in the tree structure with Burnt Umber. Start at the base of the tree, pressing the rigger to the paper to create a broader line and releasing the pressure as you work your way up the tree to produce thin branches.

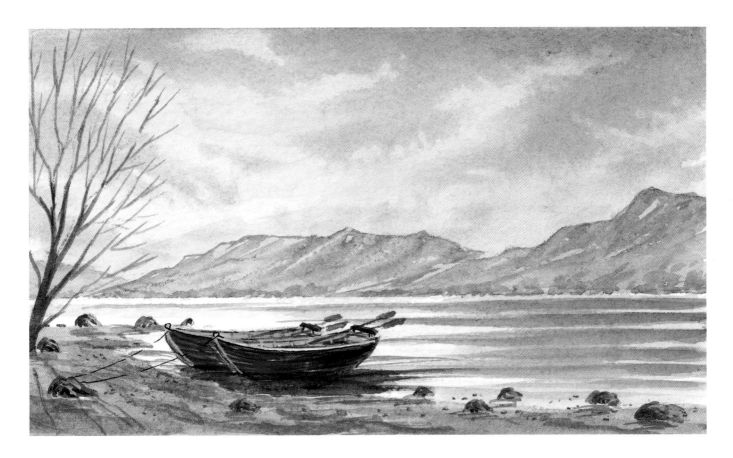

FINAL STAGE

Practise drawing your boat shapes on a piece of paper first before drawing them in on the final painting. Their shape and size is important. Page 48 should be helpful to you. Using a rigger and a mix of Burnt Sienna/Burnt Umber, paint the boats. It may seem an obvious point, but the boats are the centre of interest.

To complete this 'doodle', apply a Raw Sienna glaze to the sky, water and foreground shore to add warmth and depth.

DEMONSTRATION 4: PAINTING A SNOW SCENE

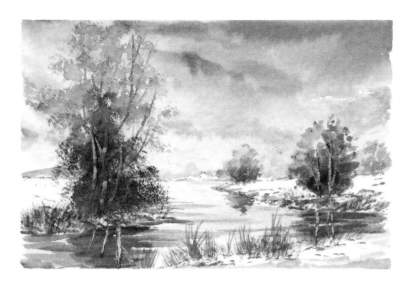

INTRODUCTION

I've created this river scene to give you practice painting trees and water. It's typical of scenes you'll find on most rivers: I thought a snow scene would provide you with something different to try. The dead leaves are still on the trees covered by a light coating of snow. I find these snow scenes very pleasant to paint and have several hanging on my walls.

FIRST STAGE

Lightly draw in the scene using the crayon. Don't worry about lines as the crayon is water-soluble and the lines will disappear as the painting progresses.

Paint the sky by applying a very weak Raw Sienna wash. Whilst the area is still wet, use the hake and our usual mix of Payne's Gray/Cerulean Blue with a small amount of Alizarin Crimson added to paint the clouds.

SECOND STAGE

Use the previous mix to paint impressions of distant mountains. To paint the snow, use the rigger, making 'dot and dash' brush strokes to indicate stubble projecting through the snow. The snow is represented by the white paper which has been left uncovered. Don't overdo your dots and dashes at this stage.

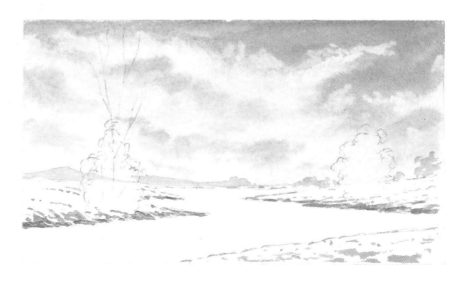

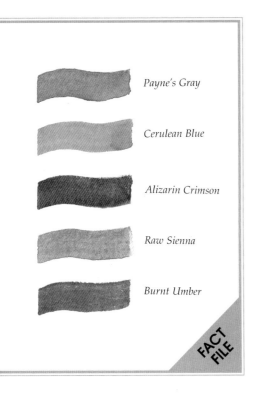

Payne's Gray

Cerulean Blue

Alizarin Crimson

Raw Sienna

Burnt Umber

FACT FILE

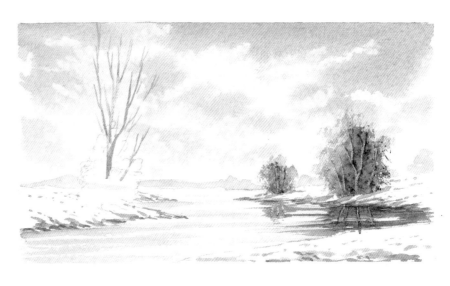

THIRD STAGE

Paint the water with the size 16 round brush, using our previous mix with a little water added to lighten the tone. As I have mentioned previously, it is important to keep your brush strokes horizontal. The next stage is to paint in the left-hand tree structure and the bushes on the right.

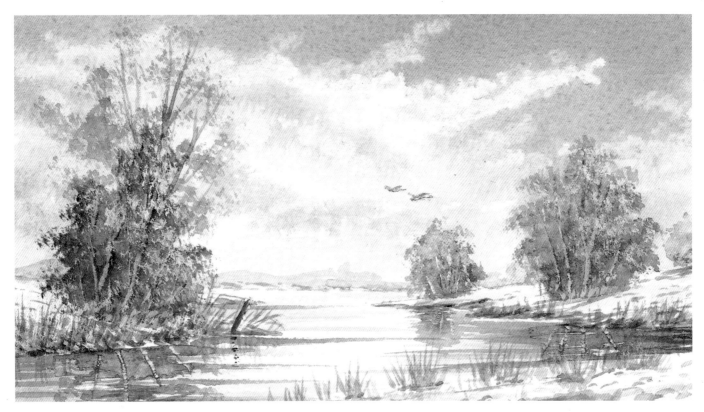

FINAL STAGE

Paint the foliage on the left-hand trees and their reflections in the water using a mix of Payne's Gray/Burnt Umber. I used the 'unique' brushes (see description on page 28), but you could use any of the techniques described on pages 70–77. Before the paint dries, scratch in some structure using your thumbnail and do the same for the corresponding reflections in the water. Allow to dry.

Dip the brush in white paint with very little water added and use a stippling action to paint the impression of snow on the foliage. Paint the tufts of reeds around the river bank by holding the rigger at the top of the handle and flicking upwards using the previous mix (you may want to practice this technique before attempting it on the final painting). Apply a Raw Sienna glaze to selected areas of the painting.

DEMONSTRATION 5: PAINTING A MOUNTAIN SCENE

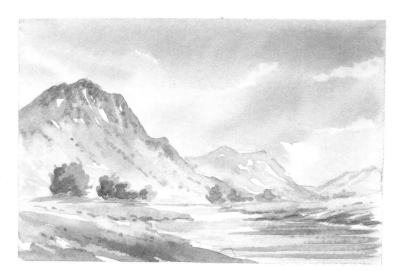

FACT FILE

MATERIALS

Brushes:
Hake, Rigger, Size 16 round, 1" flat

Paper:
300 gsm (140lb) Winsor & Newton artist's quality rough

CONSIDERATIONS

1. Use masking tape to retain the shape of your grass areas.
2. When painting mountains, your brush strokes should follow the structure of the mountain.
3. Apply glazes to selected areas to add warmth.

INTRODUCTION

It's off to Scotland to paint some mountains, water and rocks; in particular, you'll be able to practise the painting of mountains. I've kept them simple, so you should find this a pleasure to paint.

It's important to keep the colours as soft, pastel tones, so use lots of water with your washes. The initial tonal study is important to clarify where your lights and darks are going to be.

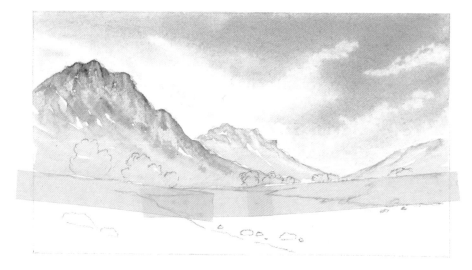

FIRST STAGE

Draw the outline, then position masking tape in line with the tops of the river banks. Paint the sky by wetting the paper and brushing in some clouds with the hake, using a mix of Payne's Gray/Cerulean Blue. Allow to dry. Paint the mountains with the hake or the 1" flat, using the cloud mix with a little Alizarin Crimson added. For the distant mountains, add more water to lighten the tone. These strokes should follow the structure of the mountain from peak to ground. Using the size 16 round, apply a Raw Sienna wash to the mountains with upward strokes from the tape level, allowing the wash to blend with the initial application of paint.

SECOND STAGE

Paint in the distant trees using various mixes of Hooker's Green/Raw Sienna. When the paint is dry, carefully remove the tape. With the point and side of the size 16 round, paint in the river banks and grass area. Use a weak mix of Hooker's Green/Cadmium Yellow and, when half dry, paint in some darker tones using a Hooker's Green/Raw Sienna mix, adding some Burnt Sienna to the foreground bank.

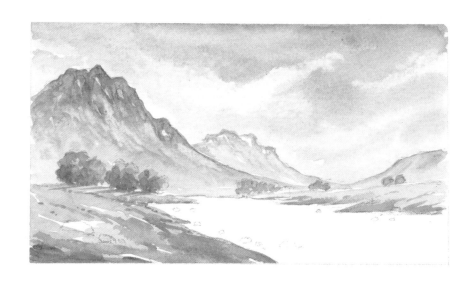

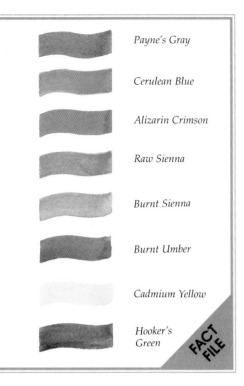

Payne's Gray

Cerulean Blue

Alizarin Crimson

Raw Sienna

Burnt Sienna

Burnt Umber

Cadmium Yellow

Hooker's Green

FACT FILE

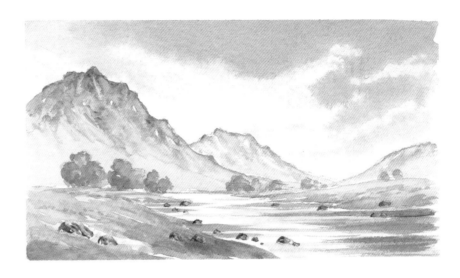

THIRD STAGE

Paint the water using a pale wash of Payne's Gray/Cerulean Blue and, when dry, paint the darker tones by adding more Payne's Gray to the wash. Note that some of the paper has been left uncovered. Paint the rocks with the point of the size 16 round, initially using a weak Raw Sienna mix. Add the darker tones to the rocks with Burnt Umber and Payne's Gray.

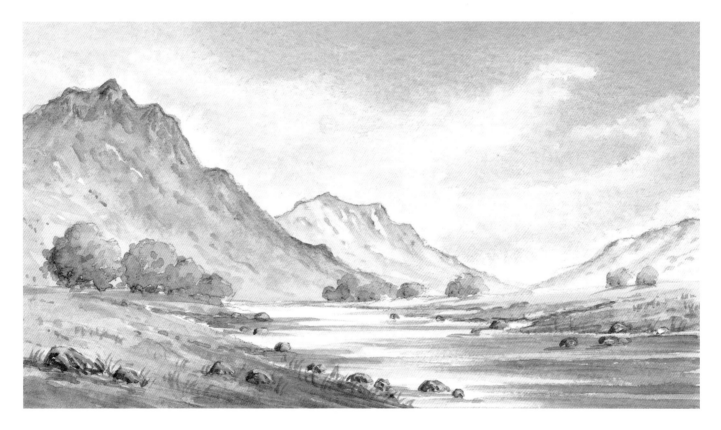

FINAL STAGE

Use the rigger with a mix of Payne's Gray/Alizarin Crimson to add more definition to the mountain peaks, then use Raw Sienna and Burnt Sienna glazes to add warmth to selected areas of sky, mountains, foreground grass and water. Use the rigger to paint some shadows under the rocks and to add texture.

Finally, paint a few reeds on the river banks, using a Payne's Gray/Alizarin Crimson mix. Don't forget to keep it simple.

DEMONSTRATION 6: PAINTING A WOODLAND SCENE

FACT FILE

MATERIALS

Brushes:
 Hake, Rigger, 'Unique'

Paper:
 300 gsm (140lb) Winsor &
 Newton, artist's quality, rough

CONSIDERATIONS

1. To achieve a sense of recession,
 the timing is important when
 painting the tree structures into
 the under-painting.
2. The trunks of foreground trees
 should be painted darker than
 those of more distant trees.
3. Don't paint the figures too
 large.
4. In the path area, leave some
 white paper unpainted.

INTRODUCTION

I have created this woodland scene for you as an exercise in painting wet-in-wet. The scene is typical of many you will discover on autumn walks through the woods. This technique is ideal for creating a sense of distance in your paintings and is often used to create mist or fog or as a background to street lights. I think you will enjoy experimenting with this valuable technique.

FIRST STAGE

Draw a basic outline and apply a pale Raw Sienna wash to the background. Using the hake, paint in various mixes of Raw Sienna, Burnt Sienna and Alizarin Crimson, then add a mix of Payne's Gray/Cerulean Blue with a touch of Alizarin Crimson added. Tilt the paper to help the paint to run downwards, thus creating an abstract background. This fusion of colour is extremely useful for evoking subtle, diffuse moods. This is the first half of the wet-in-wet technique.

SECOND STAGE

When the paint is half dry, we are ready to move on to the second half of the wet-in-wet technique. To do this we add stiffer paint which, though it will still fuse somewhat with the background, will nonetheless retain some shape, in this case tree structures. Use the hake and a stiffer mix of Payne's Gray/Cerulean Blue with a touch of Alizarin Crimson to paint the distant trees and the smaller bushes on the left. Allow the painting to dry completely. Paint the foreground land with a pale Raw Sienna wash and, when half dry, add some texture using a Payne's Gray/Alizarin Crimson mix. This should give a soft effect. Leave to dry.

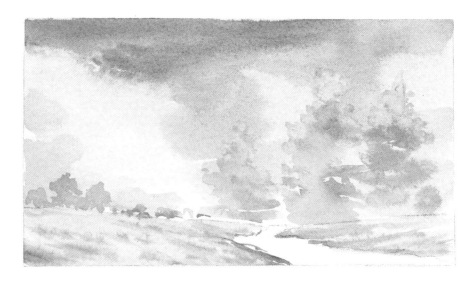

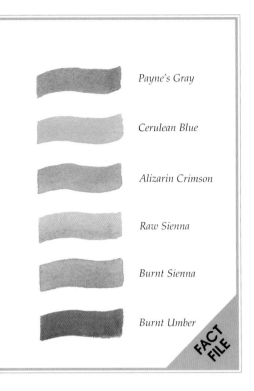

Payne's Gray

Cerulean Blue

Alizarin Crimson

Raw Sienna

Burnt Sienna

Burnt Umber

FACT FILE

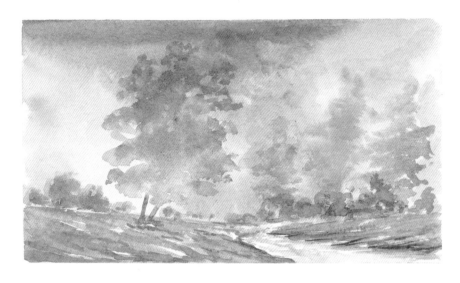

THIRD STAGE

Apply a Raw Sienna glaze to the whole of the painting using the hake. When half dry, paint the large, middle-distance tree using a fairly dry mix of Payne's Gray/Burnt Sienna. I used the 'unique' tree brush to paint the large tree and a few bushes. Whilst the under-painting is still wet, add texture and depth to the woodland floor. Leave the path a lighter tone.

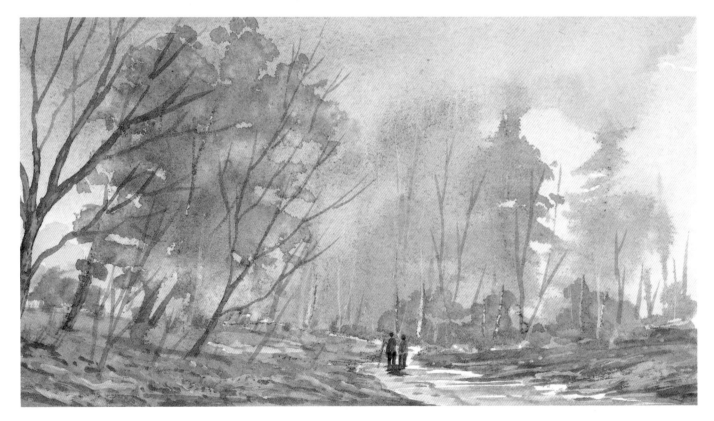

FINAL STAGE

When the paint is half dry, scratch some tree structures into the background. Use the rigger loaded with Burnt Umber to paint the left-hand tree structure and the several smaller trees on each side of the path. Add some additional detail to the path and woodland floor. To complete this 'doodle', I added the figures with the rigger. While some landscapes are solitary scenes, others benefit from the addition of figures. (Refer to page 33 for help in the painting of figures.)

THE PAINTING KIT

The materials you use are very important. You'll have enough problems learning to paint without extra difficulties caused by using the wrong materials. There's a school of thought which recommends you start with student quality brushes, paints and paper. The brushes my students purchase are the main problem. They are usually too small for the job and are made from the wrong hair. My advice is to use the largest brush appropriate for the painting of each specific element in the landscape. The use of a small, flat brush to paint a sky, for example, would result in a streaky and fussy cloud formation. In comparison, I would use a large sky brush (also known as a hake).

Student quality paints are satisfactory, but to me they are not cheaper in the long term as their pigment is much weaker than in artist's quality paints and therefore they do not last as long.

As for papers, I have a thing about them. You'll find a wide choice of papers available. Some papers are very absorbent, some less so. Personally, I prefer an absorbent paper which allows me to create interesting effects and facilitates the fusing together of colours. I always use rough-surfaced paper, which I find ideal for painting trees and sparkle on water, creating texture in foregrounds and much more. I will never forget using a paper having little absorbency whilst demonstrating to the British Watercolour Society. I spent more time controlling the paint running down the paper than actually painting. Never again – use an absorbent paper.

The final problem I encounter is that my students arrive with palettes that are much too small for sensible painting. It's important to have adequate space to lay out colours and to mix washes and glazes. The following pages specify requirements in more detail and make recommendations.

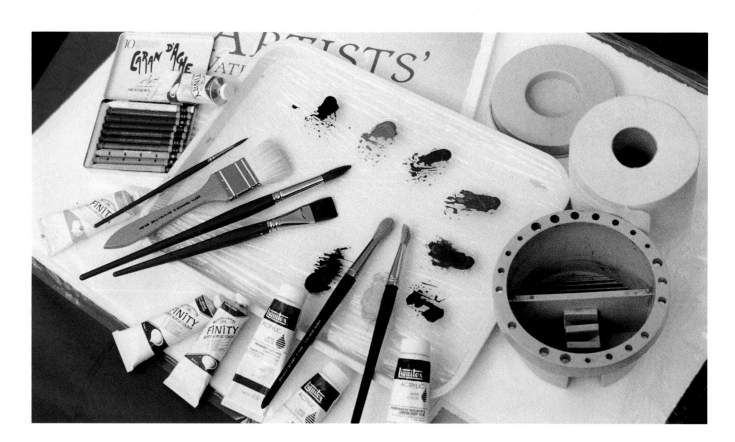

BRUSHES

Over the years, I've had the opportunity to use a wide variety of brushes supplied by manufacturers, for whom I've demonstrated at the fine art shows. There's no doubt that brushes vary significantly in use. They can be made from pony, ox, goat, squirrel, sable and bristle hair and from man-made fibres, to name the most common, and within this range one encounters significantly different quality levels. Kolinsky sable are the most expensive, but you don't have to purchase sable brushes. I find the sable/man-made fibre blends perfectly adequate and, of course, they're only a tenth of the cost.

My own set consists of six brushes, which enables me to paint any landscape that presents itself. For skies, mountains, water and foreground, I use my large hake brush. When I need to paint buildings, rocks or objects requiring straight or angular lines, I use the hake or a 1" flat sable/nylon mix. To enable me to push paint around and when I need more control, I use a sable/synthetic size 16 round, pointed brush. For detailed work such as tree structures, fence posts, grass, reeds and figures, I use my Kolinsky sable size 6 rigger.

In addition to this set of four, like most people faced with the problem of painting tree foliage, heather, rough foreground and many other elements in the landscape, I needed a particular brush which didn't seem to be available on the general market. After years of experimentation, changing the shape of brushes with pliers and cutting them with scissors, I came up with the design of two brushes which I call my 'unique' tree and foliage brushes. These are very important to me, making the painting of tree foliage simplicity itself. Try experimenting for yourself!

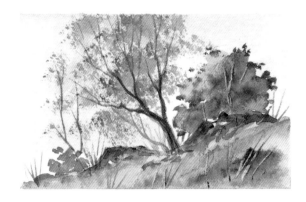

PAINTS

As mentioned earlier, a 59ml tube of acrylic watercolour costs approximately the same amount as a 5ml tube of traditional watercolour, so the saving is self-evident, especially as, for landscape painting, I find I need the following minimum palette of colours:

○ SKIES, MOUNTAINS, WATER, SHADOWS, ETC: Payne's Gray, Cerulean Blue, Alizarin Crimson

○ EARTH COLOURS: Raw Sienna, Burnt Sienna, Burnt Umber.

○ MIXERS: Hooker's Green Dark (or Sap Green) and Cadmium Yellow (or Yellow Hansa).

○ White: I use this sparingly, but find it useful for sheep and rocks.

With these nine colours I find I can paint any landscape I wish.

PAPER

There are many fine papers available and it really comes down to personal preference. I look for certain qualities in a paper: it must be absorbent, i.e. able to accept wet washes without running or bleeding too much. I prefer a rough-textured paper, as the tooth (as it is known) helps to control the paint flow and aids in the creation of interesting textures when the brush is pushed and pulled over its surface. I expect to be able to use and remove masking tape and paint and to scratch in details without tearing the paper surface. It must be sized on both sides, as when demonstrating at shows I use both sides of the paper.

A word about purchasing paper, as it comes in many textures and forms. There are three basic surfaces, each of which varies between manufacturers:

○ HP: Hot Pressed, a smooth texture particularly suited to pen and wash work or drawing.

○ CP/NOT: Cold Pressed or 'not' surface paper, the middle of the road texture. Many artists use this paper.

○ ROUGH: A rougher-surfaced paper which I use and find ideal for all kinds of work, except pen and ink, when the surface would cause splatter.

Paper can be purchased in glued pads, in spiral-bound pads and in blocks (where the sheets of paper are glued all round the edges except for a 2" unglued area which enables you to insert a flat object, such as a knife, to remove the top sheet). Due to the extra processing involved, blocks are the most expensive.

I prefer to purchase my paper in sheets, usually measuring 76x56cm (30"x22"), which enables me to cut them to my required size. I then fasten the paper to a board with masking tape prior to painting. I never use paper less than 300gsm (140lb) in weight. With paper of this weight or heavier, there's no need for stretching. (Stretching is a process whereby you soak your paper in water in a sink or bath, allow the surplus to drain off and then secure it to a board with gummed paper. On drying, the paper will be as tight as a drum.) I haven't stretched paper for 25 years.

You won't go far wrong if you use any of the following papers. I find them all excellent:

○ Winsor & Newton 300gsm (140lb) and 640gsm (300lb) artist's quality, rough

○ Arches Fontenay 300gsm (140lb) and 640gsm (300lb) artist's quality, rough

○ Saunders Waterford 300gsm (140lb) artist's quality, rough

○ Bockingford 300gsm (140lb) artist's quality, rough

It's a matter of personal choice, you need to experiment to determine which suits you the best.

WATERPOT

The plastic waterpot I favour, seen in the photograph to the right, has two sections: one with a corrugated bottom for brush cleaning and the other with brush supports. This pot has a lid which I use for mixing large washes or glazes. I also have a set of three small, plastic pots which fit into each other for ease of travelling. I use these when sketching with my water-soluble crayons.

PALETTE

When I start to paint, I like to put fresh paint on my palette. I've never been a supporter of small palettes with little indentations to house the paint. I find them messy and it is almost impossible to transfer paint from them to a large brush. I prefer to use a large baker's tray covered in clingfilm (plastic wrap). When I've finished painting, I can remove the clingfilm and dispose of it into the nearest waste bin, leaving me a clean palette to be re-covered for the next painting session.

DRAWING MATERIALS

I find a tin of water-soluble crayons ideal for drawing and for producing my tonal studies. I have a thing about being able to see pencil lines in a watercolour painting. With the water-soluble crayon, as the painting progresses the lines will be washed out.

TISSUE
(facial tissue or toilet roll)

I find this excellent for removing paint to create cloud formations, for adding texture to rocks and foregrounds and for many other applications.

My outdoor set-up

MAKING THE BRUSHES WORK FOR YOU

I've headed this section 'Making the Brushes Work for You', because the first thing you have to realize is that the brush is just the tool of the artist and that each brush is capable of being used in a number of different ways. When you paint every day, as I do, you study your subject and decide which techniques are appropriate for painting each element in the landscape and which will be the most suitable brush to use. Once painting begins, there's a tendency to become so absorbed in what you're attempting to achieve, you don't always change to the appropriate brush – you learn to adapt. For example, I may be using a large, pointed, round brush and need to cover a large area with paint. Rather than take up a flat, I may use the full length of the brush by pressing the brush to the paper. When painting tufts of grass, instead of taking up a rigger, I may spread the hairs of my round, pointed brush in my fingers, hold it by the handle and flick it upwards to achieve the same effect; or, to produce a thin line, I may flatten the tip of the large round between my thumb and forefinger.

So you see, each brush can be used in several different ways and, as your skills develop and you experiment with your brushes to achieve various effects or finishes, you will realize just how versatile your brushes are. As I said on page 28 in my discussion of the brushes I prefer, there's no need to purchase expensive sables: the less expensive sable/synthetic mixes are just as suitable. Brushes do, however, behave differently. I have twelve flat brushes made by various manufacturers and no two behave alike. Some of my brushes are soft, others quite stiff, but each is useful for painting particular elements in my paintings.

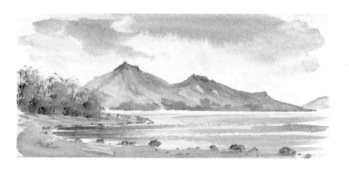

Eventually, you will discover your own pet brushes.

The secret of watercolour painting is knowing how wet the paint on the brush should be in relation to the wetness of your under-painting. We have all produced unwanted hard edges in our paintings by applying wet paint over an under-painting that is less wet. If we had painted a drier layer of paint over a wetter under-painting this would not have occurred.

In the next few pages, I will illustrate some of the ways the different brushes can be used. I'd like you to use these examples as exercises. It's important to practise: make your mistakes, but learn from them. Don't forget – practice makes perfect.

USING THE ROUND, POINTED BRUSH

1. I've painted a straight line with the point of the brush, moving it left to right, applying constant pressure. Second, I've lightly touched the paper with the point of the brush and gradually increased pressure moving left to right. Finally, I've flattened the end of the brush between my thumb and forefinger to produce a chisel edge and lightly touched the paper, moving left to right to create a thin line.

2. I have loaded the brush with very wet paint and, using the side of the brush pressed firmly against the paper, moved slowly across the paper left to right, which has resulted in a band of colour.

 When the brush is quickly moved across rough-textured paper, paint will only be deposited on the peaks of the paper, leaving areas of white uncovered. This is a much-used technique to add sparkle, especially for water.

3. Here, I've spread the hairs of the brush between my thumb and forefinger, then held the brush at the top of the handle vertical to the paper and flicked upwards to achieve the effect of reeds or grass.

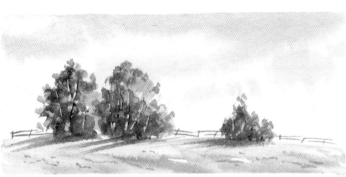

4. In this example, to create the bushes I've dabbed or stippled using a brush laden with three tones: with a light tone first, followed by darker tones. When the shine has gone off the paint, I've scratched in some structure. The timing is important. If you scratch in whilst the paint is too wet, it will fill in, producing unwelcome dark lines. I've used my thumbnail for this purpose, but a razor blade or knife can be used.

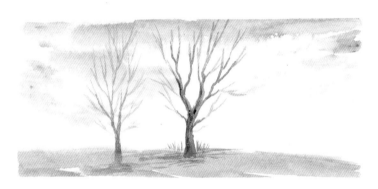

5. I have painted the tree stuctures with the point of the brush, working upwards, and gradually reduced the pressure on the brush to produce thinner lines for the outer branches and twigs.

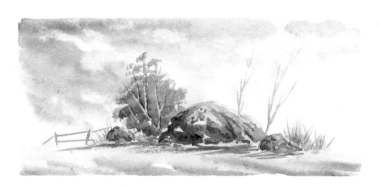

6. Here, I painted the rocks in a light tone, followed by darker tones when the under-painting was half dry, then painted the bush using fast downward strokes with the brush held horizontally and close to the paper.

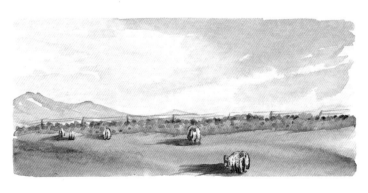

7. I painted the stone wall using the point of the brush and a dabbing action. I added the impressions of sheep by painting white over a darker tone made from Burnt Umber/Payne's Gray (refer to page 95).

USING THE FLAT BRUSH

The following 'doodles' could have been painted with my large hake or the 1" flat. It really depends on the size of the painting. The hake isn't only used for the painting of skies but also for washes, trees, land areas, water, reflections and mountains, hence my description 'sky and texture' brush.

1. I painted the water and left it to dry. To paint the reflections, I loaded the brush with wet paint and stroked downwards. Then, having rinsed the brush in clean water and squeezed out the excess water, I moved the chisel edge of the brush across the still-wet reflections, removing some paint to represent wind lines.

2. I painted the trunk with a light tone; then, when dry, lightly brushed across several darker tones of fairly stiff paint to create the texture of the bark. This is known as the 'dry-brush' technique and is often used for texture on rocks, stonework and foregrounds.

3. The whole of this 'doodle' was painted with the 1" flat. I drew the boathouse and landing stage by dabbing with the chisel edge of the brush, using the full width of the brush to good effect, moving the brush in 1" intervals, depositing paint as a thin line until the drawing was complete.

 To paint the roof, I positioned masking tape in line with the top and bottom and loaded the brush with a mix of Burnt Sienna/Alizarin Crimson. Then, holding it at right angles to the paper with the chisel edge turned to a 45-degree angle, I employed a dabbing action, moving the brush left to right. Finally, I removed the masking tape, leaving neat edges to the roof. This is a useful technique for painting pantiles.

4. I painted the bushes using the 'pecking' action described on page 72. I used three colours to paint the trees and indicated some structure by scratching in with my thumbnail.

USING THE RIGGER BRUSH

A good-sized rigger brush is an important addition to any painter's 'kit'. A word about riggers – they usually come in three lengths: very long hairs, which have a limited use; short hairs, which I don't favour; and one in-between length, which I find the most useful. Whichever length you favour, for some reason unknown, art shops only seem to stock smaller-diameter riggers. I find most of the riggers stocked only go up to a size 3.

Personally, I favour sizes 6 and 8. A rigger of this size with a fine point can be used to paint figures, animals, birds and small rocks and also to add foreground texture, reeds, texture on mountains and tree structures. There needs to be sufficient hair in the brush to push the paint around. You can't achieve this with the smaller sizes, so be warned.

1. In this 'doodle', I used the rigger to paint the bush (refer to page 71), the dead tree and the fence and to add shadows and tufts to the foreground grass. Don't forget when painting fences that a useful guide is to keep the distance between the fence posts twice as far apart as the height of the fence. Don't paint your fences too neatly.

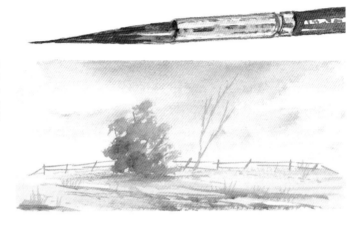

2. Here, I've used the rigger to add the rocks in the foreground and to paint the leafless trees. I've also painted the darker-toned textural effects on the shore line by wiggling the rigger.

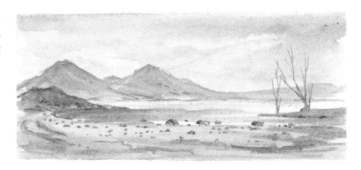

3. The rigger is ideal for painting figures in a street scene, a lone fisherman, birds or small animals. I've shown in three stages how easily figures can be painted. Don't forget to paint some shadows under your characters, it makes a difference.

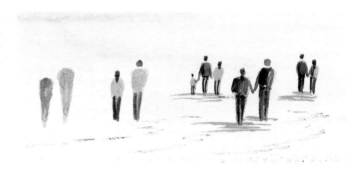

4. In this 'doodle', I used the rigger to add some structure and shadows to the mountains and to paint the boat. Don't forget the shadows under the boat.

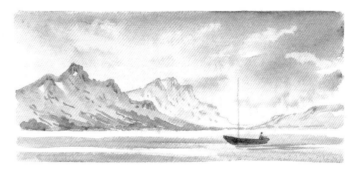

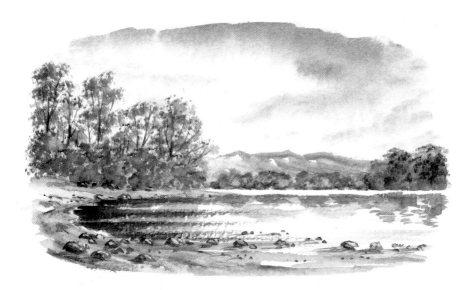

I painted this sketch of Derwentwater using the following brushes: for the sky, the distant mountains and the shore, I used the hake. For the trees and bushes, I used the 'unique' brushes, and I painted the water and rocks with the round brush. For detailed work, such as the tree structures and the shore-line shadows, I used the rigger.

EXERCISE

1. Paint the scene in summer using Payne's Gray/Cerulean Blue for sky and water.

2. Use a pale Raw Sienna for the lake shore.

3. For the trees and bushes, use various green mixes made from Hooker's Green, Raw Sienna and Cadmium Yellow.

4. Paint the rocks and shadows with Payne's Gray/Burnt Umber.

For this sketch, I painted the wet-in-wet background and river banks with the hake, the tree structures, rocks and fisherman with the rigger, the tree foliage with the 'unique' brushes and the water with the round brush. I could have used the corner of the hake for the foliage by dabbing or by using the pecking action described on page 72.

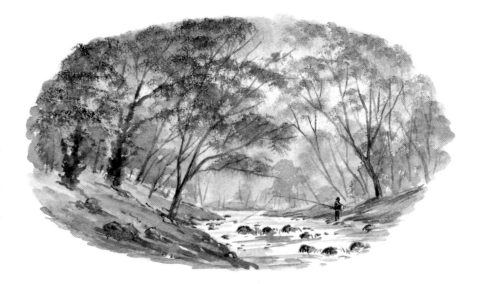

EXERCISE

1. Create a snow scene by painting the abstract background with a light Raw Sienna wash and dropping in some Payne's Gray to represent distant trees when the under-painting is half dry.

2. Use the rigger to paint the tree structures and to add texture to the river banks, leaving the paper uncovered to represent snow. Use a Payne's Gray/Burnt Sienna mix.

3. Paint the water and rocks with the round brush using various tones of Payne's Gray. Add a little Burnt Umber for the rocks.

4. Add a few dead leaves using the 'unique' brushes and a stiff mix of Burnt Sienna/Burnt Umber.

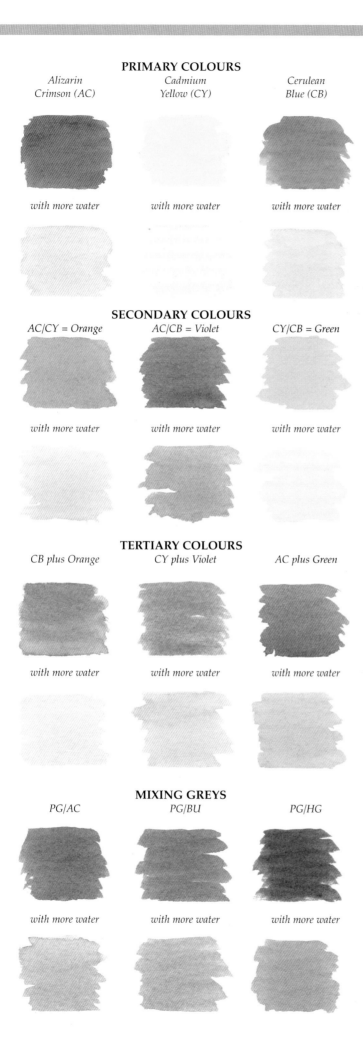

PRIMARY COLOURS

Alizarin Crimson (AC)

Cadmium Yellow (CY)

Cerulean Blue (CB)

with more water *with more water* *with more water*

SECONDARY COLOURS

AC/CY = Orange *AC/CB = Violet* *CY/CB = Green*

with more water *with more water* *with more water*

TERTIARY COLOURS

CB plus Orange *CY plus Violet* *AC plus Green*

with more water *with more water* *with more water*

MIXING GREYS

PG/AC *PG/BU* *PG/HG*

with more water *with more water* *with more water*

COLOUR MIXING WITHOUT TEARS

Most of my students experience difficulty mixing their colours. They seem to go to extremes. Some have been told that all they need are the primary colours, consisting of red, yellow and blue, and they will be able to mix any colour they require; others arrive with dozens of different colours, including turquoise blues and garish greens. In particular, students experience difficulty mixing natural greens and warm greys.

By mixing the primaries, secondary colours result. In the colour exercises opposite, I have used red and yellow to produce orange, red and blue to produce violet and yellow and blue for green. I have then mixed secondary colours with primary colours to produce tertiary colours (one primary mixed with one secondary). For example, Cerulean Blue has been added to orange to produce a warm brown.

Varying the amount of each colour mixed will result in different shades and tones. It's interesting to watch students painting the same scene and to find that their colours and tones are completely different, depending on how much of each colour is mixed together and how much water is added.

Let's now consider the basics of colour mixing. If you wish to mix a light tone, common sense tells you that you should start with the lighter colour and add a small amount of the darker colour. If you're aiming to produce a dark tone, then you should start with the darker colour and add a small amount of the lighter colour. If you want a rich orange, then start with the red and add a small amount of yellow; however, for a bright orange, start with the yellow and add a small amount of red. It's common sense, really.

To lighten your colours, add more water. Another exercise I undertake with my students is to mix two colours and paint a small area on a sheet of watercolour paper. I then ask them to hold some tissue in their hand, dip the brush without shaking or wiggling it about 8mm into some clean water. Then remove the brush immediately, very gently wipe it on the tissue and make another mark on their paper. If you do this, you will see your colour has lightened. Dip and wipe again, make your mark and carry on with the process. With practice, you'll find that you will be able to produce at least six lighter tones of the original colour. My students don't go to bed counting sheep, they dip and wipe, but it works.

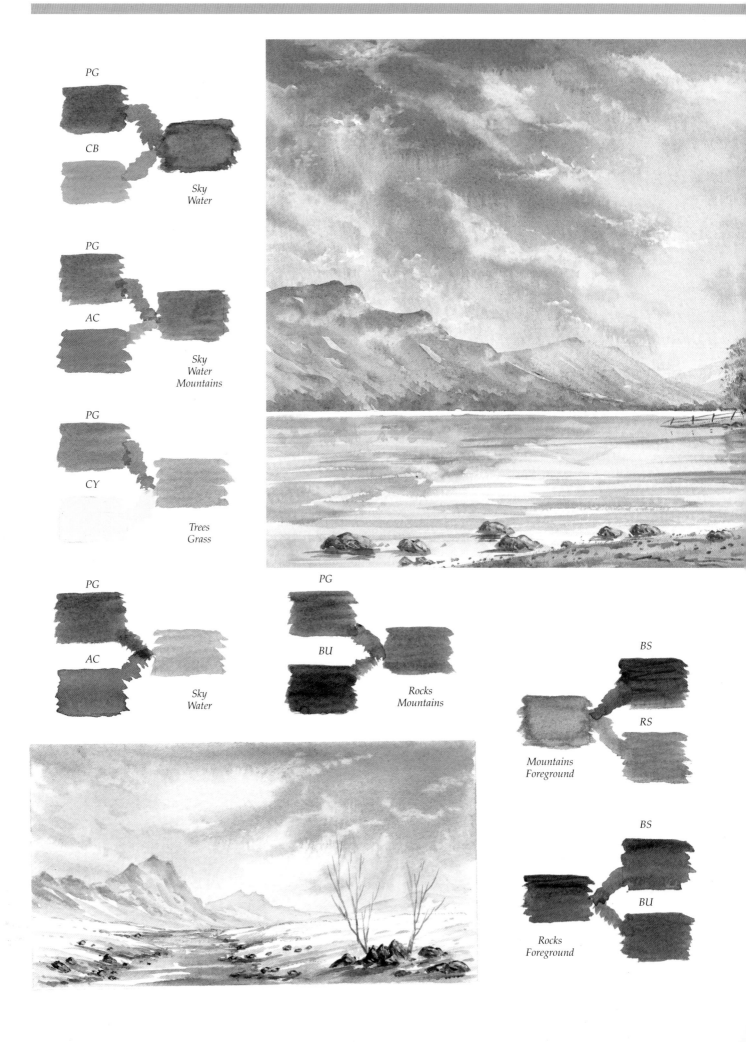

PG

CB

Sky
Water

PG

AC

Sky
Water
Mountains

PG

CY

Trees
Grass

PG

AC

Sky
Water

PG

BU

Rocks
Mountains

BS

RS

Mountains
Foreground

BS

BU

Rocks
Foreground

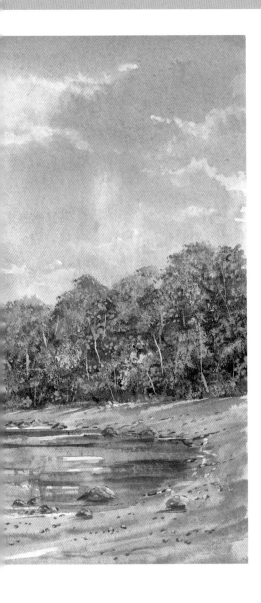

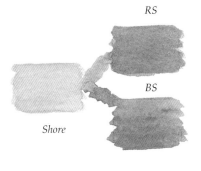

Shore

RS

BS

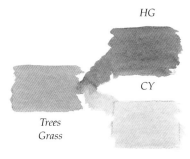

HG

Trees
Grass

CY

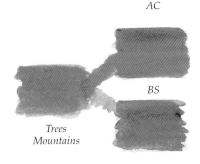

AC

Trees
Mountains

BS

PG

Trees

HG

RS

Sky

PG

Another tip is to never dip your brush into the middle of the paint: I observe so many artists doing this and then hear their reaction that the paint is too thick. I always tease my paint away using circular movements of the brush, lightly touching only the side of the deposited paint. By this means, I'm able to control the strength of paint on the brush and to keep my wrist supple.

Also, I very rarely use the colour direct from the tube, preferring to mix together two colours, sometimes three, to create a particular tone. If you mix more than three colours together you are likely to create a dull colour often referred to as 'mud'. We must also remember to be sympathetic to nature. We mustn't forget we aren't producing a gaudy billboard which may need to be bright and garish to attract the eye of the passing motorist. 'Subtlety' is the key word.

What I recommend you do is experiment. Purchase a small sketch book and spend some time creating several pages of colour mixes for yourself.

PG

BS

Trees
Shadows

PG

CY

Trees
Grass

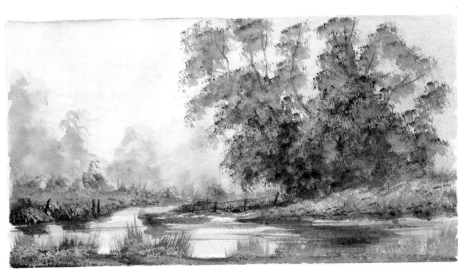

PAYNE'S GRAY

Payne's Gray is regarded by some as being too near black to be used and this is often frowned upon. Personally I find this colour the most versatile in my palette. I use it with Cadmium Yellow and Raw Sienna to mix greens, with Alizarin Crimson it is ideal for distant mountains and with Cerulean Blue for painting skies. Mixed with Burnt Umber and Burnt Sienna, it produces warm greys.

with more water *with Cerulean Blue* *with Burnt Sienna*

CERULEAN BLUE

I prefer Cerulean Blue to Ultramarine Blue, the latter being rather too bright for my taste. Mixed with Payne's Gray, it is ideal for water and skies. Mixed with Burnt Sienna, it produces a pleasant grey and with Raw Sienna a realistic grass green. Mixed with Cadmium Yellow, it produces spring green. Cerulean is a very strong colour and must be used sparingly.

with more water *with Alizarin Crimson* *with Burnt Sienna*

ALIZARIN CRIMSON

A very strong colour to be used sparingly. Mixed with Burnt Sienna, it is perfect for painting pantiles on old farmhouses or French villas. With Payne's Gray, it adds warmth to skies and is useful for shadows. Mixed with Raw Sienna, it produces a rich orange suitable for sunsets.

with more water *with Raw Sienna* *with Burnt Sienna*

RAW SIENNA

A colour I couldn't do without, used in almost all of my paintings. Ideal for river banks, lake shores and sandy beaches with varying levels of water. Or, with a touch of Burnt Umber or Burnt Sienna, it is a very useful colour for under-painting building stonework. I use it regularly for the first wash of a wet-in-wet sky. Furthermore, it is wonderful for applying a glaze to warm up or revitalize certain areas of a painting.

with more water *with Burnt Sienna* *with Cadmium Yellow*

For this lake scene, the sky is created by painting the clouds with a Payne's Gray/Cerulean Blue mix over a Cadmium Yellow / Burnt Sienna under-painting. The water is Payne's Gray; the trees are Payne's Gray/Cadmium Yellow, with a Burnt Sienna glaze applied when dry. The foreground is a Burnt Sienna/Cadmium Yellow mix and the mountains are mixes of Payne's Gray/Burnt Sienna.

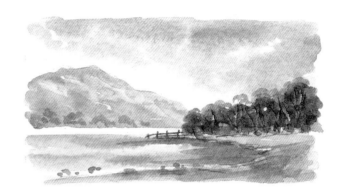

with Cadmium Yellow

This winter scene is painted using Alizarin Crimson and Cerulean Blue for the sky. Raw Sienna and Burnt Sienna are used for the foreground and a mix of Cerulean Blue/Burnt Sienna for the fir trees.

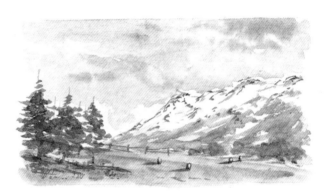

with Raw Sienna

In this river scene, a Raw Sienna wash is applied as an under-painting for the sky and a mix of Alizarin Crimson/ Payne's Gray for the clouds. A Payne's Gray wash is used for the distant mountains. Burnt Sienna/Payne's Gray are used for the fishing posts and for edging the river bank. The water is Raw Sienna with Burnt Umber for the shadows.

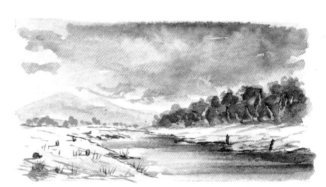

with Payne's Gray

In this French village scene the sky is Raw Sienna with Payne's Gray for the clouds. The roof tops are a mix of Raw Sienna and Burnt Sienna. The vineyard is a Raw Sienna / Payne's Gray mix for the greens over a Raw Sienna wash.

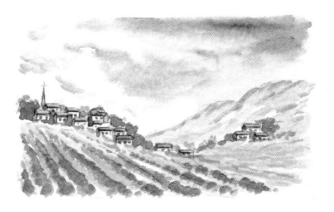

with Payne's Gray

BURNT SIENNA

A useful colour for glazing, to add warmth to a painting, often used to warm a mountain or shore. Mixed with Payne's Gray, a warm grey suitable for shadows can be produced. Added to Hooker's Green, it produces a rich, dark green, useful for painting trees. When a small amount of Alizarin Crimson is added, a colour useful for painting pantiles on old farmhouses and Spanish villas is created.

with more water *with Alizarin Crimson* *with Payne's Gray*

BURNT UMBER

Often used to darken other colours, particularly greens. Useful for shadows and for painting tree structures. Mixed with Cadmium Yellow, it produces a useful colour for rocks and, with Cerulean Blue, an interesting grey. When mixed with Alizarin Crimson, a rich red results.

with more water *with Cadmium Yellow* *with Cerulean Blue*

CADMIUM YELLOW

When added to Payne's Gray, a wide range of greens can be produced. Mixed with Burnt Sienna, it produces a lovely warm colour ideal for glazing stonework, grass, mountains, etc. and for making paintings glow. Added to Alizarin Crimson, it produces a soft orange, useful for autumn scenes, boats, clothing, etc.

with more water *with Payne's Gray* *with Burnt Sienna*

HOOKER'S GREEN

With Cadmium Yellow, it produces lovely soft greens for spring foliage. On its own and mixed with Payne's Gray, it is useful for adding depth and shadows to trees. Mixed with Alizarin Crimson and Burnt Sienna, it produces a variety of greys, useful for many purposes.

with more water *with Cadmium Yellow* *with Alizarin Crimson*

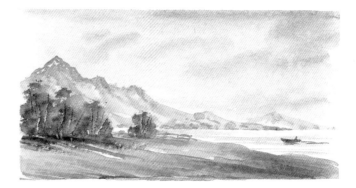

The sky is a Burnt Sienna/ Payne's Gray mix painted over a weak Burnt Sienna under-painting. The mountains and water are painted in various tones of the same mix. The trees and foreground are a Burnt Sienna/Hooker's Green mix. The boat is painted with Burnt Sienna.

with Hooker's Green

In this harbour scene, the sky is a Burnt Umber/Alizarin Crimson mix over a weak yellow under-painting. The mountains and water are Burnt Umber/ Cerulean Blue. The foreground grass is Cadmium Yellow/ Cerulean Blue, with a little Burnt Umber added for the trees. The boats and roofs are a Burnt Umber / Alizarin Crimson mix.

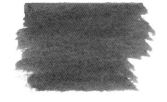

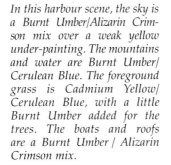

with Alizarin Crimson

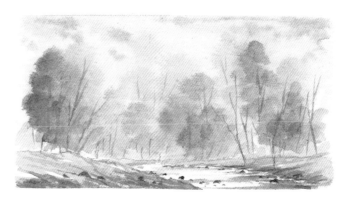

Wet-in-wet techniques are used for this quickly painted wood-land scene. Payne's Gray is painted over a yellow wash to create the misty background. A stiff Burnt Sienna is used to paint the trees. The river banks are Cadmium Yellow/ Payne's Gray. The water is Payne's Gray with a stiffer Payne's Gray for the tree struc-tures.

with Alizarin Crimson

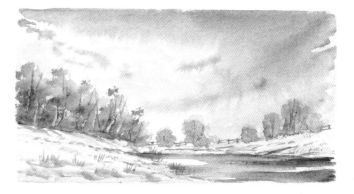

The sky in this winter scene is a weak Hooker's Green/ Alizarin Crimson mix over a Yellow Hansa wash. The water, trees and reeds are painted using the cloud colours. The darker tones added to the trees are a Hooker's Green/Alizarin Crimson mix. A Cadmium Yellow/Burnt Sienna glaze is added to the snow areas to add warmth.

with Burnt Sienna

To mix a range of interesting greys in addition to the ones mentioned already, try adding various amounts of water to neat Payne's Gray. As an exercise, also try adding Burnt Umber, Burnt Sienna or Hooker's Green to Payne's Gray and you will be surprised how easy it can be. For shadows, distant mountains and heather, add a little Alizarin Crimson to Payne's Gray, diluting it with varying amounts of water. Colour mixing requires a little forethought before splashing it on all over, but ultimately it is common sense.

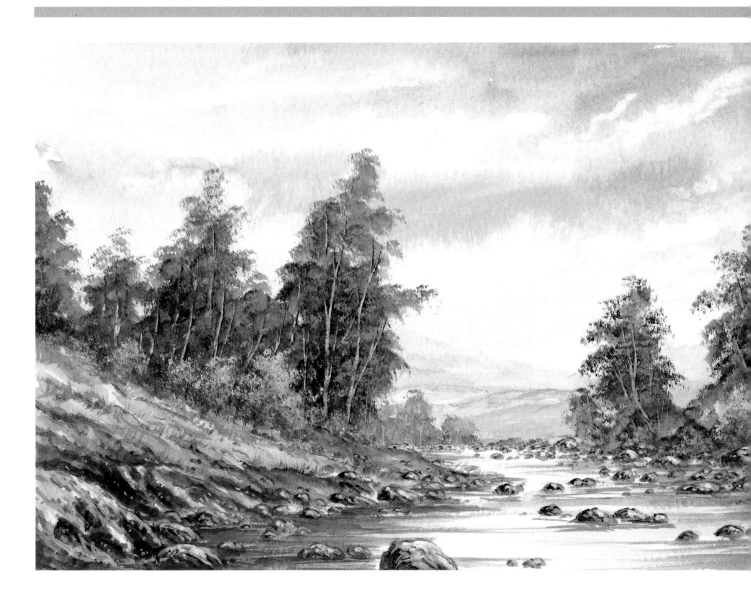

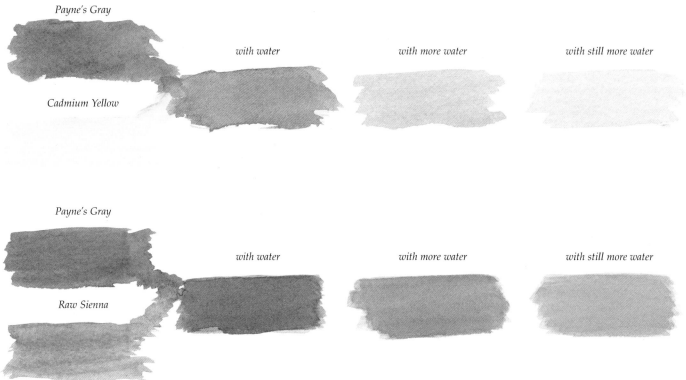

Payne's Gray

with water *with more water* *with still more water*

Cadmium Yellow

Payne's Gray

with water *with more water* *with still more water*

Raw Sienna

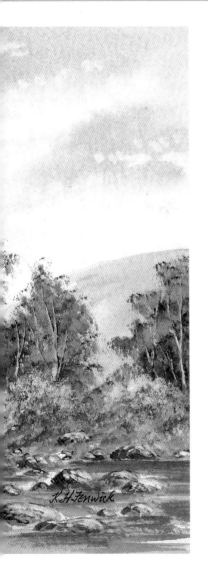

FURTHER MIXES USING THE BASIC PALETTE

If you stick to my basic palette, you won't go far wrong. Depending on the landscape you are painting, you even may find that you will only use a few of the colours and not the complete palette.

As I mentioned previously, my **SKY** colours are Payne's Gray, Cerulean Blue and Alizarin Crimson used in various combinations. My **EARTH** colours are combinations of Raw Sienna, Burnt Sienna and Burnt Umber. As **MIXERS** I use a light yellow, usually Cadmium Yellow or Yellow Hansa, and Hooker's Green or Sap Green.

Using various combinations of Payne's Gray, Cerulean Blue, Cadmium Yellow and Raw Sienna, it's possible to mix an extensive range of greens to meet any occasion. Whilst it's important to learn how to mix your greens, I can never understand why it's considered bad practice to use one of the available greens and mix it with other colours to produce a range of subtle blue-and-yellow-greens. Although it's quite possible to produce fifty subtle greens with only four colours when needed, you will have noted that a reliable proprietary green has been included in my basic palette as a mixer.

Hooker's Green is a very useful addition to my palette. By lightening Hooker's Green with Cadmium Yellow or Raw Sienna, or by darkening it with Payne's Gray, Burnt Umber or Burnt Sienna, it's easy to create a range of cold or warm greens.

What about white? In transparent watercolour, the plain white paper is probably more important than any of the colours you will use, but personally, when I paint sheep, I prefer to use white over a dark colour. I don't make any apologies for this. I like my sheep to look three-dimensional and not like balls of cotton wool about to blow away.

If you're not supposed to use certain colours, why do the fine art companies produce them for you? My advice is: 'Ignore these prejudices' and use what you are happy with. After all, Turner, Constable and Gainsborough, to name but a few, all used white. I don't normally use black, preferring to mix Payne's Gray and Burnt Umber, but I can't see any reason why it shouldn't be used when required, except that it's a very cold colour.

Colour is used to create atmosphere and mood. The warm colours – red, orange and yellow – or the cool colours – purple, blue and green – being used as appropriate. Artists find colour fascinating. That is probably why whole books have been written on the subject. You will hear terms such as 'value' – the lightness or darkness of a colour – and 'gradation' – the gradual change from a dark colour to a lighter one, which is particularly important when painting skies, foregrounds, buildings, etc. You will also hear jargon such as 'colour balance' and 'colour harmony', which basically mean the production of a painting that one can live with.

However, don't worry about this jargon. I will be explaining it more fully at appropriate stages throughout the book.

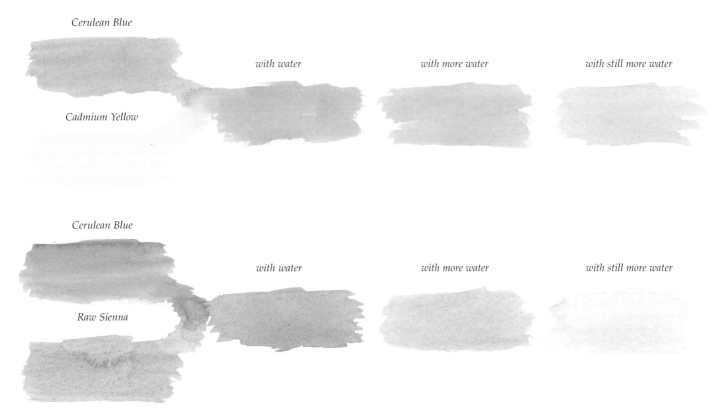

Cerulean Blue

with water *with more water* *with still more water*

Cadmium Yellow

Cerulean Blue

with water *with more water* *with still more water*

Raw Sienna

PAINTING BY DESIGN

I love touring Scotland, but prefer to leave the main roads and explore minor or unclassified roads, hoping to find that lovely waterfall, old priory or cottage hidden in the wilderness. I discovered such a cottage on one of my recent expeditions and I couldn't resist sketching it on the spot. Scenes like this one usually offer several possible compositions in both landscape and portrait formats; I show two of several possibilities here. The viewfinder (a piece of mount-card with a 8x5cm (3"x2") aperture) is an essential tool on these occasions to frame the alternative views. In the end, I chose composition 'A', the finished sketch shown on the facing page.

So what makes a successful painting? There's no simple answer but there are certain key elements of design that you'll find are important and integral within every successful composition. In the following pages, I have provided a check list of considerations for you to digest and practise.

When visiting an area looking for scenes to paint, I follow a logical procedure. I may walk up and down a river, for example, looking for inspiration and identifying several possibilities, such as an interesting group of trees in the background, a bend in the river with an unusually shaped bank, a specimen tree which could become the focal point in the painting, a waterfall or a group of rocks. Having identified several scenes, I feel excited at the possibilities: the sound of running water, the colours, the tranquillity of the scene will all have stirred my emotions and raised my adrenaline level; I can't wait to get started.

Out comes the viewfinder. Holding the viewfinder to my eyes, I move it towards or away from me, allowing me to frame potential scenes. I view the area from several vantage points and, by turning the viewfinder through 90 degrees, I can compose landscape or portrait views.

Choosing the composition is discussed in more detail on pages 46–47, but briefly, what I'm determining by looking at potential scenes through the viewfinder from different vantage points is the most attractive aspect. It's about relationships. Where does the river enter and leave the frame? The specimen tree mustn't be in the centre, so what is the best relationship I can achieve between the rocks and the tree? Where is the light coming from? From where I'm standing, does it bring the best out of the scene? Is the foreground interesting? And much more.

My next task is to produce some simple tonal studies using a single colour. As mentioned previously, I prefer to sketch with a dark-brown, water-soluble crayon, to determine where the lights and darks should be (see also pages 54–57). These tonal studies are quick 'doodles' produced in less than five minutes. I'm not attempting at this stage to represent the elements in the landscape accurately but to clarify my thinking.

I can't overemphasize the importance of spending this time thinking about your approach to the painting. It's better to spend an hour thinking about how to approach the painting and five minutes applying paint, than the other way round. This time

well spent is vital to success. If you think about it, this approach is only common sense. I see so many of my students, many of whom have been painting for several years, commence a landscape without any pre-planning or forethought only to regret it later.

Now, let's examine the keys to success. The first thing to appreciate is: you can't compete with nature, so **SIMPLIFY** the scene. This is an art in itself. My approach is to view the scene through squinted eyes. This blurs the view and helps to identify the key relationships and the important tonal values, and loses much unnecessary detail. **OBSERVATION** and **SIMPLIFICATION** are important. Only include those details that are significant.

I then think about **TEXTURE**. How rough are the rocks, how much sparkle is there on the water? Is the trunk of the specimen tree rough or smooth? These considerations are going to determine which brushes and which techniques I will use. I may use a wash, for example, some dry-brush technique perhaps for the rocks or I may lift paint with tissues. Are you receiving the message yet? It's important to consider your approach.

Which **COLOURS** do I need to use: reds, yellows, siennas for warmth or blues, greens, violets for serenity? Warm colours are aggressive and jump out at you, whereas cool colours are calming and fade back. Ask yourself, 'What statement am I trying to make in this painting?' and select the most appropriate colours for the purpose. (Incidentally, when you're actually in progress with the painting, the light will inevitably change and wind may blow across the water, changing the colour from a dark to a light tone. Don't try to change your painting as you progress; try and remember what attracted you in the first place to paint that scene and paint it as you remember it.)

Now, let's look briefly in more detail at some further considerations for a successful painting.

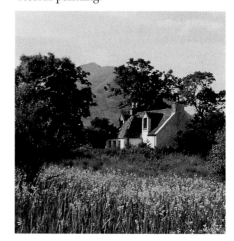

GRADATION

A gradual change from a light to a dark colour, or vice versa. An example would be grass: grass is not the same colour across a field. The play of light, cloud shadows, undulation in the level of land, even the delicate change in colour from rear to foreground can all cry out for the subtle modulation known as gradation.

COLOUR HARMONY

Similar colours placed next to each other; for example, a gradual change from greens through to yellow-greens then through to siennas, etc. A glaze applied over parts or the whole of a painting can help to harmonize your colours, as one colour has been painted over every other colour. (For further discussion, see pages 107–109.)

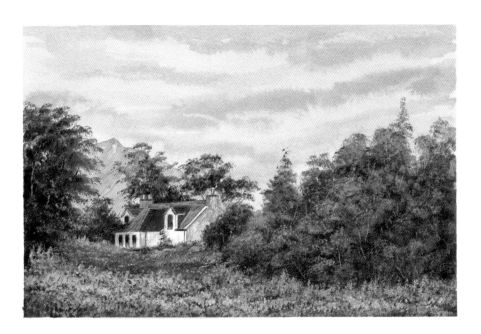

COUNTERCHANGE

The effect of light against dark, dark against light. Counterchange is used primarily to lead the eye to the centre of interest in a painting by placing your lightest light colour against your darkest dark colour, but counterchange should also be used in a less obvious way throughout your painting, e.g. a light figure against a dark building.

CONTRAST

The juxtaposition of complementary colours (opposite colours on the colour wheel), i.e. red against green, orange against blue, yellow against violet. Note how Constable used to clothe his figures in red against a green background.

RECESSION

A sense of distance, achieved by painting distant elements with cool colours which are lighter in tone (see pages 51–53).

TONE (VALUE)

The lightness or darkness of a colour. A frequent fault with beginners is that they don't vary their tonal value in a painting. Extremes of lights and darks in a painting are important to success.

BALANCE

The relationship between the elements in your painting (see also pages 110–111).

VARIATION

This is not an element, per se, but it is a necessary consideration when dealing with all the elements listed above as well as shape, form and size. It is essential to making your painting work. For example, don't make all your trees the same height, all rocks the same size, all fence posts vertical or all tree trunks equally spaced or the same colour and thickness.

I've given you a lot to think about, but don't despair. These considerations become automatic with experience.

I regularly use my viewfinder to help me determine the best composition.

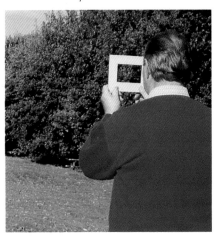

COMPOSITION AND FOCAL POINT

I think of **COMPOSITION** as a means of arranging all the elements in a painting so that unity is achieved. It's a process of positioning or framing all the elements to the best effect. Ask yourself what statement you're trying to make and select the one element that you feel is the most important as the **FOCAL POINT** of your scene. This could be a building, tree, waterfall or other subject, all other elements being there to support not conflict with it. Simply remove any shape, structure, colour or texture that doesn't support the centre of interest, the focal point. There should only be one focal point in the painting or you will confuse the viewer.

The distance from the focal point to all four sides of the painting should be different. That is to say, while the focal point should be the centre of interest, I do not mean it should be positioned in the centre of the painting. I've simplified this for you in the diagram illustrated top right, this page.

Think of the area in your viewfinder as divided by two horizontal and two vertical lines, the distances between them being equal. In other words, divide the area into nine equal areas. Draw two additional vertical lines to divide each of the far left- and right-hand areas into six equal areas, for a total of fifteen areas. Imagine that your focal point is a church steeple or a tree. To arrange a subject like this in a painting, my first choice would be for its top to be placed at point B, C, F or G.

(Incidentally, it's a useful guide to divide your frame so that your foreground is located in the bottom third of your field of view and your main subject in the next third, leaving one third for sky. A basic fault with beginners is that they commence drawing from the bottom upwards, but do so out of scale and they find they haven't left sufficient space for painting in the sky. While there are exceptions that can work, this division into thirds is a sensible rule.)

In the other two 'doodles' on this page, and in the ones on the facing page, I have shown you some compositions that do not work very well and also how these compositions could be improved. The changes are common sense, really, but study them to help improve your own composition.

The top of your centre of interest, your focal point, preferably should be placed at B, C, F or G; or, as a second choice, A, D, E or H. If looking straight at your subject, use A, B, C or D; or E, F, G or H, if looking down on your subject.

In this 'doodle', the tree grouping has been placed too near the centre, the horizon has been placed halfway up the sketch and the river has been centred: not a good composition.

This is a much-improved composition with the main tree grouping placed under B, the horizon situated one third up the sketch and a smaller group of trees added to balance the painting. The river runs off to the right with the cloud formations balancing the painting.

There's a lack of variation and depth here. The river banks look too deep and there's a lack of tone in the water. Moreover, there is insufficient detail to maintain the viewer's interest.

The distant trees have been painted in a lighter tone to achieve recession, a small bush and fence have been added to create interest and the rocks, saplings and shadows in the water provide detail, all of which improve this composition.

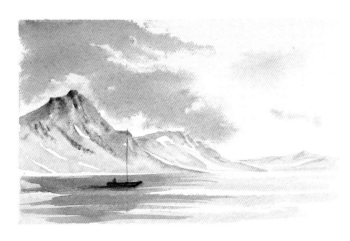

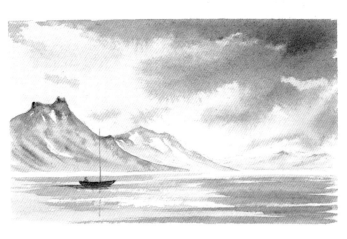

This poor composition shows a basic fault: the failure to achieve tonal balance. All the tone is on the left-hand side of the sketch. Moreover, the mast cuts through a mountain peak – not good practice.

To improve this composition, dark cloud formations and shadows in the water have been added on the right; these balance the foreground mountain on the left. Note also that the direction in which the boat is moving leads your eye into the scene.

This is another poor composition. While the farmhouse is interesting, it is too central and has been viewed straight on; also, the fence is too even and the dominant clouds are directly above.

A better viewpoint enables the gable ends of the farmhouse to be seen. The fence, now angled, leads the eye into the scene. The dark clouds diagonally balance the farmhouses. The smoke from the chimney and the sheep add interest.

DRAWING MADE EASY

I often hear people say 'I wish I could paint, but I can't even draw.' Well, it's not that difficult, really, and in some of my paintings I don't need to do any drawing at all. When creating the lake scene on page 16, for example, all I needed to do was position a piece of masking tape to represent the water line and paint away. However, for a more complex scene, such as a street scene, it's better to lay down some guide lines before applying paint.

All drawing consists of is producing shapes, forms and textures and creating relationships between them (composition) to represent a scene. It's a matter of establishing the distances between each element and ensuring the proportions are right before making marks on the paper.

Sounds complex? It's not really.

Study the example on page 54: take a look through your viewfinder to determine the best composition. (When looking through the viewfinder, close one eye.) In this case, we want the grass level to be approximately one third of the way up the painting. Now you've fixed one parameter. Move the viewfinder backwards and forwards until you've framed the darker-toned foreground trees on the left. Now you've established two parameters. Move the viewfinder backwards and forwards, retaining the two established parameters, until the right-hand crag is seen. Now you've established three parameters. You will also find that you will be able to include a significant sky area.

Having established your composition, prior to completing the drawing on paper, you need to do a tonal study to establish your lights and darks. (I have mentioned tonal studies previously and discuss them in further detail on pages 54–57.)

So, let's start drawing this actual scene in Borrowdale in the English Lake District and I'll describe my thinking as the drawing takes shape.

1. Draw the horizontal line (grass level) approximately one third up the painting.

2. The left-hand trees don't quite reach the top of the painting but project approximately one third into the frame.

3. The top of the crag on the right appears lower than the height of the trees; it's angled at 15 degrees at the top, falling to 45 degrees, before levelling off at ground level.

4. The top of the distant mountains start halfway up the tree.

5. The middle-distance bushes must not be drawn too large or the sense of distance will be lost. The bushes and fence also must be drawn to scale.

It's simply a matter of ensuring the relationships between all elements in the landscape – the distances between them, their respective heights, etc. – are correctly represented. We call this **MEASUREMENT**.

This procedure must be followed with every drawing you complete. It's simple and will ensure your drawing is to scale. No matter how good you are when applying paint, if your drawing is wrong, you're wasting your time. The painting just won't work. However, if you practise, you'll find your drawings will improve, they will be enjoyable to do and they will make you think about your subject and teach you to simplify, skills you will need to develop as a painter.

I'm going to describe some simple transfer methods I used when I was learning to draw, but I must emphasize that these short cuts are no substitute for practice to improve your drawing skills.

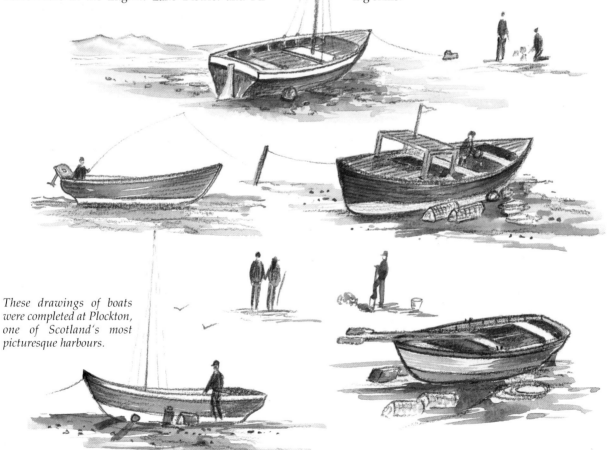

These drawings of boats were completed at Plockton, one of Scotland's most picturesque harbours.

THE POINT SYSTEM

First, take a photograph of a scene and have a 6"x4" print made. Then, if you decide to paint three times this size, or 18"x12", ensure the view transfers reasonably accurately to your watercolour paper as follows. With a rule, measure the co-ordinates of the key features in the scene, such as a mountain peak, and multiply the co-ordinates by three, transferring these measurements to the paper, marking the point with a pencil dot. For example, if the mountain peak is 3" up and 1" from the left, measure 9" up and 3" from the left on the paper. By joining the dots up and filling in the other, less significant features, you are then able to draw a reasonably accurate representation of the scene, as shown alongside.

THE GRID SYSTEM

On some tracing paper, draw a grid with small squares and a similar grid with squares four times larger. This will allow you to draw a scene four times larger than your photograph. Number each grid vertically and horizontally. Position the smaller grid over your photograph and note in which square a particular feature is seen, i.e. 16/9. Using the numbering system, draw the feature in the equivalent square on the larger grid, ensuring an accurate representation. Determine the co-ordinates of the other elements in the same way until your drawing is completed.

THE TRANSFER SYSTEM

Use a black-and-white photocopier to enlarge your photograph. Turn the photocopy over and, using a soft 6B pencil, trace the outline as seen through the back. Then place the photocopy over your paper and rub with the end of a pencil; the outline drawing will be transferred to your paper.

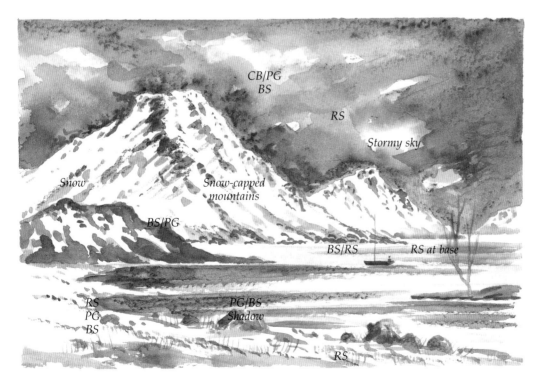

This sketch of a Scottish landscape was completed in ten minutes by drawing with a dark-brown Caran d'Ache water-soluble crayon and washing out areas with a wet brush to create a monochrome study. Using the colours in my box of ten, I've indicated the colours I would need when I complete the painting. It is best to complete a painting as soon as possible, while the atmosphere is still clear in one's mind. Sometimes I also take a photograph to support the sketch.

THE PROJECTION SYSTEM

For a more high-tech solution, there are also various projectors which will shine an enlarged image of a slide onto your paper, allowing you to trace round the projected image.

Whichever transfer method you use when you are starting out, remember to move on to drawing as quickly as possible so that you improve your skills. When drawing, the process of measurement is important in determining the distances and heights between neighbouring elements. You can use your brush handle, your pencil or your thumb, it really doesn't matter. If you are using your pencil, it's a good idea to make marks on it that you can use as a

consistent guide, i.e. the farmhouse is three divisions long and one and a half divisions high or the tree is one division away from the end of the building. Whatever you use, it's important to always hold it at arm's length, horizontally for distance and vertically for height. Unless your arm is kept at the same distance from your eye at all times, consistent comparisons can't be made. Measure your key subjects this way and draw them in the correct position. Other less important elements should then fit into place.

Practise this process as the basis of all successful drawing. Eventually, it will become automatic, your eye will become trained to make comparisons accurately and you will be able to draw elements in the correct position and relative size. Practise your drawing techniques whenever the opportunity arises.

I couldn't resist this old barn I discovered on one of my adventures in Scotland. This is the kind of quick sketch I'm able to produce with the water-soluble crayon, washing out specific areas such as the sky to create a tonal study rather than just a drawing.

PERSPECTIVE SIMPLIFIED

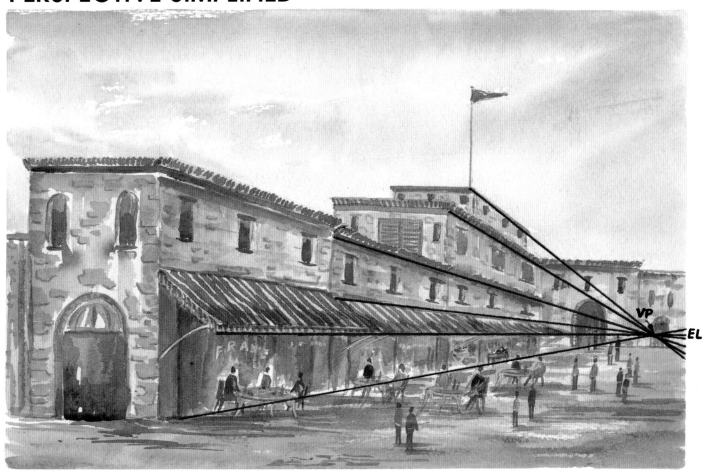

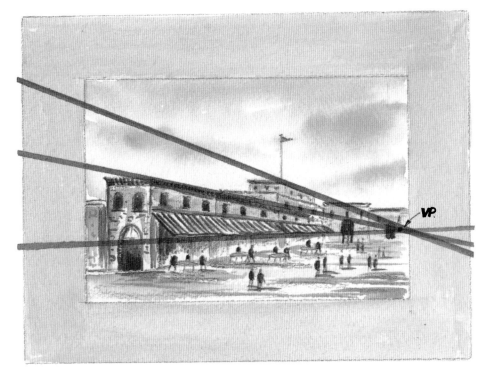

Please don't ignore this section, as it's very important. Whenever this topic is raised on my courses, there's a deathly hush and I can see the fear in students' eyes. Topics like eye level, vanishing point and the drawing of lines seem to conjure up visions of school days and the subject of geometry. Certainly, when I judge at art societies the greatest problem I encounter is poor perspective. Yet, the principles are simple and really it's just a matter of observation.

As artists, there are two types of perspective that concern us, **LINEAR** perspective and **AERIAL** perspective.

As a shorthand explanation, linear perspective can be taken to mean that distant objects appear smaller and then vanish and lines converge on the horizon. Examples of this are seen everyday, the best being a railway line or road where the lines appear to draw closer together with distance until they appear to meet and disappear at the **VANISHING POINT** (VP), which usually occurs on the horizon. An avenue of trees or a row of telephone lines, street lights or houses also provide good examples of linear perspective. A related topic is **EYE LEVEL** (EL), which you can find by holding a pencil at arm's length and looking beyond it. In the case of a flat

moorland scene or a seascape, the eye level is the horizon.

If you observe the lines drawn parallel to the roofs of the buildings in the sketch on page 51, you will note that they all meet on the eye level at the vanishing point. Note also that lines below our eye level slope upwards to the vanishing point and lines above our eye level slope downwards to the vanishing point. The same applies to doors, windows and canopies: the lines all meet at the vanishing point. It's simply a matter of observation.

Still worried? Well, don't be: we have a secret weapon.

In practice, all you have to do is hold a pencil at arm's length, line it up with the angle of the roof and, maintaining this angle, transfer it to your paper. Perform the same procedure with windows, doors, ground level, etc. and you should find that all lines cross at the same point, the vanishing point.

Let's make it even simpler for you. Cut yourself a good-sized viewfinder and stretch several elastic bands across it. Now, look through your viewfinder and line up each of the bands with a particular feature, i.e. roofs, windows, etc. (see page 51). Then, transfer these angles to your paper by resting the

viewfinder on the paper and drawing along the elastic bands. It's as easy as that. (The subject becomes slightly more complex when portraying a street where the houses are on a curved road, as the eye level is the same but each building will have a different vanishing point.)

Aerial perspective involves painting distant objects lighter in tone with cooler colours to create the illusion of distance and depth in the painting. This has already been discussed in the section on recession on page 45. To achieve recession, the basic rule is that foregrounds should be painted in darker tones, with warm colours and in

more detail, while distant objects, which appear paler in tone, should be painted with cooler colours and in little detail.

It's important to remind oneself, when painting outdoors, that you don't necessarily always paint what you see: you're creating a painting and you must adjust your colours accordingly. I've often seen the most distant mountain at a particular time of day appear virtually black, but I know that if I painted it as it appeared, the painting wouldn't work.

When painting, start with the background and work forward adding darker tones and more detail. Of course, to be able to do this effectively, it is important to complete a tonal study prior to applying paint. A basic fault is taking the trouble to prepare a tonal study and then ignoring it when painting in colour. Take a black-and-white photocopy from your coloured painting and you'll soon see whether your tonal values are correct. I discuss this in greater detail on the following pages, but if the photocopy appears to be a similar tone throughout, you'll know you've got it wrong and it's a case of making the necessary changes. Don't forget the basic rule: warm colours and detail in the foreground, cool colours and less detail in the distance. (The only exception that may arise is a stormy landscape.)

In this Welsh landscape, I've used the bends in the river to lead the eye to the farmhouse. Note how the far-off mountains have been painted in lighter tones to provide a sense of distance.

This river scene below provides a good example of aerial perspective. The gradually diminishing tonal values in the trees lead the eye into the distance and round the bend in the river.

UNDERSTANDING TONAL VALUES

To become a successful artist, it's essential to develop an understanding of tonal values. I believe this to be the most important contributing factor to painting a successful landscape, yet many of my students want to splash paint all over without initial preparation. They often feel producing tonal studies before adding colour is a waste of time. They tell me they want to get on with the painting, but in eight cases out of ten, their paintings lack depth. Then they ask me for help when they've ruined a perfectly good piece of watercolour paper. Don't rush through this section and I'll guarantee your paintings will improve.

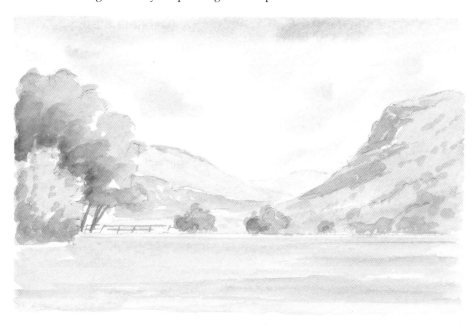

This sketch lacks tone. The painting is flat and lacks interest. It's boring. Squint and you'll see there are no distinctive tonal differences. This is the quality of sketch produced by those who can't be bothered to produce a tonal study.

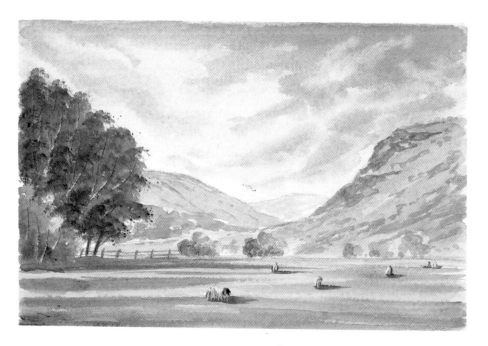

Here, a few well-chosen brush strokes have given life to the painting. The dark-toned clouds on the right provide balance with the trees on the left, which now have been painted in a darker tone. Shadows have been added to the foreground grass to help achieve a sense of recession. Greater definition has been given to the crag on the right. A few sheep have been added for interest. Overall, it is a much more pleasing composition.

All paintings need contrasts of tone: dark colours against light colours, lights and darks arranged in relationships that enhance the quality of the painting.

Another way of thinking about tone is how dark or light a colour appears on a scale of 1 to 10, where black is 1 and white is 10. Liquitex acrylics, for example, display the colour tone (they call it value) on the front of their tubes: Payne's Gray is 1.5, Hooker's Green Dark 2.4, Alizarin Crimson 3.2, Raw Sienna 4.2, Cadmium Yellow Pale 8.8 and white 10, to name but a few. Liquitex also produce a card which has 10 holes with the tones indicated against the appropriate holes numbered 1 to 10, from black to white. The idea is that you look through the card and match the tonal value on the card against the particular element in your view. When you have done this, you read off the corresponding value number. By noting the value number on the tube colour that you intend to use, you will know whether you need to darken or lighten your colour by adding water. A simple but useful idea, and I am always in favour of these.

At this stage, it's appropriate to reiterate the three principal ways that tone can be used in a painting.

The first is **COUNTERCHANGE**, which is the most effective way to highlight the principal subject matter, such as the focal point. By painting extremes of light against dark, dark against light, the centre of interest can be made to stand out. Examples would be painting a dark tree behind the light roof of a building or dark clouds over a snow-capped mountain peak. We can also use this effect to add sparkle and create interest.

The second way is to gradually change a colour from a dark to light tone, or vice versa. This is known as **GRADATION**. Examples would be the transition in colour from wet to dry sand on a beach, or from foreground grass to that in the distance.

The third way to use tone is **VARIATION**. When painting a roof, stone building, garden shed or rock, we may wish to apply a first wash and, when it is partially or completely dry, add further colours or glazes to selected areas to create interest and variety.

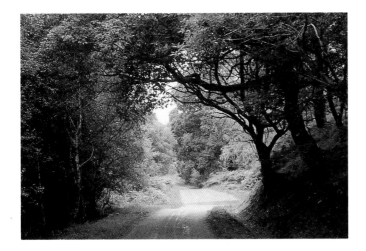

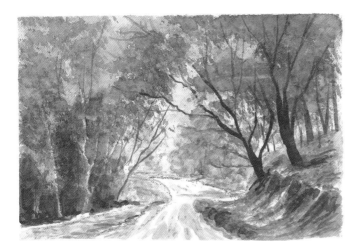

I've used this country lane I came across on one of my expeditions off the beaten track to demonstrate the value of tonal studies and to indicate the steps I take before painting a scene.

Avenues of trees have always fascinated me, and they can be discovered in every area of the country. Using the viewfinder in my camera, I observed this scene from several different positions and chose the one shown as the best composition.

Using a Caran d'Ache dark-brown, water-soluble crayon, I completed the tonal study, though you can produce your tonal studies with the side of a 4B or 6B pencil, a builder's pencil or a broad felt-tip pen. Producing tonal studies at this size or smaller encourages simplification, as there's insufficient space for detail. You'll notice that I've used a wet brush to produce a monochrome study, which I prefer to a straight drawing.

I used the crayon in the following way: I placed my viewfinder on a sketch pad and drew the aperture. Down the side of the pad, I made three deposits or marks about 1" square. First, using the crayon dry, I drew the scene. Then, having dipped the brush in water, I extracted colour from the first deposit and painted the monochrome tonal study, taking care to establish the lights and darks.

Once the first square has been used, I moved on to the second and so on. When a very dark tone was required, took the colour directly from the end of the crayon with the brush. In this way sufficient pigment can be lifted to give the darker tones needed.

I produced the finished colour sketch using various mixes of Raw Sienna for the background, Hooker's Green and Cadmium Yellow for the grass and foliage, and Burnt Umber for the tree structures and darker-toned foliage. I used my thumbnail to scratch in some tree structures on the left, and used the 'unique' brushes for the foliage and the rigger for the fine detail. I also used the rigger to add the figures, which provide interest and take the eye along the track into the distance.

This is a good example of how carefully one must establish tonal values to achieve the tunnel effect that was the inspiration for this sketch.

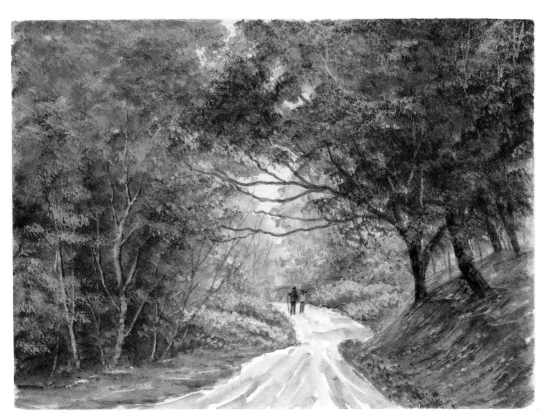

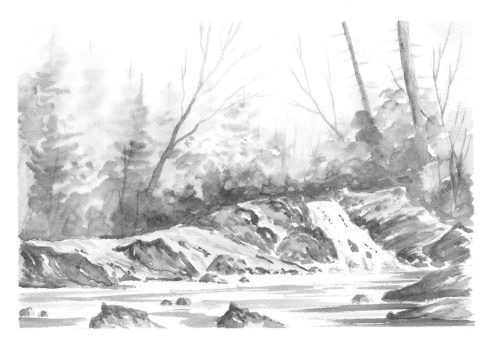

I painted this tonal study in preparation for the river scene below. The distant trees were shrouded in mist, giving the scene a lovely atmospheric look. Such studies enable artists to think through their approach to the painting. By the time they're ready to apply paint, the lights and darks will have been established and they will have a feel for their subject.

I fell in love with this Scottish river scene immediately I saw it. The distant trees were shrouded in mist in the early morning, and I've attempted to capture that atmospheric look by painting the background wet-in-wet. The colours were softened with the morning light but there was sufficient variation in tone for the painting to work. I have glazed the rocks with several colours to provide variation and have increased the depth of tone at the water line to provide adequate counterchange between rock and water. The black-and-white photocopy taken on my return verified that the tonal values established in my initial tonal study had been transferred successfully to the colour painting.

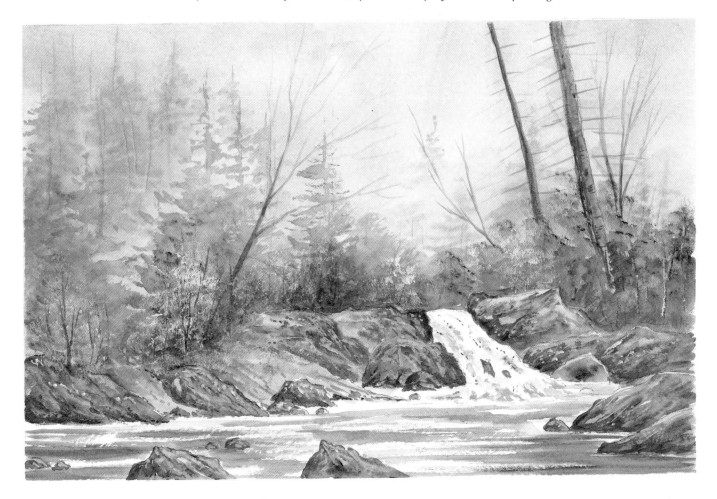

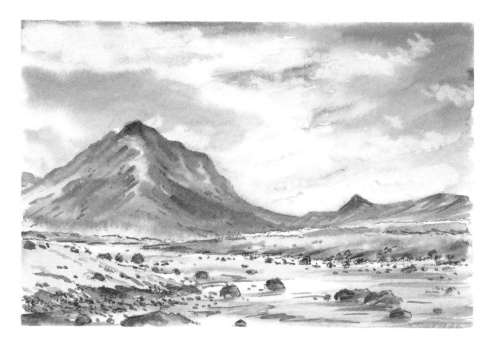

EXERCISE

Using the tonal study to the left as a guide, create an autumn scene for this Scottish landscape.

Paint the wet-in-wet sky with a weak Raw Sienna under-painting followed by cloud formations made from a mix of Payne's Gray/Cerulean Blue/Alizarin Crimson. Use the same colour for the water.

For the mountains, begin with a slightly stronger Raw Sienna under-painting, this time followed by a mix of Payne's Gray/Alizarin Crimson.

For the river banks, start with a Raw Sienna wash, followed, when dry, by a Hooker's Green/Raw Sienna mix.

A Raw Sienna base is also used for the rocks, with Burnt Umber/Payne's Gray being used for the shadows.

EXERCISE

Using the tonal study below, create a summer scene. For the clouds, brush a Payne's Gray/Cerulean Blue mix into a wet Raw Sienna under-painting. Use the same colours for the water. Paint the river banks using a variety of greens made from mixes of Payne's Gray/Cerulean Blue/Cadmium Yellow.

Use darker mixes of the same colours to paint the trees, making sure you use the deeper tones for the left-hand grouping. For the rocks, use a Raw Sienna under-painting and a Payne's Gray/Burnt Umber mix to add texture and shadows.

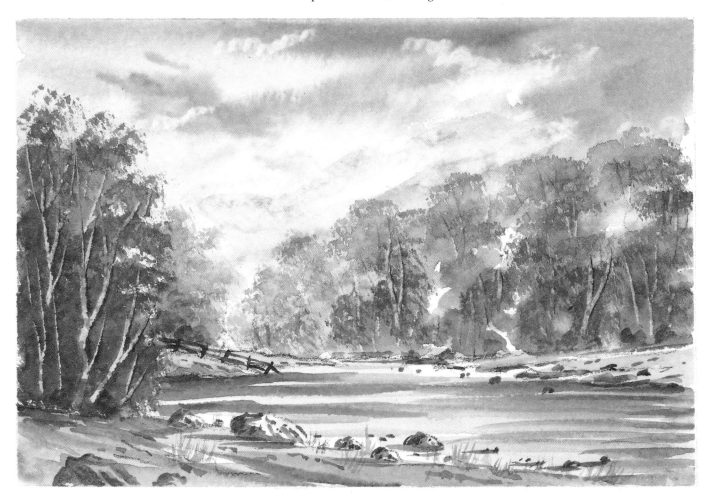

GALLERY: THE MOUNTAIN IN THE SKY

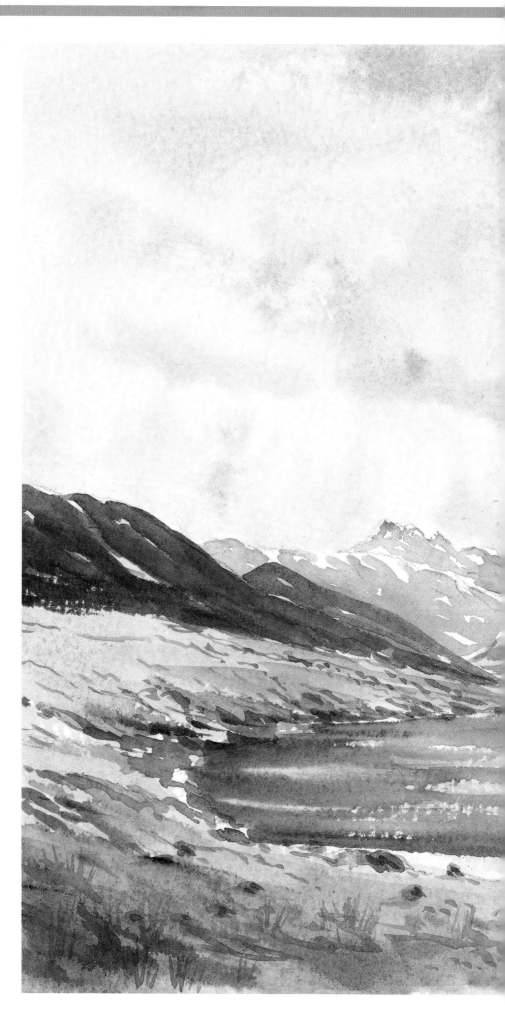

Mount Cook, New Zealand's highest mountain at over 3700 metres, appears to rise from the still waters of Lake Pukaki. The Maoris have their own name for this great mountain, 'Aorangi', or the mountain in the sky. Lake Pukaki now holds 35 per cent of New Zealand's water supply.

In this forty-minute sketch I wanted to capture the majesty of the snow-capped mountain and the tranquillity of the still waters of the lake. It was the pastel colours of this composition that inspired me to paint this peaceful scene. I have balanced the dark-toned ridge on the left by the darker cloud formations on the right and applied darker washes of Raw Sienna and Burnt Sienna to the foreground, to provide a sense of recession. I then applied a Raw Sienna wash, introducing Payne's Gray, Alizarin Crimson and Cerulean Blue to paint in the cloud formations.

I used similar colours to paint the mountain range. The water is a weak Payne's Gray using the 1" flat brush, with a little Alizarin Crimson added for the reflections.

The sketch is shown actual size and is painted on 140lb Canson Fontenay artist's quality rough paper. I'm looking forward to producing a larger painting from the sketch in the future.

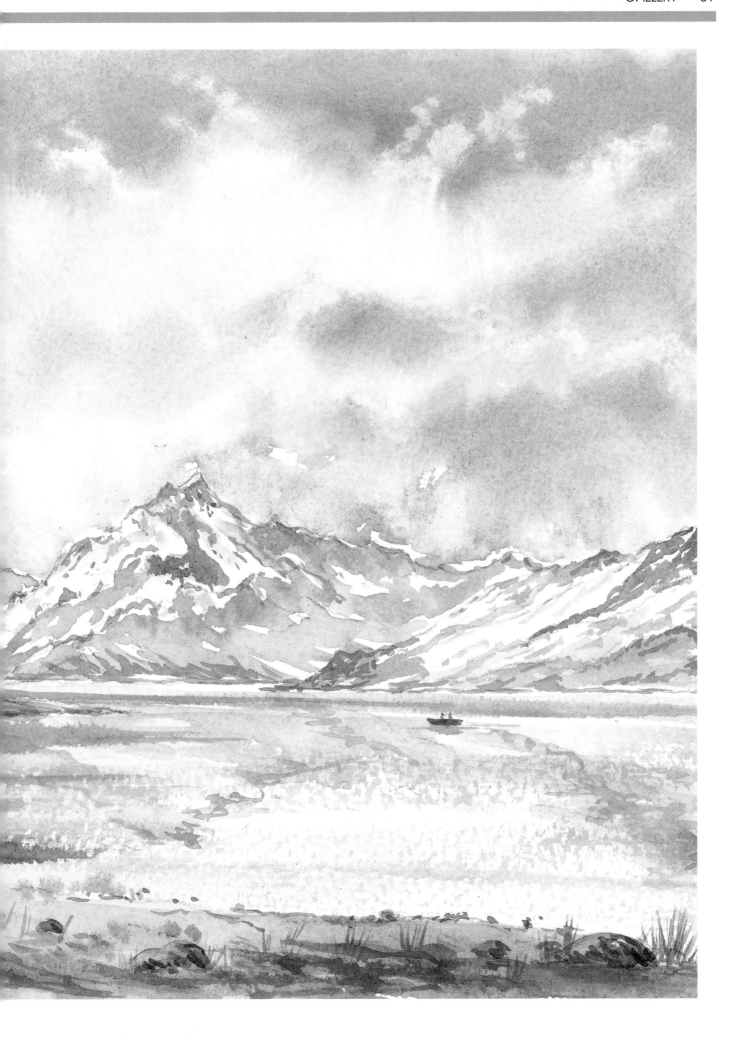

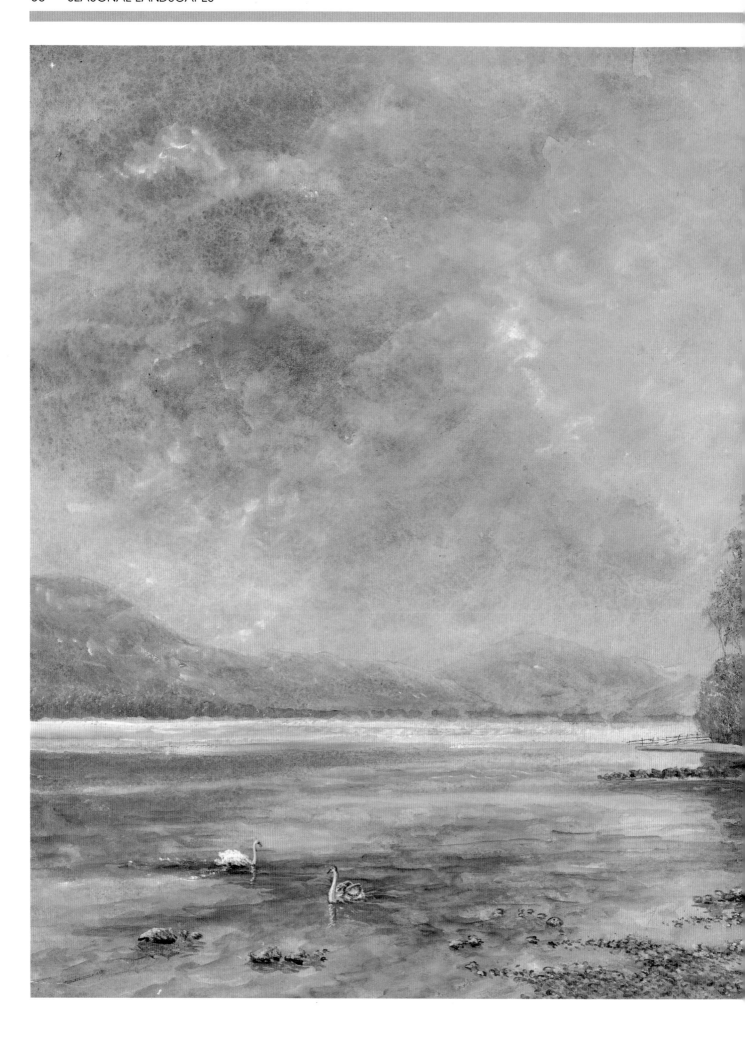

GALLERY: APPROACHING STORM

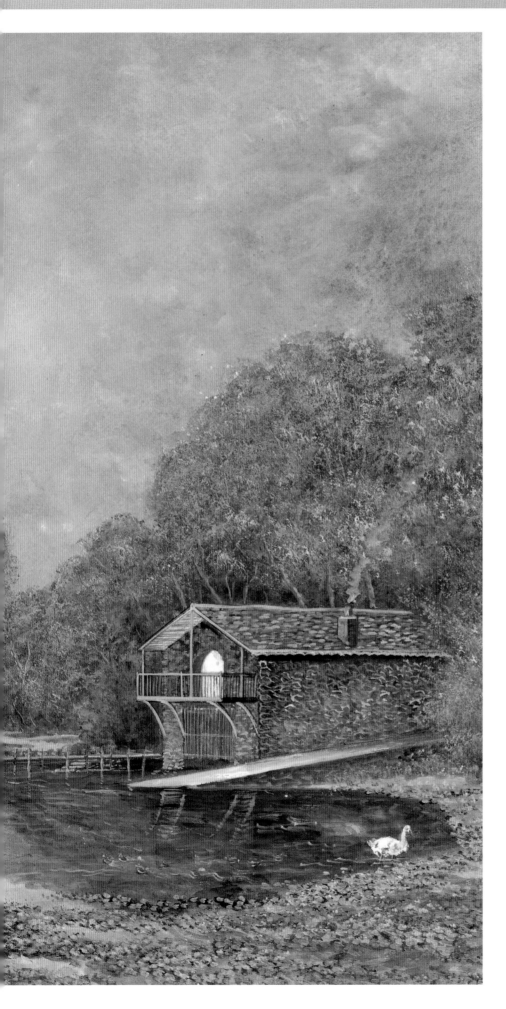

Ullswater in the English Lake District is one of my favourite places to paint and this particular old boathouse is no exception. The painting is called 'Approaching Storm' for a good reason. It was originally intended as a warm peaceful scene, but, having painted in the region for thirty years, I know that this area is surrounded by high fells and is prone to the occasional shower. After all, that is what made it so exciting for artists such as Turner and Constable, who visited in times past.

Over the years, I have learned to assess the lakeland weather and on this particular day I could see that something dramatic was about to happen. The light was changing and the clouds were moving rapidly across the sky – in short, a storm was brewing.

I've attempted to capture that moment. All seems at peace: the water is calm and the swans appear content (an occasional piece of bread enticed them closer), but all eyes are on the sky. It is the moment of anticipation: literally, the calm before the storm.

To create a dramatic sky, I gradually built up the character and variety of the clouds by adding several glazes. I then finished the sky by using a small amount of white to add the light tips to the clouds. I also used white for painting the swans.

PAINTING THE ELEMENTS IN THE LANDSCAPE

I've always thought that painting was a bit like making a cake. With a cake, you decide on your ingredients and arrange them together prior to baking. With a painting, you decide which elements to include, arrange them in the best composition and create your painting. The elements may include sky, mountain, trees, water and foreground, and with careful consideration – hey presto! you've composed your painting.

But of course it is not quite as simple as that. You need to know which techniques to use to paint each separate element. Moreover, it is not just a matter of using the appropriate techniques to produce a topographical study. To capture the mood and atmosphere, it's important to become immersed in your subject, to have a feeling for it. I reiterate: there's no substitute for painting outdoors, feeling the wind on your face, listening to the sounds of nature, experiencing the landscape first hand. All this will show through in your paintings.

We're very fortunate to be surrounded by a wonderful variety of landscapes to be experienced in different weather conditions over the different seasons. It's only natural to wish to respond by representing them as skilfully as Turner or Constable, but we've got to be realistic. When we first start to paint, we experience moments of elation when things are going well and moments of total despair when things are going badly. It's important to recognize your weaknesses, learn from them and don't forget – 'practice makes perfect'. With knowledge, experience and lots of practice, composing and painting will become automatic.

As I mentioned on page 8, there's a quotation I often use when teaching: 'Achievers never quit and quitters never achieve.' This has been my philosophy through life.

Now that we have discussed the basics, more advanced questions arise – how do we paint that sky, tree, mountain or lake? Which brush should we use and which technique is the most appropriate?

In the next thirty-five pages I'm going to show you in greater detail how to paint most of the elements you'll encounter as a landscape painter and, by doing so, help you to experience more moments of elation than despair. As your experience grows and you recognize your strengths and weaknesses, you will inevitably select subjects that are appropriate to your abilities at that period in time. I can assure you that if you study and practise the techniques shown in this book, you'll soon be able to paint a successful landscape that you'll be proud to hang on your wall.

Good luck with your painting!

I've attempted to capture the atmosphere in this winter scene of Blencathra in the Lake District. The group of walkers has been added to indicate scale.

In this Jersey seascape, warm colours have been used to capture the 'evening glow'. Notice the counterchange between sea and rocks and how the white paper has been left uncovered on the left. The rosy glow was achieved by applying several glazes mixed from Raw Sienna, Burnt Sienna and a little Alizarin Crimson.

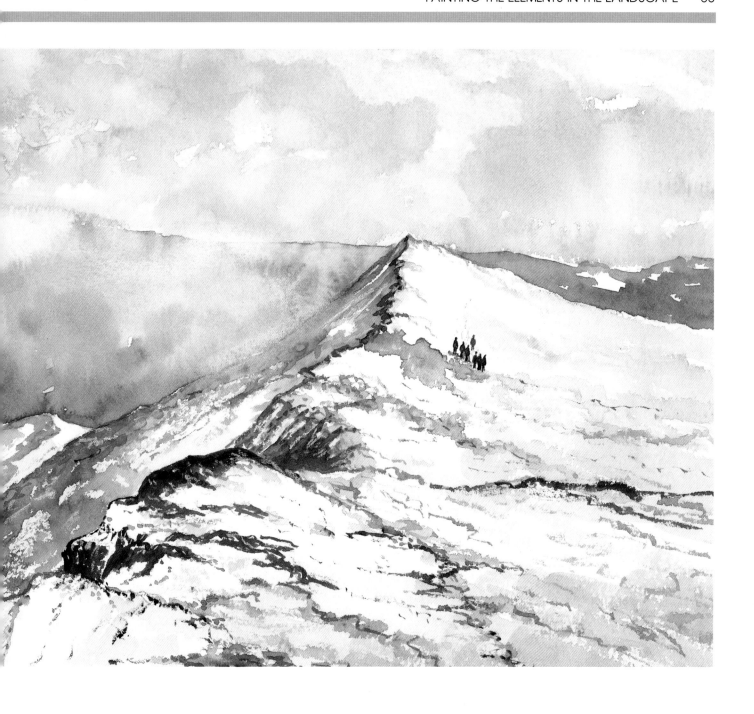

I've called this 'doodle' 'The Bait Diggers'. Note the subtle variation of colour in the sky and the overall use of soft colours. The right-hand rocks have been painted in a darker tone to balance the lighter-toned rocks on the left.

LESSON 1: PAINTING SKIES

I created these rain clouds over Lake Derwentwater by tilting the paper almost vertical, encouraging the paint to run down.

Skies are an important part of the landscape and one of the most dramatic elements of nature. They influence the atmosphere and mood of the painting. It's not surprising, therefore, that we find them one of the most difficult and challenging subjects to capture in watercolour.

The problem with watercolour painting is that we have to be able to paint a sky in less than two minutes if we are going to avoid those hard edges or run backs. With traditional watercolour, we have the additional problem that when the paint dries there's a possibility of losing up to thirty per cent of the colour strength, particularly when painting wet-in-wet. Don't despair, this is one of the advantages of acrylics: on drying, very little colour is lost. What you put on, you're left with.

Also, when using acrylics, several coloured glazes can be applied to create atmosphere and mood or to add warmth or sparkle to your painting without the worry of lifting the under-painting. (With traditional watercolour, if extreme care isn't exercised the under-painting will lift, resulting in hard edges and the formation of 'mud'.)

To the beginner, painting skies can be a daunting experience, but confidence comes speedily with experience. Soon you will be painting boldly with a large brush. This is especially important, as skies painted with small brushes always look streaky and take longer to complete, which risks the formation of those unwanted hard edges. Remember: create your wet-in-wet skies in under two minutes.

However, this doesn't mean you should only spend two minutes to create an atmospheric sky. As with all facets of composition, it's very important to establish your sky pattern prior to applying paint. When painting cloud formations, don't drop your paint in anywhere; establish your design and position your clouds accordingly. Determine the colours you will use and decide where the dominant cloud formations should be placed to balance the painting: the larger, darker-toned clouds should be at the top of your sky, with the clouds becoming smaller and lighter in tone as they approach the horizon. Perspective is important.

Basically, I use four colours to paint my skies: Raw Sienna for my wet, pale under-painting and mixes of Payne's Gray, Cerulean Blue and Alizarin Crimson for cloud structures. On occasions I may use other colours; for example, I may add a little Burnt Umber to paint storm or rain clouds and a little Cadmium Yellow or Cadmium Orange to paint sunsets. (A word about sunsets: too many are ruined by painting them with horrendous oranges, reds and yellows. Subtlety is the key word here.)

For the first few weeks try and paint several skies each week. Be prepared to waste some paper while you're developing your technique and speed of application. Try painting early morning, afternoon and evening, you'll find it pays dividends. We enjoy magnificent sunsets on the Wirral peninsula looking across the Dee estuary towards Wales. Turner was a frequent visitor to the area, and it is said that he used these views as a basis for his dramatic, atmospheric skies. But you don't have to travel far: just step outside your door and look upwards. I would encourage you to take lots of photographs, to complete quick sketches and to build up a resource that you can draw from when needed.

Before I describe the various techniques for painting skies, I think you may find an explanation of the principal types of clouds useful. **NIMBUS** clouds are the dark cloud formations usually associated with rain. They tend to lie low in the sky. **CIRRUS** clouds are thin, wispy clouds seen high in the sky, usually associated with high winds, which create distinctive feathery or rippled patterns. **STRATUS** clouds, as the name suggests, tend to lie in almost horizontal layers across the sky. **CUMULUS** clouds are the soft, fluffy clouds that look like balls of cotton wool. They tend to have shadows beneath them and light tops which reflect the sun.

In nature, cloud formations tend to be a mixture of the above types. To the meteorologist there are hundreds of cloud types but fortunately the artist only has to look and copy. But don't forget that you are *creating* a painting.

It's essential as artists that we're able to paint an interesting sky. After all, the sky can represent up to half of the painting. The **GOLDEN RULE** is that a complex landscape requires a simple sky and a simple landscape, such as moorland or a seascape, demands an atmospheric sky to create interest.

The sky in this painting of the River Teith in Scotland was created by applying a pale Raw Sienna wash and brushing in the cloud formations using mixes of Payne's Gray/Cerulean Blue/Alizarin Crimson. The clouds have been painted down to the top of Ben Ledi to provide counterchange to the snow-capped peak.

The behaviour of the paper is most important in the painting of successful skies. An absorbent paper with a rough surface is helpful in controlling the flow of the paint, facilitating the fusing together of the colours. The watercolour paper should be firmly fixed to a rigid board using clips or masking tape.

Now let's examine the key considerations when doing the actual painting. The basic procedure I follow when painting skies is to wet the whole sky area. If this isn't done, when the cloud structures are added, paint will run down the paper and build up around any areas of paper left dry, creating a dark edge. (Of course, on occasion this is a technique which may be used to advantage.) For this, I use a pale Raw Sienna wash.

Having quickly brushed in the rough shapes using the hake for maximum coverage, whilst the wash is still wet, I use the side of the large, pointed brush, which provides greater control, to create realistic cloud shapes. For this, I use mixes of Payne's Gray and Cerulean Blue, adding some Alizarin Crimson for variation.

Then, I use tissues, dabbing the paper gently to remove paint. This is a wonderful technique to add interesting shapes and avoid hard edges. You'll see lots of examples in this book where this technique has been used. I can assure you that it does not harm the paper or the painting. However, it's important to keep turning the tissue as, once colour has been removed the tis-

sue will be stained and this stain can be transferred easily to your painting. Occasionally, a scrap of tissue will adhere to the paper. Don't attempt to remove it while the paint is wet; when the paint is dry, the paper can be removed easily by wiping the sky area with a clean, dry tissue.

When painting skies, don't forget you're using acrylics. There's no need to paint your colours darker than you require, as, unlike traditional watercolour, your colour won't dry lighter.

If more colour needs to be added, do so gradually to build up an interesting sky: first dry the painting thoroughly (I use a hair dryer); then, with clean water, wet the area where you intend to add more colour. Add the colour, using a tissue to soften the edges.

One final consideration when painting skies is the wetness of paint on your brush in relation to the wetness of your under-painting. This is where the less experienced run into trouble: they apply their initial wash and then take too long to mix and apply their cloud colours, resulting in hard edges. Make no mistake, when working on any sort of watercolour painting, applying wet paint over an almost-dry under-painting is fatal. If you doubt this, as an exercise, wet some paper with Payne's Gray and allow it to almost dry. Then, drop some very wet paint onto this under-painting – and watch the hard edges form.

When painting skies, it's important to incline your board at an angle of at least 15 degrees to allow the colours to slowly run down the paper and blend together. When painting rain or mist, the angle would need to be increased to almost vertical to encourage the paint to flow much faster. Another exception would be when creating an atmospheric sky, wet-in-wet: in this case the board would be taken up and tilted in several directions to allow the paint to run and fuse together. The sky on pages 96–97 was painted using this method. The following procedure will help you to paint **SUNSETS**.

1. Don't forget to keep your colours pale and subtle. Use the sky and texture brush, or a similar large brush. Start by applying a pale Raw Sienna wash to the whole of the area. It's important to keep this wash light in tone.

2. Whilst the initial wash is still wet, paint the cloud formations using a mix of Raw Sienna with a little Alizarin Crimson added. Mix some Cerulean Blue with a little Payne's Gray and add the blue clouds at the top. These mixes should be less wet than the under-painting. Use a hair dryer to speed up the drying process.

3. When it has dried, re-wet the whole of the surface with clean water and leave to half dry. There's no need to worry about the colour lifting with acrylics. Paint some darker clouds using a Payne's Gray / Alizarin Crimson mix to create a soft violet. Add some sparkle by applying a Raw Sienna / Alizarin Crimson mix to selected areas. The simple foreground of Bamborough Castle was painted to show off the sky.

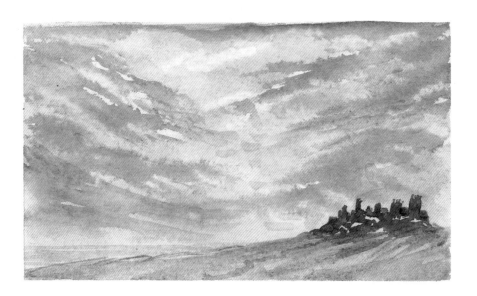

I painted this simple sky study by applying a pale Raw Sienna wash and brushing in the usual Payne's Gray/Cerulean Blue mix. Note that the brush strokes are not all horizontal but are angled to direct your eye into the centre of the scene. Make the brush dance across the paper. Don't dab and don't brush over the same area several times. I used tissues to lift paint to shape the clouds.

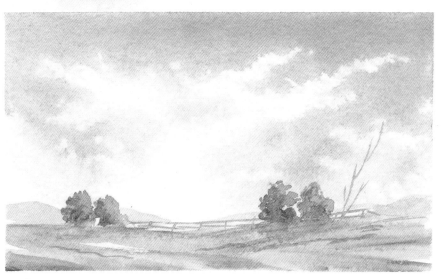

In this sketch, I have followed the same basic design as above but have used a Payne's Gray/Alizarin Crimson mix over the usual Raw Sienna under-painting. Note that the darker cloud formations are on the right to balance the left-hand mountain. The secrets of success when painting skies are brushing the paper lightly and knowing when to add the paint. Vary the angle of your strokes and make each successive application of paint less wet to avoid hard edges.

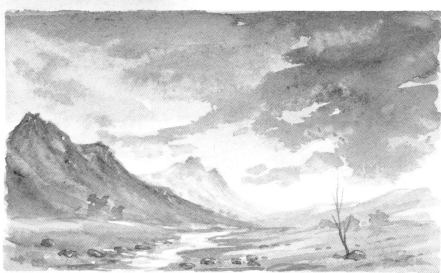

EXERCISES

1. Practise the technique for painting rain clouds.

2. Paint a cumulus sky while sitting outdoors.

3. Paint a sunset, taking care to ensure your colours are subtle and not garish.

One way to paint a cumulus sky is to apply a graduated wash and to lift out some fluffy cloud shapes with tissue. Allow the painting to dry completely, then re-wet the cloud areas with clean water and paint the cloud shadows using mixes of Payne's Gray/Alizarin Crimson. A very pale Raw Sienna added to the top of the clouds gives sparkle.

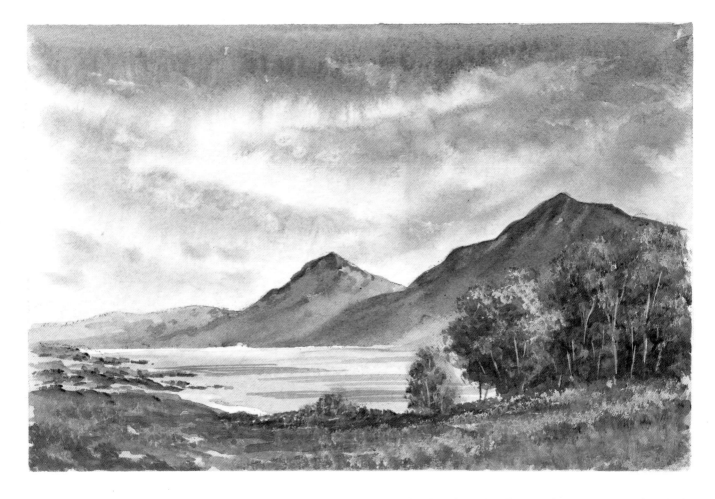

This painting of a Scottish loch provides a good example of rain clouds. To paint the effect of rain, brush your colour into a wet under-painting, tilt the board almost vertical and watch the paint run. When the paint has run sufficiently, lie your board flat and let it dry naturally.

CONSIDERATIONS

1. The sky creates the mood of the painting.

2. A complex landscape requires a simple sky – a simple landscape a dramatic sky.

3. Use cloud structures to balance your painting.

4. Clouds become smaller and lighter in tone with distance.

5. Aim for a variety of colours in your skies.

6. Tissues are helpful to create form and soften edges.

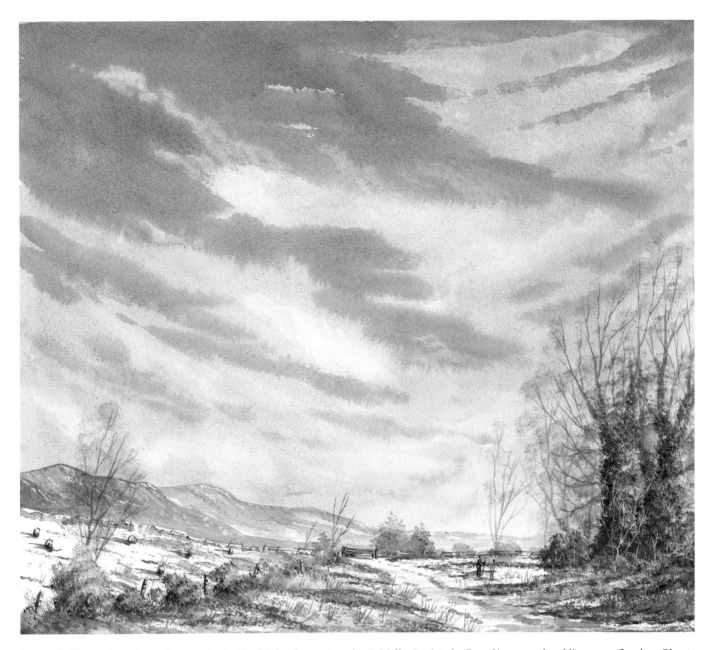

'Winter's Walk' – I was immediately attracted to this lovely evening sky. Initially, I painted a Raw Sienna wash, adding some Cerulean Blue to the top of the sky. I then immediately added a Payne's Gray/Alizarin Crimson mix to create the darker cloud structures and used tissues to finish them.

Painting skies is exciting and challenging, and will provide you with the opportunity to represent nature in all its moods. Be prepared to waste some paper; use both sides for economy when you're learning. You don't have to paint on a large piece of paper: 15x10cm (6"x4") is satisfactory, as this will allow you to use your paper effectively. It's the technique and the speed of application which you need to develop.

Enjoy your painting – paint a sky a day and watch your landscapes improve.

LESSON 2: PAINTING TREES AND FOLIAGE

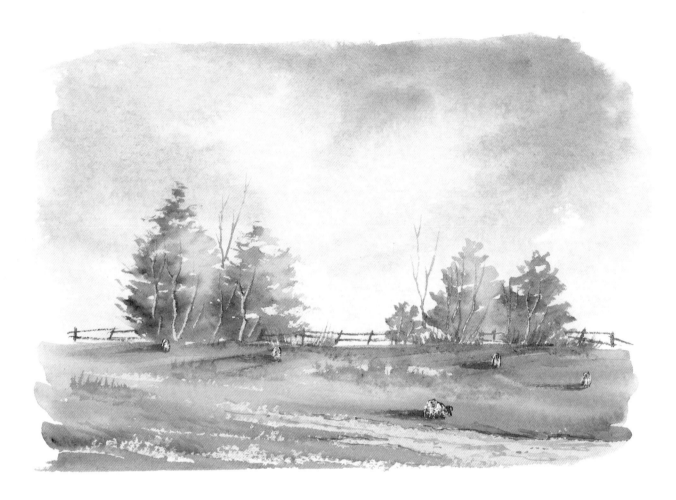

Trees form a significant part of our surroundings and, therefore, being able to paint them well is vital to success in landscape painting (from many years' experience of teaching painting techniques, I know that, after skies, beginners have most difficulty with the representation of foliage).

Trees are living things, with trunks which support branches, which in turn accommodate twigs, which carry foliage. This foliage has a variety of tonal values, which can best be seen by squinting one's eyes when viewing it.

Although it isn't necessary to be able to identify the type of tree you are painting, it is important to look at it carefully to determine its overall shape and structure. To achieve a three-dimensional, natural effect, branches leaving the trunk and growing away from you should be painted in a tone lighter than branches growing towards you.

Observation will reveal that tree trunks and branches are not always brown in colour, but vary with the type of tree and the time of year. They can range from a red-brown in summer to a light grey or grey-green in winter. Compare the different shades of green in the foliage in spring and summer and note how sunlight can create depth and cast shadows. In the autumn, the tree may have lost its leaves or the foliage may have taken on a new colour, from a pastel yellow to a rich

sienna. When studying an individual tree, you will observe gaps in the foliage, the precise nature of which depends on the type of tree and its structure. In a group of trees, such as a copse or wood, gaps will probably be visible only at the tops or the perimeter of the grouping. You should consider painting a few branches in these gaps.

Each season has a significant effect on tree structures and, as an exercise, I recommend painting a study of the same tree or trees each month throughout the year. You will be surprised at the changes. Branches can be painted in, blocked out with masking fluid (which can be removed once the washes have been applied) or scratched in with a knife or other sharp implement. Personally, I prefer to use my thumbnail – it's ideal: I always know where it is and it doesn't tear the paper. Turner used his little finger.

However, even if students can cope adequately with the structure of trees, they often run into problems after that. There are at least thirteen techniques for painting foliage and the following pages describe some of them, using a variety of brushes. When you are practising these techniques, remember each tree displays its own character and shape, and don't forget to paint in some grass or texture at the base of the tree; it wasn't planted yesterday.

When using these techniques, it is important to test the wetness of your washes on a scrap of watercolour paper before applying them to the final painting.

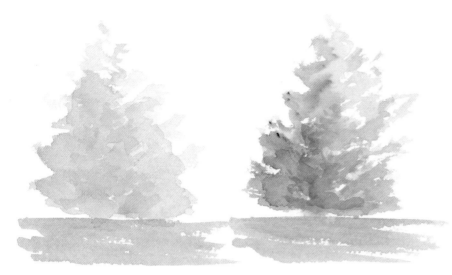

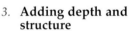

1. **Applying the first wash**
To create the rough shapes, apply an initial pale-green wash, pressing a size 6 **RIGGER** to the paper and wiggling it from side to side while moving it upwards from the base of the bush.

2. **Adding a second wash**
As the light source is from the right, to shadow the left-hand side and the base of the bush, apply a darker, less-wet wash, starting at the base and working upwards.

3. **Adding depth and structure**
To complete the bush and add depth, apply a drier, darker tone of Payne's Gray and Raw Sienna to the base and work it halfway up the left-hand side. When the paint is half dry, use your thumbnail to scratch in a few branches.

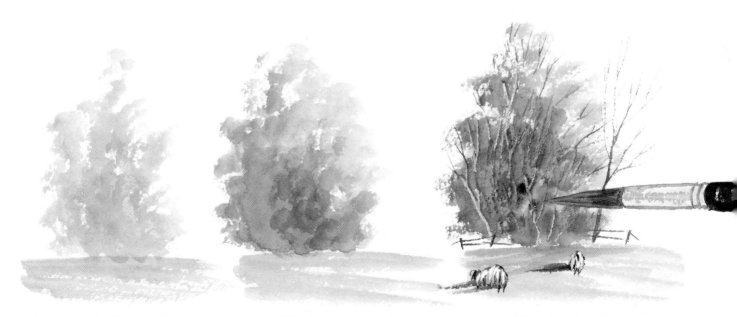

1. **Applying the first wash**
For this technique, load a size 16 **ROUND** brush with a not-too-wet pale-green wash. Hold the brush almost parallel to the top of, and close to, the paper, and paint the bottom half of the bush using fast, downward strokes. Paint in the top of the bush using drier paint and similar strokes, taking care to leave a few gaps in the foliage.

2. **Adding a second wash**
Using a drier Payne's Gray/Raw Sienna mix, apply a darker tone to the left-hand side of the bush, working it downwards to the base, which will also be in shadow, using fast, 12mm (¹/₂″) strokes.

3. **Adding depth and structure**
To complete the bush and to add depth, apply a final, drier and darker tone, taking care to shape the bush and to leave a few gaps in the foliage. Scratch in some structure with your thumbnail.

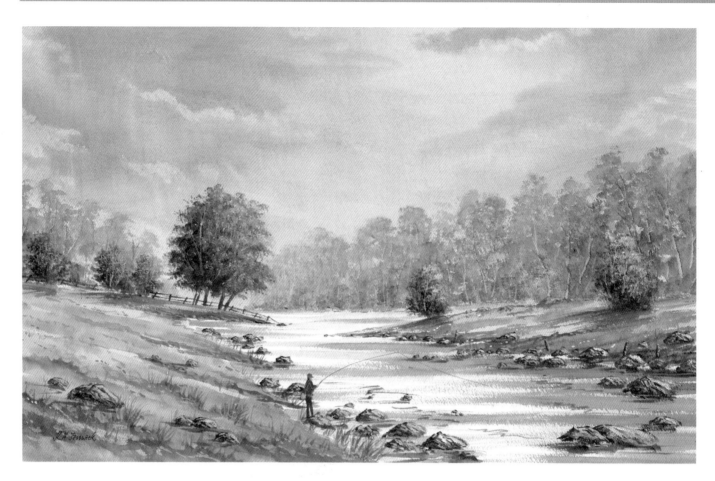

In this painting, 'Autumn Splendour', the focal point is the dark tree grouping to the left of centre. The values of the right-hand trees have gradually been painted in lighter tones to lead the eye into the distance, past the focal point. The bushes have been placed to break the long line of trees on the right. Note the subtle colours used to paint the sky.

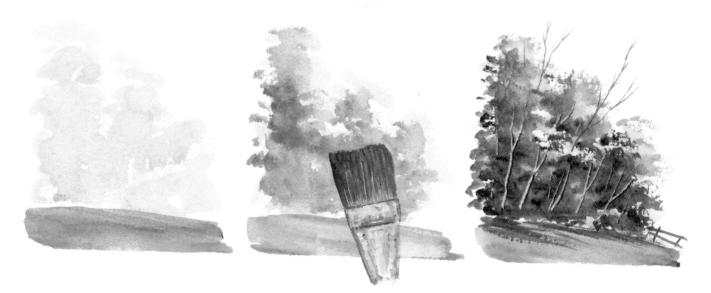

1. Applying the first wash
For this technique, use a **FLAT** brush and a weak Raw Sienna wash. Hold the brush above the ferrule and straight in front of you, at an angle to the paper of approximately 45 degrees. Peck like a chicken, brushing gently over the paper in strokes approximately 1" long, then lifting the brush off the paper.

2. Adding a second wash
To gradually build up the shape of the bushes, apply some Burnt Sienna. Don't forget to leave some of the under-painting showing through. Each successive over-painting should be applied using a dryer, stiffer paint whilst the under-painting is still wet.

3. Adding depth and structure
To complete this autumn grouping, add depth to the bushes, using the pecking action once again, this time with a darker Payne's Gray/Burnt Sienna mix. Scratch in some structure with your thumbnail when the paint is half dry. Add the fence and saplings with the rigger.

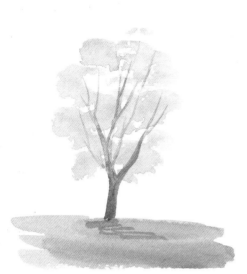

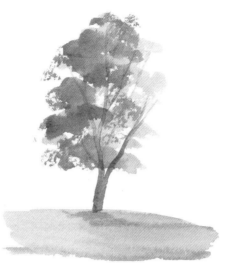

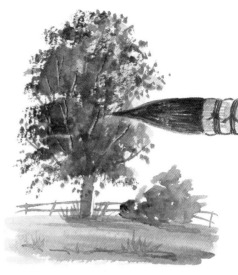

1. **Applying the first wash**
 To paint this tree foliage, use a hand-made **QUILL** brush. These brushes originated in the Far East and are sometimes called Chinese brushes. They have very soft hair and superb points, and thus are perfect for the sideways and dotting technique. Hold the brush horizontally and close to the paper, and use downward strokes which lightly touch the paper to apply a first wash.

2. **Adding a second wash**
 As the light is coming from the right, add some darker tones to the left-hand side of the tree. Gently brush over the rough paper using approximately 1" strokes. Don't forget to leave some gaps in the foliage.

3. **Adding depth and structure**
 To complete the tree, add more Payne's Gray to the green mix and use a dotting or dabbing action to create the feathery shapes of the outer foliage. Scratch in a few branches.

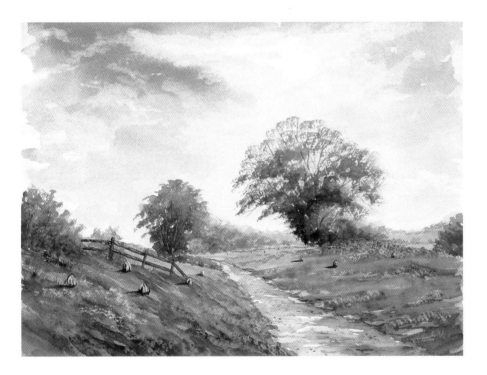

In this quick sketch of a country lane only a few minutes by car from where I live, I've used the technique described above to paint the trees. The sketch only took nineteen minutes to paint.

KEY FACTORS

The wetness of paint on the brush in relation to the wetness of the under-painting is a key factor which only experience will determine. Each successive layer of paint needs to be less wet than the previous one or your trees will lack shape and tone: if each layer is too wet, the colours will run together, resulting in a lacklustre 'blob'. The type and absorbency of the paper, together with the speed of the brush strokes, are also significant. A rough-textured paper is a great asset when painting trees, as it will give your foliage some substance and the faster the brush strokes, the better the resulting texture.

When painting trees, creating **TEXTURE** is important, not just to add interest to your scene, but also to give it depth by differentiating between foreground and background elements.

To achieve the shape of trees receding in the mist or into the background, we require a **SOFT TEXTURE**. For this, we use a version of the wet-in-wet technique. Wet the background with colour and, when half dry, paint in your tree shapes with a stiffer cool colour. The tree shapes will gently blend into the background under-painting, creating a distant, misty effect. As mentioned previously, timing is important when using this technique.

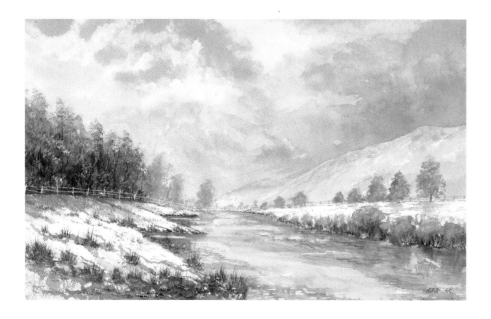

The trees in this snow scene were painted using the layering method I devised some years ago, described below. Various tones of Raw Sienna, Burnt Sienna and Burnt Umber were applied with the quill brush and the tree shapes softened by using a dabbing action with tissues. An impression of snow on the foliage was achieved by stippling with the 'unique' brush dipped in a semi-dry white paint.

To achieve the **ROUGH TEXTURE** required for foreground trees, there are two basic techniques. The first is to hold a nearly dry brush at an angle virtually flat to dry paper and drag or push the brush over it: this is known as the dry-brush technique.

The second is to move a wet brush quickly over dry paper. This is known as wet-on-dry. Think of your paper surface as mountains and valleys. If a loaded brush is moved slowly across the paper, the paint will not only touch the mountains but will also run down into the valleys, resulting in a flat band of colour. When a drier paint is applied, or a wet paint moved quickly across a rough-surfaced paper, the paint will only be deposited across the peaks of the mountains and will be unable to run down into the valleys, thus creating texture and sparkle.

These techniques are important and will come in handy time and again. As ever, it's essential to practise them.

To achieve recession when painting trees, the same principles apply: paint distant trees in little detail using a light tone, middle-distance trees in some detail using a mid tone and foreground trees in more detail using a variety of colours in darker tones. If the trees you wish to paint are on the horizon, a simple blue-grey wash may suffice. To achieve softness, you can paint them in when the background is still partially wet or soften their edges with a tissue. When I'm painting a woodland scene, I like to use the wet-in-wet technique. I begin by painting the background and, as it dries, I gradually add more detail as I progress into the foreground.

1. **Applying the first wash**
 With the side of a pointed or quill brush loaded with paint, use quick, downward strokes, gently brushing across the peaks of the paper to deposit a layer of paint. Using a tissue, remove some paint with a gentle dabbing action.

2. **Adding a second wash**
 Add a further layer of paint whilst the under-painting is still wet and, once again, use the tissue to remove some paint. I call this technique the **LAYERING METHOD**.

3. **Adding further washes**
 Add further layers of paint using a range of colours, dabbing with a tissue at each stage, until your foliage patterns have been developed to your satisfaction. Scratch in some structure.

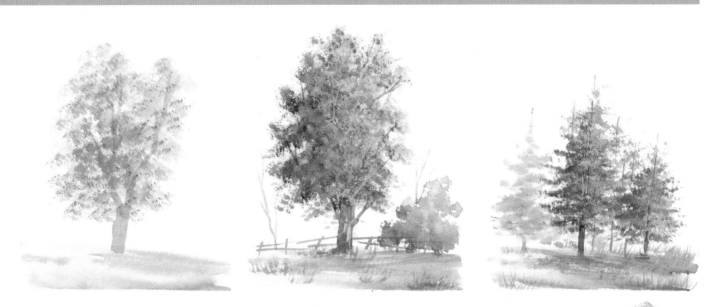

For the left and middle trees, with the round-ended 'unique' brush, or a pointed brush, using a stippling action and a semi-dry paint, paint the first layer, roughly shaping the tree structure. Add darker tones to create depth and to shape the tree. Using the 'unique' brush, trees can be painted loosely or in great detail; it will take a bit more practice to do this with traditional brushes. I have painted the fir trees on the right with the 'unique' angled brush using a stippling action and rocking the brush from side to side. I painted the distant trees with a blue-grey mix and the foreground trees in darker tones of green.

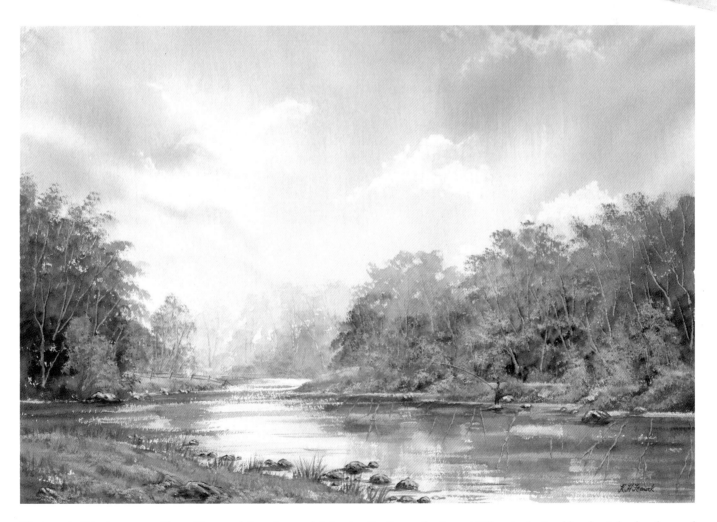

The trees in this river scene, 'Green Harmony', have been painted using the Derwentwater and Ullswater 'unique' brushes I developed several years ago for painting natural-looking trees. There are very few of my paintings where these brushes would not be used. I'd be lost without them. In this painting I have also used them to paint the distant trees and river banks. Note that the distant trees are painted in a light-blue tone to achieve recession. The 'unique' brushes are used by artists worldwide.

Note the variety of colour and tone in the right-hand tree grouping. To add diagonal balance to this grouping, the foreground bushes have been placed on the left. The distant trees have been painted in less detail, using blue-grey mixes to achieve recession. The reflections were painted wet-in-wet with vertical strokes, using a 1" flat brush. They are an important feature in this painting.

Remember not to neglect counterchange – light trunks against a dark background or dark trunks against light grass – and remember to paint adjoining trees and bushes as if the branches and foliage overlap, as they would in nature.

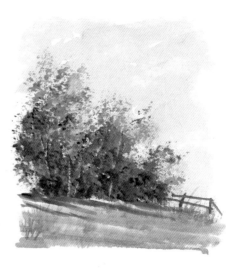

1. **Applying the first layer**
 Use a **SPONGE** dipped in paint to paint these bushes. Sponges can be natural or synthetic, though natural sponges are considered to be the best. Just dip your sponge in paint and, using a stippling action, deposit your first layer.

2. **Stippling further colour**
 Rinse your sponge and squeeze to remove surplus water. When the under-painting is half dry, dip the sponge in the paint and add a second coat, taking care to shape your bushes.

3. **Creating shape and texture**
 Allow to dry. Rinse your sponge, squeeze out surplus water and add some darker tones, taking care to create realistic foliage patterns and texture. It's important not to squeeze your sponge whilst stippling or you will lose control over your paint.

Winter tree

Take care when painting your tree structures. In nature, branches don't normally leave the trunk opposite each other or all from the same point. The above is an example of 'what not to do'.

This is an improved example: the trunk appears capable of holding the boughs which support the branches which hold the twigs. Take some photographs of winter trees to use as a reference.

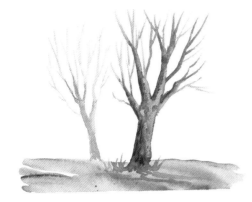

Summer tree

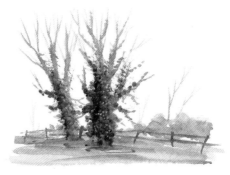

Tree with ivy

WASHING OUT AND GLAZING

Here, the tree structure was painted, then a tissue used to remove some colour. Once dry, a warm glaze was applied to provide variation in tone and to create a three-dimensional image. Note the distant tree is lighter in tone.

USING THE DRY-BRUSH TECHNIQUE

This section of a birch tree was painted by initially applying a weak Raw Sienna wash and allowing it to dry. The angled 'unique' brush with a dryish mix of Burnt Umber and Payne's Gray was then gently dragged across the trunk to create the dark bands associated with birch trees.

EXERCISES

1. Paint a group of bushes, taking care to vary the colours between them.

2. Paint the structure of a winter tree, taking care to wash out some light areas. Apply a glaze and, using a dryish paint, add the impression of dead leaves by gently stroking the brush over the paper.

3. Paint a tree structure and, using a stiff brush, add some ivy to the trunk. Note that ivy normally grows a half to two thirds of the way up the tree.

CONSIDERATIONS

1. When painting trees, at least three tones of colour should be applied.

2. When painting a long stretch of trees, add a few bushes to improve the composition.

3. Distant trees should be painted lighter in colour.

4. To paint trees in the mist, allow your under-painting to half dry before painting your trees in. Your colour will blend in nicely to create impressions of distant trees.

LESSON 3: PAINTING WATER

Water is a constant source of inspiration, presenting the landscape painter with many exciting challenges. With a choice of lakes, tarns, mountain becks, waterfalls, rivers and seascapes to paint, what more could we wish for?

Before attempting to paint water, the flow patterns, reflections and the direction of the light need to be studied carefully. Additionally, consideration must be given to the fact that water itself has no colour but reflects the colours of cloud formations in the sky and the objects behind it. Remember: seeing critically is an important aspect of painting.

There are three types of water we need to consider:

❍ MOTIONLESS: Examples would include a pond, calm lake or perhaps a puddle in a country lane.

❍ MOVING: Which would include rivers, mountain streams or a wind-blown lake.

❍ TURBULENT: A waterfall, fast-flowing mountain beck or a seascape.

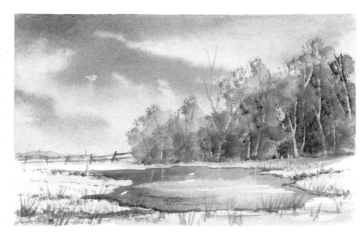

In this scene, the water has been painted in dark tones using a Payne's Gray/Burnt Sienna mix to provide counterchange with the snow-covered field. The hake has been used to remove still-wet paint to represent a wind-blown surface. Note that, while the weather might be chilly, the tones used for a snow scene don't have to be cold.

MOTIONLESS WATER

Motionless water will reflect a mirror image of the sky and any land features behind it. Cloud colours may be blue-grey or brown-grey, whilst an evening sky may have a rosy glow, and reflections from surrounding mountains also provide a wide range of colour – all of which can appear on the water surface and will enhance your painting, if painted with sensitivity.

Broad, flat washes are the simplest way to paint a motionless expanse of water. A brush loaded with semi-dry paint which is dragged quickly across the paper will create sparkle representing breeze-ruffled water or shimmering light. As discussed previously, rough-textured paper has the advantage of helping the brush to dance lightly over the peaks of the paper, leaving the valleys uncovered – a simple but effective way to

add life to your painting. Practise this technique.

While motionless water will show a mirror image of reflecting objects, as we all know, a slight breeze across the surface will immediately blur these images. This change in the water surface always causes confusion in my students. Naturally, they want to keep changing their painting as it progresses, a practice which is doomed to failure; remember my earlier advice: you are creating a picture. Attempt to capture the scene in your mind and paint it as you remember it – after all, this was what inspired you to paint the scene in the first place.

The wet-in-wet method is ideal for allowing the layers of colour to blend together which will create soft impressions without hard edges. Once dry, darker tones can be added to

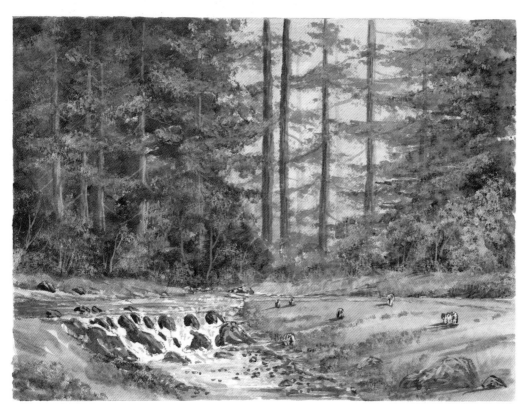

(left) This is my secret place in the Lake District where the sound of the water helps me to relax and plan my next adventure with paint. There are only passing sheep to distract me. The water has been painted simply, allowing the white of the paper to represent the rough water. A few strokes of a Payne's Gray/Alizarin Crimson mix have been applied to represent patterns of flow.

(middle opposite) In this Scottish loch scene, the sparkle on the water has been achieved by moving the side of the size 16 round brush across the rough paper surface quickly.

(bottom opposite) This lake scene has been painted using warm colours. The reflections are a mirror image of the mountains. Note how a light line where the water meets the land, as found in nature, has been retained.

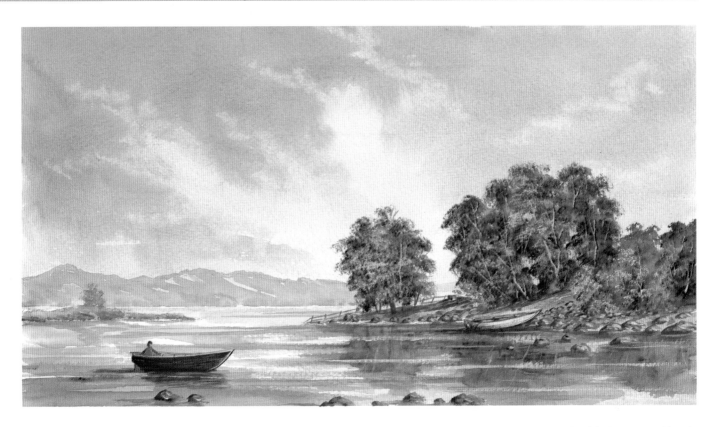

In this quick sketch completed on the spot in Scotland, the water has been painted using horizontal strokes with the side of the large, round brush, lightly brushing across the paper to create sparkle. The white of the paper has been left to show through between strokes. Various mixes of Cerulean Blue/Payne's Gray with a little Alizarin Crimson added were used. The tree reflections were painted using vertical strokes of the 1" flat brush with a Hooker's Green/Payne's Gray mix.

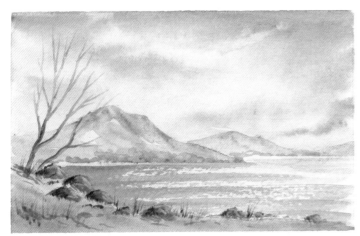

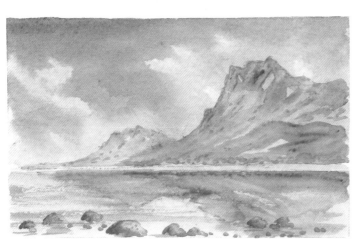

provide variety. Don't forget to leave that band of light in the distance where the land and water meet and to add darker tones in the foreground to achieve that sense of distance in your painting.

A word about reflections. It's not unusual for dark objects to reflect lighter and light objects to reflect darker. My usual technique for painting reflections is to apply an initial wash to represent water and, when it is half dry, to apply vertical strokes with the 1" flat to represent the reflections. I paint lighter tones first, followed by darker tones representing the colours of the reflected objects. The colour mixes I find useful for representing water are Payne's Gray/Cerulean Blue, Payne's Gray/Cerulean Blue/Alizarin Crimson, Payne's Gray/Hooker's Green or Payne's Gray/Raw Sienna. To represent shadows, I use darker tones of the same mixes.

MOVING WATER

Moving water will not exhibit detailed reflections but will still show variations in colour. The reflection of an overhanging tree, for example, won't show a detailed profile but will indicate the particular shade of its foliage and a blurred image of its structure.

In a fast-flowing river or mountain stream, particularly when the water flow is restricted by rocks, white water provides an indication of the speed of the flow. The faster the flow, the quicker and lighter your brush strokes should be. See 'Woodland Stream' on page 80. This is another instance in which rough-textured paper is especially beneficial.

Whenever I paint water, my approach is to sit quietly by the water, soak in the atmosphere and observe. I like to study the water for some time and, by squinting my eyes to achieve a blurred image, attempt to determine the flow lines, colours, tones and reflections. Painting water can be daunting for the beginner, but by closing one's eyes slightly, it's much easier to establish these characteristics.

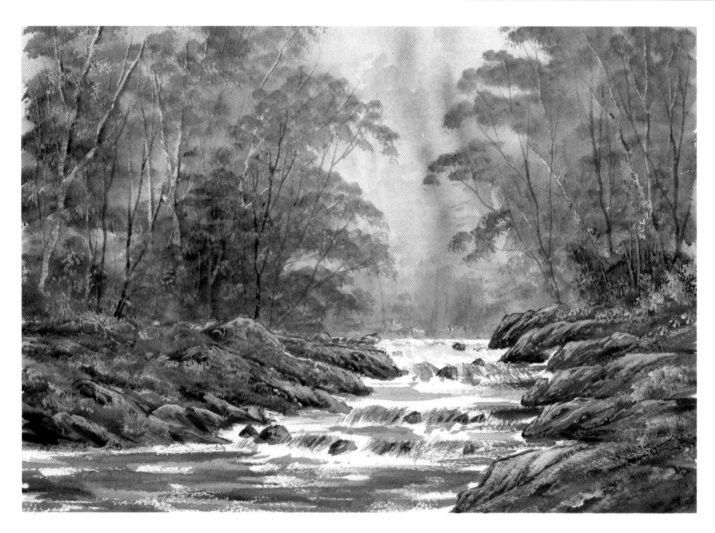

This painting, 'Woodland Stream', provides a good example of fast-flowing water. The minimum number of brush strokes has been used to capture the essence of the current. The large pointed brush was loaded with varying tones of Payne's Gray/Cerulean Blue with a little Alizarin Crimson added. Then, the hairs were spread (fanned) and quick light strokes applied to represent water flowing between the rocks. To complete the image, horizontal strokes with the side of the pointed brush were used.

As a general guide, reflections should be painted as a mirror image of the reflected object, in this case some bushes. Reflections are best painted either wet-in-wet or wet-on-dry. In this example, the former technique was used. A pale Cerulean Blue wash was painted to represent water. When half dry, vertical brush strokes were applied to paint the reflections using Raw Sienna and darker greens. When half dry again, a thumbnail was used to scratch in some structure.

As ever, a quick tonal study is useful: holding it in front of you, compare it with the water beyond and make any necessary changes before painting the scene.

You can't hope to compete with nature. Too much detail will make your water look artificial, so only attempt to paint the main flow patterns. The secret is to keep your brush strokes to a minimum. The general rule is: the more strokes you use and the more overpainting you do, the less wet your water will appear. Also, the water should always be painted in last, once the colours of the sky and reflecting objects have been established. A third important rule is that water is always level unless falling; and don't paint too many ripples. The watchword is: simplify. Rather than copying, your aim should be to paint a believable impression of the scene in front of you.

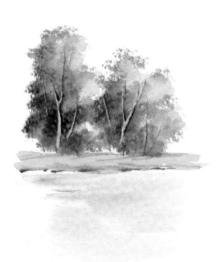

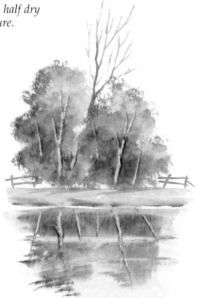

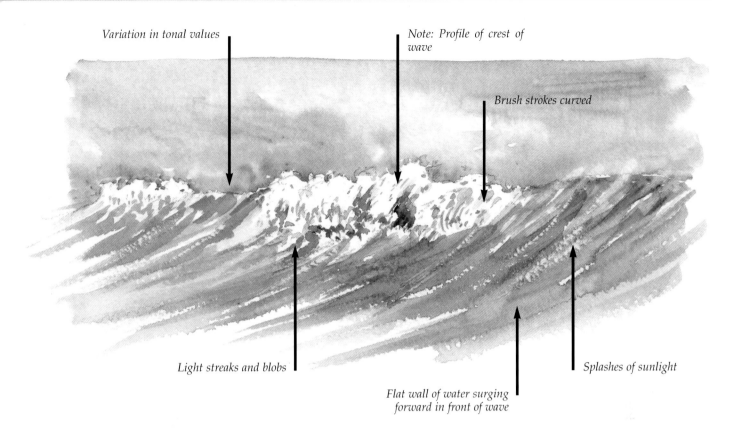

Variation in tonal values

Note: Profile of crest of wave

Brush strokes curved

Light streaks and blobs

Splashes of sunlight

Flat wall of water surging forward in front of wave

TURBULENT WATER

Turbulent water such as a seascape or waterfall provides further challenges. For advice on colour mixes useful for painting seascapes, see pages 62 and 83, and for the construction of a wave, see below; waterfalls are also discussed below, and on pages 56 and 83.

Photographs can be useful to capture structure and tone, but colours are best observed outdoors. In fact, the most effective way to observe the structure of a wave is to stand in the sea up to your knees and study it. Analyse particular aspects of the wave and produce a quick sketch using a water-soluble crayon. Watch several waves breaking and concentrate on a specific feature of each wave. Note its profile, the light- and dark-toned streaks and blobs at its base, and the general variation in tone. Observe any splashes of sunlight, the flat wall of water surging forward in front of the wave and the curvature of the crest of the wave. Notice also the white streaks and light areas that appear when the foam breaks up. These are best scratched in with a razor blade once the finished painting is dry. Don't forget to leave the white of the paper to represent the crest of the wave and to darken your tonal values to establish flow patterns and to achieve counterchange. You should also observe the direction of spray that results from waves hitting rocks and the rivulets of water which run back over the rocks. Note how the rock colours are enhanced when wet, providing an opportunity to add sparkle to the painting. The sketch above shows the main features of a wave.

There is no more beautiful sight than a tumbling mountain stream or waterfall – I just can't wait to paint it. As ever, though, careful observation is most important. The speed of flow and the depth of water will determine whether the fall appears light or dark in tone where the water flows over the edge. If the depth of water over the edge is considerable, the water will appear light in tone; if low, it will appear darker, as the rocky shelf can be seen through the flow. If the flow is interrupted by rocks before cascading over the edge, white water will be seen. When the water has completed its fall, some spray will occur, and the water will become darker in tone as it flows away from the base of the fall.

PAINTING ROCKS

Rocks are a boon to the landscape painter, as they help to establish an interesting foreground. Like waves, they become smaller in the distance. Study their shape, size and colour.

I use three methods for painting my rocks. One way is to paint the main body colour in a light tone and, when half dry, paint in other colours, allowing them to fuse together. This may involve an initial pale Raw Sienna or neutral grey wash with mixes of Burnt Umber and Payne's Gray/Alizarin Crimson being added to create shape, form and depth. When the wash is completely dry, I dip a white or light-coloured Caran d'Ache water-soluble crayon in water and draw in the light on the top of the rocks. When painting large numbers of rocks, these crayons make effort simplicity itself.

Another technique I sometimes use is to apply the base colour, drop in the darker tones and, with a piece of tissue screwed to a point, remove some of the paint whilst it is still wet, to represent the light areas on the rocks.

For larger rocks, I may paint them using several colours. Once they are dry, using a stiff hog-hair brush dipped in clean water, I will stipple areas of the rock and dab off the paint using a tissue. This is a useful technique for creating

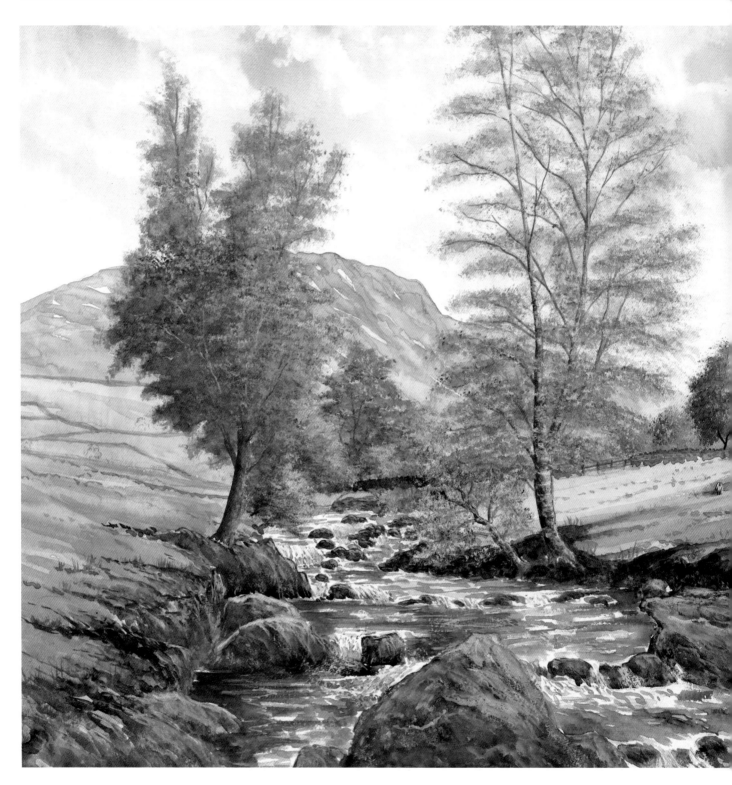

This scene is typical of the numerous lakeland becks waiting to be discovered on a day's adventure in the wilderness. Flowing into the lovely hamlet of Hartsop, it provides us with an excellent example of fast-flowing water tumbling down from the fells. The foreground rocks were a special feature, contrasting with the water, which was painted with quick strokes of the large hake. The texture on the rocks was achieved by applying several coloured glazes, allowing each to dry before applying another. (This is where acrylics have the advantage over ordinary watercolours.) The shadows and the fissures in the rock were painted at the end to capture realism.

texture. When dry again, I sometimes apply glazes and paint in a few cracks in the rocks.

Don't forget the basic rules: don't make your rocks all the same size or equally spaced. Never paint them in lines. Add some darker tones to represent shadows under your rocks, otherwise they will give the impression that they're floating on top of the water. But remember: black is not a good colour for shadows – it deadens your painting. Twenty per cent of any colour added to eighty per cent Payne's Gray will produce an interesting grey. My favourites are Alizarin Crimson, Cerulean Blue, Burnt Sienna or Hooker's Green. Above all else, spend extra time observing your subject before applying paint.

I've always been attracted to these small, cascading falls which can be found almost anywhere in the Lake District, particularly in winter. I've used the rigger loaded with mixes of Cerulean Blue, Payne's Gray and Burnt Umber to paint flow patterns. At the base of the fall, a few horizontal dark tones help to highlight the white water.

When painting wave structures, it's important to observe them very carefully to determine shape, colour, tone, foam, holes created by the dispersal of foam and any spray which comes into contact with rocks. Observe how the rivulets run off the rocks as each wave subsides. Careful observation and simplification are vital to success.

EXERCISES

1. Find a private spot by a fast-flowing river and study the flow patterns – produce a tonal study.

2. Study pages 57 and 83 and practise painting rocks and a waterfall.

CONSIDERATIONS

1. Water can be motionless, moving or turbulent.

2. Water has no colour, the variation of colour on the water surface is due to reflecting objects.

3. Unless falling, water is always level.

4. Use quick, light brush strokes when painting fast-flowing water.

5. Observe and simplify – you can't compete with nature.

LESSON 4: PAINTING MOUNTAINS

At first glance, mountains may appear difficult to paint. They can range from large hills to snow-capped peaks rising several hundred feet, and can be rounded or pointed, depending on the geology of the region. Personally, I aim to avoid mountains with rounded peaks, preferring to paint those that have a more rugged structure, but whichever form they take, it's important to capture their character and atmosphere.

In trying to capture the character of the mountain and its surrounding area, look for a stream, a path to a farmstead, an established track or even a stone wall that could lead the eye through the painting to the mountain. Also be aware of water runs, trees, climbers or walkers, farm buildings, old packhorse bridges or anything else that will indicate scale. However, make sure that whatever you include in your painting is characteristic of the region.

As with other elements of the landscape, time spent studying the structure of the mountain or mountain range is well spent. Try to determine the main features, such as distinctive gullies, fissures, promontories or peaks. Note also the main colours and tones. Be aware that the colours and tones become lighter as the mountains recede into the distance – bracken, heather, rough grass and wet rocks can be helpful by adding variations in colour.

Impressions can change with the weather. Depending on the conditions, mountains can exhibit a wide range of colour variations: sunlight highlights lots of detail, whereas rain and mist can make it difficult to determine structure and may make mountains appear to be a light blue-grey. Whatever the characteristics of the particular mountains you are painting, ignore excessive detail, simplify and paint your mountains accordingly.

Whilst photographs can be a useful aid in capturing a flash of light or cloud study, no photograph can capture the range of subtle colours or the intensity of light that occurs in nature. There's no substitute for being in the outdoors, soaking in the atmosphere and, of course, the eye can see more detail than the camera can capture.

This is a simple painting. Note the distant mountain has been painted in lighter tones. At ground level, a quick wipe with a tissue lightens the colour, indicating it is some distance behind the foreground mountain.

One way of highlighting the snow-capped peaks is to create counterchange by painting a dramatic sky in dark tones behind tthe mountains. Although this is a snow scene, a wide range of pastel colours have been painted into the bottom of the mountains and the foreground. Snow scenes don't have to be cold.

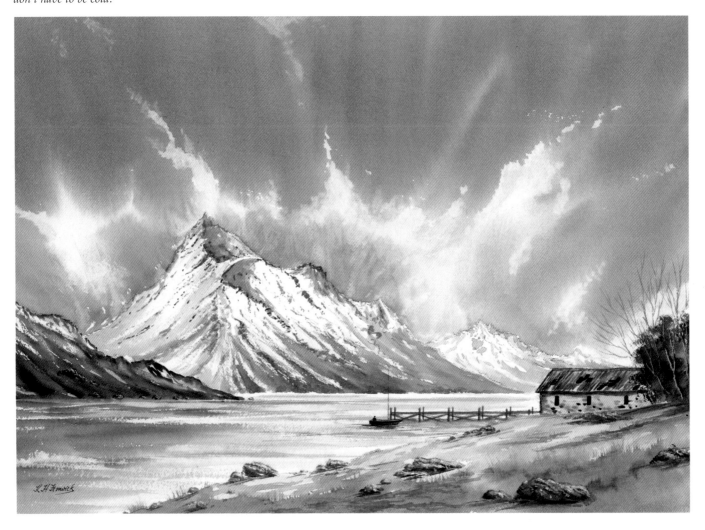

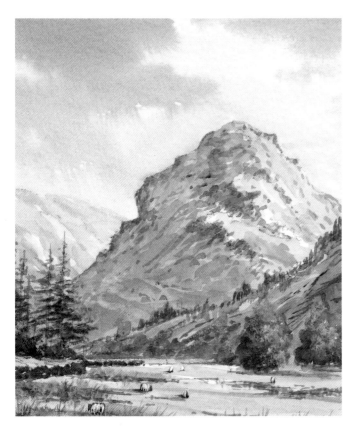

'Eagle Crag' dominates the Stonethwaite Valley in the Lake District. Note how one side of the ridge is in shadow. Broad washes were painted and, when they were half dry, various colours were added and allowed to blend together to create the under-painting.

However, you don't have to climb your mountain to obtain exciting views. Most can be approached by car, and short walks in different directions are usually sufficient for determing the best composition. Bear in mind that mountains can usually be approached from several valleys.

It is important to plan your trip before you set out on your adventure. Much useful information can be obtained from maps, books, videos, illustrated guides, walking/climbing magazines, postcards and word of mouth. If you do intend to climb to high ground, don't forget to let people know where you're going and when you expect to return. Most hotels, B&Bs, climbing shops, etc. have a check list you can complete before your expedition, but at the bare minimum, always take some food, a whistle, sensible clothing and a compass, and, if you're not used to climbing, have a check up before you attempt anything too strenuous. The weather can change dramatically in mountainous regions so beware – obtain a detailed weather report before you set out.

When working outdoors, the weather often encourages you to work quickly, which helps you to capture spontaneity and discard detail irrelevant to the composition. My normal approach is to make initial sketches to determine the most suitable composition and select cloud formations to capture atmosphere and mood. I find a pocket-size pair of binoculars very useful for determining the shape of the main features I wish to include in a painting. My sketching equipment also consists of a tin of Caran d'Ache water-soluble crayons, one round brush,

'Life on the Edge' is a painting requiring some detail. To paint the rock face, a Raw Sienna under-painting was applied and mixes of Payne's Gray/Alizarin Crimson and Burnt Sienna allowed to blend together to create variation. The rigger was used to paint the gullies and fissures. The climbers were added for realism. Note how simply the land below has been painted to indicate scale.

a small waterpot, a small pad of rough-surfaced watercolour paper, which fits into a freezer bag in case of inclement weather, a pencil/crayon sharpener; a haversack which includes a stool accomomodates these materials. When not travelling far from the car, I also include a canvas chair and a set of paints.

When painting a mountain other than a snow-covered one, I normally follow this basic procedure:

1. Using the hake loaded with appropriate colour, I roughly shape the mountains, working from peak to ground, using the full width of the brush. The angle of the brush strokes is important: they must follow the profile of the mountain, which is usually a 45-degree fall, levelling off as it reaches the ground. For this initial under-painting, gentle sweeping curves are required, and I try to leave some of the white paper showing through.

2. Changing to the round, pointed brush loaded with an appropriate colour, usually Raw Sienna, I immediately sweep the brush upwards from ground level until the two colours meet and fuse together. In order to keep the bottom of the mountains level (i.e. at the water line or grass area), I cover this with masking tape. This allows me to paint over this area when applying the upward strokes. When I have completed the mountain, I slowly remove the tape, leaving a crisp line at its base.

3. Using the tip of the round brush, the next stage is to shape the mountain with darker tones, picking out selected peaks,

For this sketch I painted an initial wash, using brush strokes which follow the structure of the mountain from top to bottom. I then used darker tones to form the peaks and added a few trees at the water line. After allowing the painting to dry, I applied Raw Sienna and Burnt Sienna glazes to add warmth to the mountain.

(below) This is the type of quick sketch I complete in a few minutes when I'm exploring a region. The mountains here appear sharp, splintered, very steep and, one could imagine, dangerous to climb. I painted a quick impression using the rigger.

(bottom) This quick sketch produced on one of my visits to Scotland shows the mountains covered in a light fall of snow. I've left plenty of earth showing through.

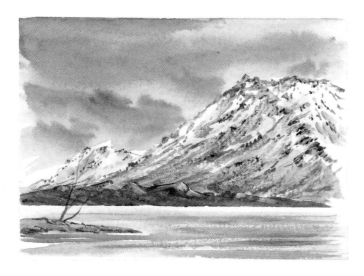

crags, gullies and other features. I rinse the brush and wash the colour downwards from the peaks, allowing it to blend into the under-painting. This technique leaves the peaks a darker tone and lightens the colour in the blended area.

4. If the mountain in my painting is large enough, I take up a piece of absorbent tissue, shape it into a wedge and wipe it downwards from the peaks to remove some colour. I find this a simple way to finish shaping my peaks and to achieve the right balance of lights and darks. In the painting on page 87, I have used this technique to good effect. Remember: with acrylic watercolours, if you're not happy with an area of your mountain, you are able to lighten, darken or reshape the area by over-painting, as, once dry, the colour cannot be lifted.

5. In the first stage, I mentioned I left some areas of the paper uncovered. These can be over-painted with a Raw Sienna wash to indicate patches of sunlight shimmering over the mountain.

Stages 1 and 2 must be completed very quickly to allow the colours to fuse together, and the first four stages must be completed whilst the paint is still wet.

When painting snow-covered mountains, as in the painting on page 84, I use a different technique, as follows:

1. Initially, I paint the shadows in a cold blue or grey and allow them to dry.

2. I then paint the peaks, rocky crags and ridges in darker tones using the rigger.

3 Finally, using a variety of colours and tones and sweeping upwards from ground level with the side of the pointed brush, I create the structure of the mountain. Note that I have painted a dramatic sky to achieve counterchange with the white of the snow on the mountain (here, the white of the paper).

Mountains are exciting and challenging to paint; practise the techniques discussed in this section – and enjoy your painting.

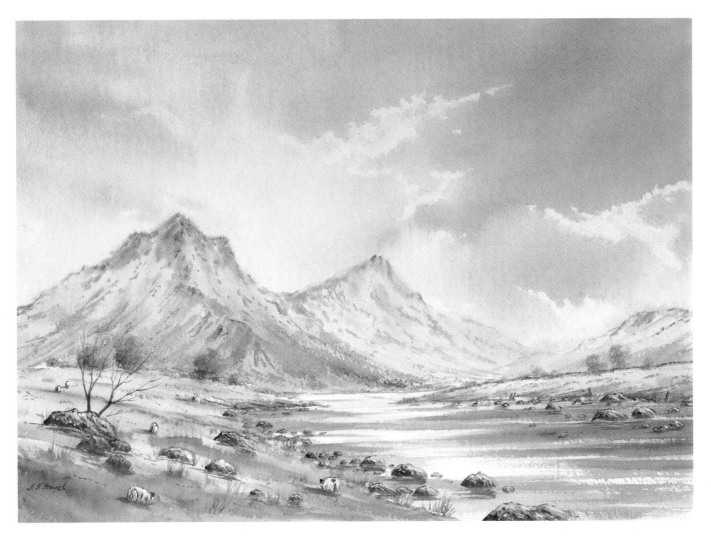

'Autumn Splendour' is a good example of colour harmony. I used various mixes of Payne's Gray, Cerulean Blue, Alizarin Crimson, Raw Sienna and Burnt Sienna throughout the painting, with the exception of the grass areas, where I applied a pale-green under-painting. To achieve colour harmony, I covered the whole of the painting with a Raw Sienna glaze, with the exception of the white areas in the water, where the paper was left uncovered.

EXERCISES

1. Practise the procedures described on page 85–86; they simplify the painting of mountains.

2. Practise copying the snow-clad mountain shown on page 84.

3. If you don't live in a mountainous region, borrow a book from the library and practise painting the structure of a rock face. Add some climbers for interest.

CONSIDERATIONS

1. Study your mountains, identify their main features and simplify.

2. To avoid frustration, choose a mountain that you feel is within your present competence to paint.

3. Find a composition with a river, track or other feature that leads your eye to the mountain.

4 Plan your visit before you set off; it will save you time.

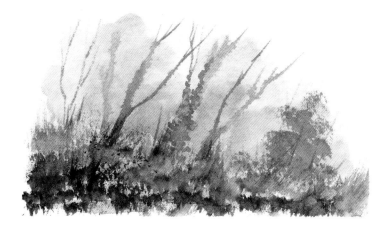

(top) I painted the foreground grass by stippling several colours with a soft hog-hair brush and, whilst it was wet, I flicked the brush upwards to blend the colours together and to create the effect of tufts of grass. When the paint was dry, I used a pale Raw Sienna to glaze some of the uncovered white paper.

(middle) Here, I used the rigger to paint in some rocks. When these were dry, I dipped the end of a white water-soluble crayon in clean water and drew in the light areas on the rocks. Note that the rocks are different sizes and not equally spaced.

(bottom) I added the wild flowers to this foreground when the under-painting was completely dry, using my 'unique' brush with a stippling action. It's sensible to stipple on a piece of waste paper first and, when you have achieved the effect you wish, move to your painting.

LESSON 5: PAINTING FOREGROUNDS

A good foreground can make or break a painting. After all, your foreground is the entry into your painting. Those new to painting tend to go from one extreme to the other: their foregrounds are either too fussy or have too little detail.

There are some basic rules that need to be remembered when painting foregrounds:

❍ To create the illusion of depth or recession, paint warm, rich colours in the foreground, cooler, greyer colours in the distance.
❍ Paint more detail in the foreground and less detail in the middle and far distance.
❍ Objects such as rocks, bushes, trees, telephone poles, etc. should be larger in the foreground, smaller in the middle distance and even smaller in the far distance.
❍ Paint rough texture in the foreground, soft texture in the distance.
❍ Apply a greater thickness of paint in the foreground, thin washes in the distance.
❍ Take advantage of a river, road, fence, stone wall, avenue of trees or ploughed field to lead the viewer's eye from the foreground into the painting.
❍ Make sure that the width of your road, river or track is much wider in the foreground than in the distance. It is almost impossible to make it too wide in the foreground.
❍ Beware when painting stone walls or fences: don't paint them right across your foreground without putting in an open gate or a break of some kind, or what you're saying to the viewer is: 'Don't enter my painting.'
 A final word about fences: I've seen many paintings ruined by square fences. I trained as a draughtsman and so it took me years to overcome my problem of painting fences with perfectly vertical posts and three or four bars. An uneven fence with two bars works best. As mentioned at the beginning of the book, the distance between the fence posts needs to be at least twice the height of the fence.

Over the years, I've found the best way to paint most foregrounds and grass areas is to wet the area initially with an appropriate light colour (green or Raw Sienna) and, when it is half dry, paint in some darker tones. As the under-painting is still wet, these darker tones, which should be in assorted colours to achieve variation, will gently blend together.

As the area dries, more detail can be added without loss of shape or form. When the paint is still wet, I may use a tissue to remove paint or to create the effect of texture, or I may use my finger or knuckle to dab the area to create interesting effects. Don't forget to paint in some shadows made from a mix of Payne's Gray and an appropriate colour (but avoid black – it's a dead colour).

To achieve tufts of grass, I may use my nail to scratch them in, or fan the end of a pointed brush and flick upwards, as described earlier. In the vignette at the bottom of page 89, I've used a variety of techniques, choosing my angled 'unique' brush to add a few wild flowers.

Imagination and experimentation are what's needed to paint interesting foregrounds.

I mixed various purple tones from Payne's Gray and Alizarin Crimson to produce the colour of heather on the moor and added a little white to soften the colour, using the angled 'unique' brush with a stippling action.

Painting simple figures to add to street scenes, etc. is very easy. Use the rigger with some Raw Sienna to rough out the shapes. Paint two strokes with darker tone for the legs and a 'dot' for the male heads. An elongated dot represents the female head. Colour the clothes to add variation. Don't make the heads too large and don't paint feet.

Here, I've used the rigger to paint the tree structure by pressing the brush to the paper and gradually releasing the pressure as I moved it upwards. I painted the tufts of grass using the technique described earlier of holding the rigger by its tip and flicking upwards.

I painted the ivy by dabbing with a pointed brush. I achieved the variation in the foreground grass by applying several colours and, whilst they were still wet, flicking upwards with the hairs of the pointed brush fanned between my fingers.

This view of the River Wear from the bridge at Pagebank in the north-east of England is one of the areas where I played as a boy. The foreground was overgrown with foliage and wild flowers which I painted by stippling for the 'tansy' and dabbing for the larger-leafed plants.

EXERCISES

1. Practise the method for painting foregrounds described on pages 88 and 89.

2. Photograph areas of a country lane when the wild flowers are at their best. Omitting unnecessary detail, paint quick sketches to build up a resource from which you can draw in future.

3. Choose a view where a road or track leads to a farm house. Practise drawing the composition to lead the eye into the painting.

CONSIDERATIONS

1. Paint warmer, brighter colours in the foreground and cooler, greyer colours in the distance.

2. Use your nail, knuckle, a knife, credit card, sponge or tissue to create interest in your foregrounds.

3. Paint more detail in your foreground and less detail in the distance.

4. Paint rough texture in your foreground and soft texture in the distance.

LESSON 6: PAINTING BUILDINGS AND STONEWORK

This lovely old timber building is the fourteenth-century manor house at Lower Brockhampton which is now owned by The National Trust. The detached gatehouse straddling the moat is fifteenth century. The painting involved a fair amount of drawing, taking care to ensure the proportions and perspective were correct. Note how the roof of the main building slopes to the right and the extension to the left; also note the reflections.

Many of my students start to panic when I suggest we find an attractive group of buildings to paint. I suspect it's the thought of drawing straight lines and getting the perspective right: as I mentioned at the beginning of the book, I suspect they imagine they're back at school and associate the drawing of lines with the difficulties they encountered with geometry. However, it needn't be an unpleasant experience; in fact, it can be a great deal of fun.

In the sections 'Drawing Made Easy' and 'Perspective Simplified' we've covered the basics, like how to draw to scale and the use of shortcuts to help you with your linear perspective. Once you've mastered these basics, we need to look at the other factors which ought to be taken into consideration. Buildings can be drawn very simply or in great detail, it's a matter of choice and the training you've had beforehand. Architects and draughtsmen, when they first start painting, tend to produce buildings in great detail. People who have been trained in these skills want to paint every brick: whether they can see them or not, they know they're there. Once they've gained experience, they realize it's not necessary, as, with a few carefully placed lines, it's possible to create the impression that the building is made of stone, brick or wood.

By using texture and gradation carefully, you can make your building look real. Add some blue, Raw Sienna, Alizarin Crimson or Payne's Gray to a light wash and your stonework will come to life.

Another practice I favour is to emphasize selected stones with a fine pen to represent shadows – but only apply the ink to two sides of the stone or brick and only apply it to a few stones. It provides a three-dimensional effect which works wonders. I see so many buildings painted with dead colours. This is where acrylic paints come into their own. You can apply any number of pastel-coloured glazes to your stonework without the fear of 'mud' and the associated lack of brilliance that arises when using traditional watercolours. A useful method for doing this when painting brick, stonework or wood is to apply a colour and, whilst it is still wet, remove some colour by dabbing with a tissue. Dry the under-painting, apply a further colour, and dab with a tissue. Dry the under-painting again, apply yet another colour, dab off and so on. Once you have applied sufficient glazes, you can touch up any light areas created by the removal of paint with a pale Raw Sienna or purple

Eileen Donan Castle in the Scottish Highlands is a popular tourist attraction. After viewing it from several vantage points, I chose this composition. There was a particularly attractive evening sky which provided a pleasant background for the castle. The castle stands on raised land approached by a long causeway and has been used in several films.

glaze to provide, in the first case, a warm glow and, in the second case, some depth to your building. Practise these techniques; you'll find they work.

A word about painting windows – don't paint them black. A cool blue or Payne's Gray will suffice, and a useful technique is to dab the paint with a tissue when it is half dry, to provide variation in tone. With small paintings it's not so significant, but with a larger painting it's important. Some Burnt Umber or light red dropped into the mix can also help.

Decide on where the light is coming from and paint your shadows with a transparent glaze (lots of water) so that the building's stonework shows through. Remember: twenty per cent of virtually any colour added to eighty per cent of Payne's Gray will produce an interesting grey. My personal choices are Alizarin Crimson and Burnt Sienna. Always paint your shadows last and you'll find your paintings come to life.

When painting street scenes, use artistic license and vary the colours between adjoining buildings. Don't always paint what you see – you're an entertainer, you're creating a painting. The inclusion of a few figures, where appropriate, creates interest. Even smoke from a chimney indicates life.

This lovely old village of Hartsop in the English Lake District has a charm all its own. The cluster of quaint cottages has been set on the grass, like many in the region, and over many years tracks have been worn to the houses. The stone buildings and walls have been decorated by numerous trailing plants and flowers, making it one of my favourite painting haunts.

Fine wines, dinosaur trails, river walks and friendly villages: 'La Rioja' has it all. This Spanish village scene, although not difficult to paint, needs to be drawn with care to establish the correct relationships between buildings. To avoid running out of paper, start with a piece of paper larger than you'll need and begin by drawing outwards from the centre. Once you've completed your drawing, you can trim it to size. This saves time and the frustration of nearly completing your drawing only to find you can't fit in the last few buildings. Remember to avoid black for your shadows, as it will make your paintings look cold.

EXERCISES

1. Attempt to copy the above painting. It will give you good experience in establishing the relationships between buildings, the direction they are facing, and the varying heights and roof angles. It can be quite tricky.

2. Seek out your local church and produce a quick sketch of it. Take care with the angles of the roof, ensuring that the perspective is correct. Note the direction the light is coming from and paint in some shadows.

CONSIDERATIONS

1. Paint a variety of colours in your stonework.

2. Don't use black for shadows – use a warm grey; and don't paint your window panes black, use a cool blue, dark brown or a warm grey. Dab with a tissue to remove some paint and soften the edges.

3. Apply glazes to add interest to your stonework.

4. Aim to achieve counterchange between your building and the objects surrounding it.

LESSON 7: INDICATING SCALE

How high is that mountain, how wide that river, how large those rocks? Whilst a successful painting should encourage the viewer to think and ponder over elements in the painting, you do not want to distract the viewer with awkward relationships. The artist has a responsibility to provide a sense of scale in his or her landscapes.

So, how do we do this? We've already discussed the concept of gradation in colour and tone and, although you may not have been aware of it at the time, we've mentioned gradation of scale in the sections on perspective, buildings and foreground.

Gradation of scale is used to create an impression of depth and recession in a painting. An example of this would be a road, river or track which is painted wider in the foreground and gradually becomes smaller as it recedes, to create an illusion of distance. The size of other elements in the painting in relation to each other and to the road or river can be estimated.

In the painting on the opposite page, 'On High Fells', the known size of the sheep provides an indication of the size of the foreground rocks. In turn, both elements provide an indication of scale for the mountain range beyond, suggesting to the viewer that the mountains are high.

There are many ways we can indicate the size of elements in our painting. We can place some figures in a street scene or a fisherman on a river bank, or we can add rocks, boats, sheep, cows, bushes and so much more. But beware! We can ruin our painting in a few minutes if we paint these indicators too large, or place them in the wrong position.

I've added a fisherman in the foreground of this Scottish scene to indicate scale. He's been positioned to the right of the sketch to balance the distant mountain.

USING TRANSPARENT FILM

A useful tip for checking the size of your subjects before applying paint to paper is to pop down to your local art shop or stationer's and purchase an acetate sheet like the kind used by teachers on an overhead projector, some tracing paper or a clear plastic wallet. Any one of these will suffice. Draw your figures, animals, rocks, etc. with a non-permanent, water-based pen, so that it can be easily removed from the clear surface. You can then lay the film over your painting and move it around to determine whether you have drawn your subjects the correct size and where they would be best placed.

Figures included in a landscape, particularly a street scene, add life to a painting, but be sure to avoid the usual faults: painting the heads too big, making the figures too wide and stumpy (rather than thin and tall) and painting feet. It's not necessary to paint feet on such small figures. Don't make them all the same height, and paint some holding hands to link them together. When painting lots of figures, only impressions are required.

I have included some figures in this beach scene to add interest to the foreground and to provide a sense of scale. Note how simply the sea has been painted, leaving the white of the paper to represent waves.

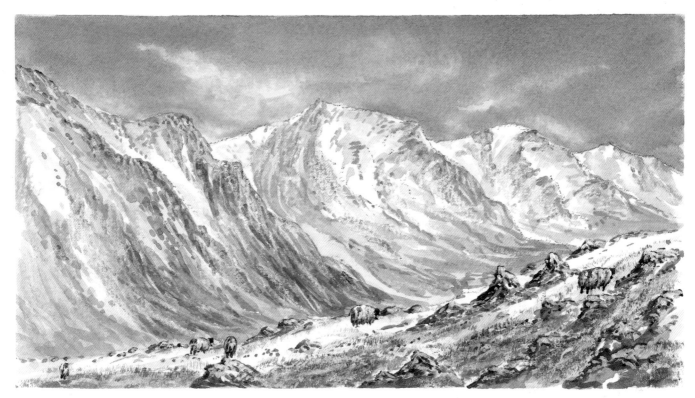

'On High Fells' captures the atmosphere of lakeland after a light sprinkling of snow. The hardy Herdwick sheep add scale in relation to the distant mountains.

HOW TO PAINT SHEEP

Whenever I tell my audience that I'm going to paint impressions of sheep by painting 'horseshoes' their response is to laugh. Yet, that's all you do.

Paint your horseshoes in different sizes, larger in the foreground and smaller in the distance. I initially use a Payne's Gray/Burnt Umber mix. If your sheep is looking to the right, add another horseshoe to the right and a triangle for the head; if looking to the left, add another horseshoe and triangle to the left. The shadows beneath them are essential. When the first colour is dry, add some white paint and give them their mark.

Horseshoes for sheep – it's as easy as that! (By the way, legs are optional: In their winter coat, you can't see their legs. When they've been sheared, you can.)

EXERCISES

1. Practise painting some sheep using the method shown above.

2. Paint a street scene and include some simply painted figures.

3. Paint a mountain scene and include an old farmhouse to indicate scale.

CONSIDERATIONS

1. Ensure your figures, animals, etc. are included as an integral part of your painting – not just as an afterthought.

2. Don't forget to paint shadows underneath your subjects.

3. Take advantage of counterchange: a light figure against a dark background or dark against light.

4. Don't paint figures in too much detail – paint heads small.

5. Use transparent film to help to establish size and position.

GALLERY: TRIBUTE TO YOSEMITE

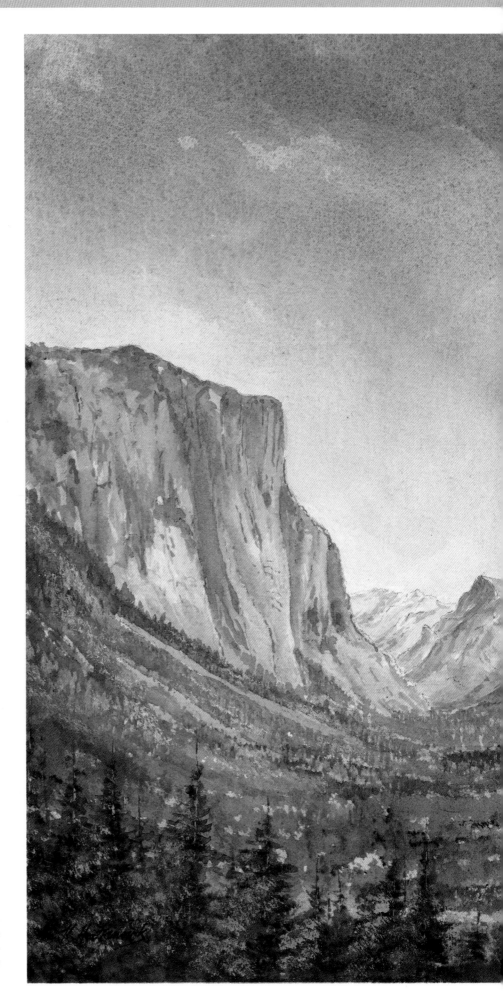

'Evening Glow' is my tribute to Yosemite National Park, where the majestic cliffs of El Capitan on the left rise to meet the heavens. While Bridalveil Falls cascade, the Merced river winds through the pine tree valley leading the eye to Sentinel Dome, Glacier Point and Half Dome in the background.

To create atmosphere and mood, I have applied several glazes to the painting. These are especially useful in achieving effects of the rose-coloured sunset over El Capitan and the neighbouring peaks.

The sky was painted by wetting the whole area with a Raw Sienna wash and dropping in strong washes of Payne's Gray and Alizarin Crimson on the right and Payne's Gray and Cerulean Blue on the left. The board was taken up and tilted at different angles to allow the paint to flow, thus creating the atmospheric sky. Tissues were used to remove wet colour to represent cloud formations. This technique requires lots of practice but you will find it exciting and, with experience, you will be able to produce some imaginative sky studies.

The sky colours were used to achieve the rosy glow in the mountains. Finally, glazes of Raw Sienna were applied to the whole of the painting except the waterfall to achieve colour harmony and that overall 'Evening Glow' which had inspired me to paint the scene.

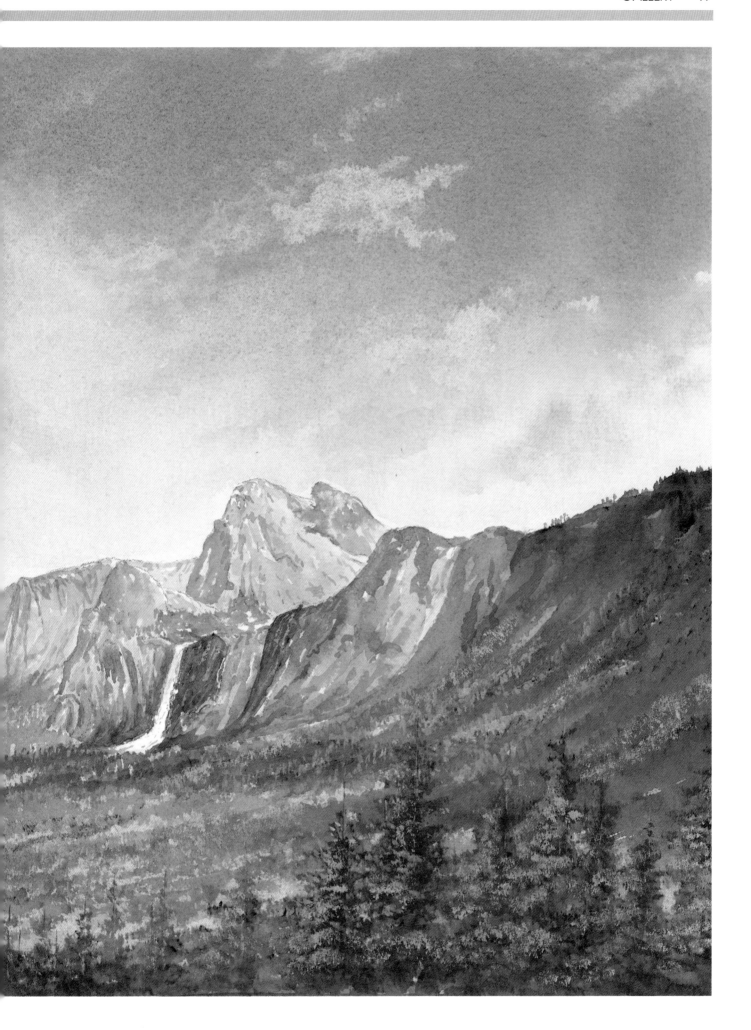

CREATING ATMOSPHERE AND MOOD
LESSON 8: PAINTING MIST OR FOG

INTRODUCTION

This was an early morning scene after a heavy fall of rain. The distant mountains could barely be seen and the fir trees were shrouded in mist. There's little intensity of colour in a scene like this, the overall atmosphere being cool and ghostly.

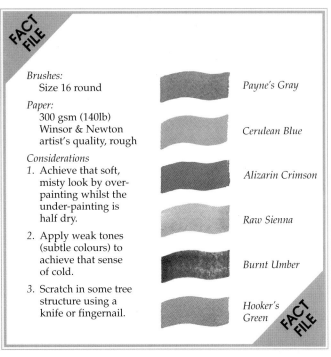

FACT FILE

Brushes:
 Size 16 round
Paper:
 300 gsm (140lb)
 Winsor & Newton
 artist's quality, rough
Considerations
1. Achieve that soft, misty look by over-painting whilst the under-painting is half dry.
2. Apply weak tones (subtle colours) to achieve that sense of cold.
3. Scratch in some tree structure using a knife or fingernail.

Payne's Gray

Cerulean Blue

Alizarin Crimson

Raw Sienna

Burnt Umber

Hooker's Green

FACT FILE

FIRST STAGE

Draw the basic outlines and apply a pale Raw Sienna wash down to the water line. Paint some deeper colour in the bottom of the sky and leave to dry. Paint the mountains using a weak Payne's Gray with some Burnt Umber added.

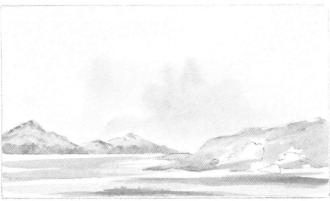

SECOND STAGE

Paint the foreground land and water using a Payne's Gray/Alizarin Crimson mix, leaving areas of the white paper uncovered. Use the side of the large, pointed brush, taking care to ensure the strokes used to paint the water are horizontal.

THIRD STAGE

Brush over the sky area down to the land mass with clean water and apply a light tone of a Payne's Gray/Cerulean Blue mix to create simple cloud structures. When it is half dry, paint the trees with Burnt Umber, adding a little Hooker's Green to the mix to provide variation. When this in turn is half dry, scratch in the tree structures.

FINAL STAGE

Add some subtle colour to the foreground land by applying Raw Sienna and a mauve glaze mix made from Payne's Gray/Alizarin Crimson.

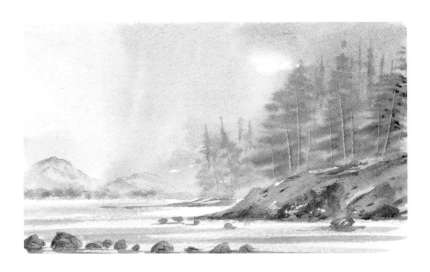

LESSON 9: PAINTING A STORM SCENE

INTRODUCTION

In this stormy moorland scene, I've used the worn track to lead the eye into the painting and towards the focal point, the distant mountain. The angle of the brush strokes used for the storm clouds is also directed towards the focal point, and the shepherd and sheep are heading into the storm.

FACT FILE

Brushes:
 Rigger, Size 16
 round, 'Unique'

Paper:
 300 gsm (140lb)
 Canson Fontenay
 artist's quality, rough

Considerations
1. Leave some white paper uncovered to represent snow.
2. Shape the track to vanish into the distance.
3. Apply dark tones over semi-dry light tones to create the storm clouds.

Payne's Gray

Cerulean Blue

Alizarin Crimson

Raw Sienna

Burnt Umber

FACT FILE

FIRST STAGE

Draw your basic outline with a water-soluble crayon. Apply a pale Raw Sienna wash to the whole of the painting and dry. Paint the mountains using mixes of Raw Sienna/Burnt Umber and Payne's Gray/Cerulean Blue/Alizarin Crimson, leaving areas of white paper uncovered to represent snow-capped peaks.

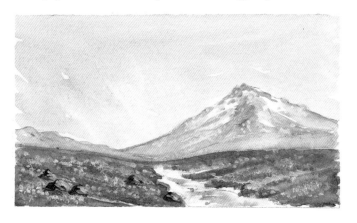

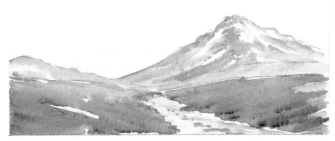

SECOND STAGE

Paint the moorland by initially applying a Raw Sienna wash. When it is half dry, over-paint with mixes made from Cerulean Blue, Raw Sienna, Payne's Gray and Alizarin Crimson to achieve variation in colour and tone.

THIRD STAGE

Using a 'unique' or pointed brush, paint the heather. Use a stippling action and a semi-dry mix of Payne's Gray/Alizarin Crimson with a little white added to soften the colour in parts. Paint in some rocks using the rigger.

FINAL STAGE

Re-wet the sky area with Raw Sienna and paint the storm clouds using mixes of Raw Sienna, Burnt Umber and Payne's Gray. Direct the brush strokes towards the mountain. Add a little white to create highlights in the clouds. Paint the shepherd and his flock very simply using the rigger (see page 95).

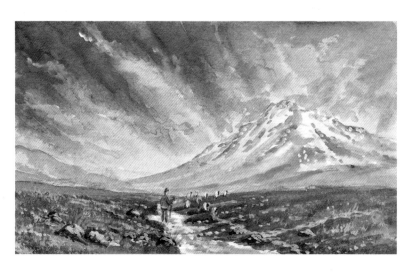

LESSON 10: PAINTING RAIN

INTRODUCTION

Rainy days are quite common during my trips to Scotland and this was no exception. The rain came cascading down, creating a variety of tonal patterns in the sky. Fortunately, it didn't last long and I was able to complete this sketch in eleven minutes. There's nothing like the possibility of a further shower to speed up your painting! It encourages you to paint quickly, guaranteeing spontaneity.

FACT FILE

Brushes:
 Size 16 round, 'Unique'

Paper:
 300 gsm (140lb) Winsor & Newton artist's quality, rough

Considerations
1. Use the white water-soluble crayon to add light to the top of the rocks.
2. Use a stippling action to paint the foreground heather.
3. To represent rain, tilt the board almost vertical to encourage the paint to run.

Payne's Gray

Cerulean Blue

Alizarin Crimson

Raw Sienna

Burnt Sienna

FACT FILE

FIRST STAGE

Draw the basic composition and apply a pale Raw Sienna wash. Dry the under-painting. Paint the distant mountains with the round, pointed brush using mixes of Payne's Gray with Alizarin Crimson and Raw Sienna.

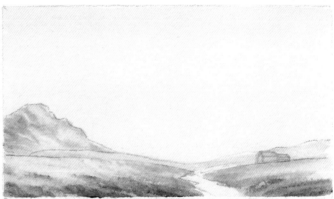

SECOND STAGE

Apply clean water to the land area. When it is half dry, use mixes of Payne's Gray/Alizarin Crimson to create the texture of moorland heather and scrub. Note that the strokes follow the lay of the land.

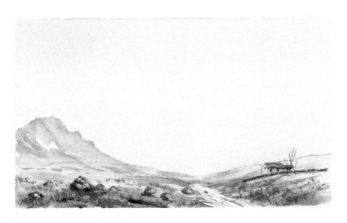

THIRD STAGE

When this is dry, add more detail to the foreground. Paint the heather first using a stippling action and a Payne's Gray/Alizarin Crimson mix. Paint the rocks and distant stone wall with a Payne's Gray/Burnt Sienna mix. For the roof of the farmhouse use a Burnt Sienna/Alizarin Crimson mix, and use a Burnt Sienna/Payne's Gray mix for the track leading into the distance.

FINAL STAGE

Wet the whole of the sky area with clean water. Immediately paint in various mixes of Payne's Gray/Cerulean Blue and Alizarin Crimson to represent clouds and tilt the board almost vertically to encourage the paint to run. Once it has done so sufficiently, lay the board flat and allow to dry. Add more detail to the track.

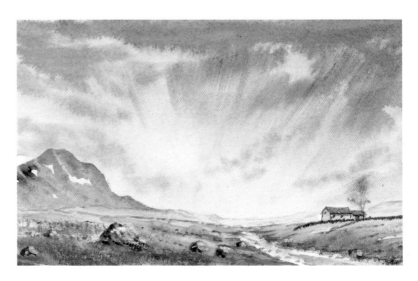

LESSON 11: PAINTING LIGHT AND SHADE

INTRODUCTION

This is part of the woodland where I played as a boy in the north-east. I love the dappled effect of light and shade as the sunlight breaks through the tree foliage, creating light effects over the grass and shadows which change with passing clouds. The path leads the eye through the painting into the distance.

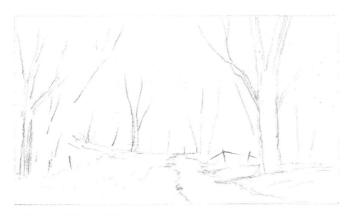

FACT FILE

Brushes:
 Rigger, Size 16 round, 1" flat

Paper:
 300 gsm (140lb) Winsor & Newton artist's quality, rough

Considerations
1. Use a variety of greens to create interest in the foliage.
2. Paint some shadows over the path.
3. Take care to leave areas of light tone to provide counter-change with the darks.

Payne's Gray

Cerulean Blue

Raw Sienna

Burnt Sienna

Cadmium Yellow

Hooker's Green

FACT FILE

FIRST STAGE

Complete the outline drawing in little detail, just enough to provide the relationships between the trees and to show the position and shape of the well-worn path. Apply a pale Cerulean Blue wash to seal the painting.

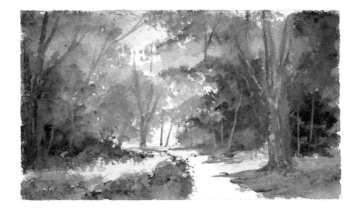

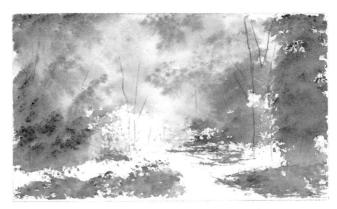

SECOND STAGE

Use various greens mixed from Cerulean Blue, Raw Sienna, Cadmium Yellow and Hooker's Green to block in the general composition. Do this quickly and simply, using the 1" flat brush and a pecking action (see page 72).

THIRD STAGE

Add more depth to the foliage using the previous mixes, adding a little Payne's Gray as required for darker tones. Dry the painting and then paint the tree structures using the rigger loaded with mixes of Payne's Gray/Burnt Sienna.

FINAL STAGE

Use stiffer mixes of various greens to create detail in the trees and foreground. A dabbing action with the large, round brush can be used to create patterns of dark and light in the foliage. Add more detail to the tree trunks and the path. Paint the fences with the rigger and use the white water-soluble crayon to lighten areas of the fence and tree trunks.

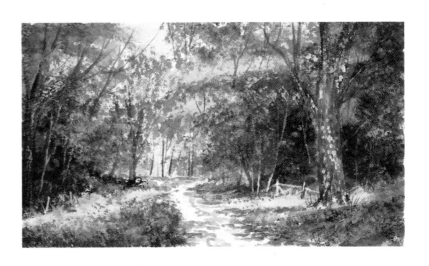

LESSON 12: PAINTING A SUNSET

INTRODUCTION

When painting sunsets with acrylics you have an advantage over the traditional watercolourist: you don't have to paint your various colours into a wet under-painting in less than three minutes. With acrylics, you can under-paint, i.e. apply the first colour and allow it to dry. You can repeat this process adding several colours and taking as long as you like. You can't do this with traditional watercolour.

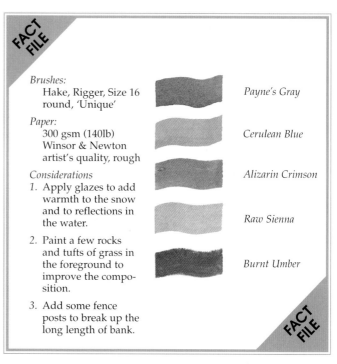

FACT FILE

Brushes:
 Hake, Rigger, Size 16 round, 'Unique'

Paper:
 300 gsm (140lb) Winsor & Newton artist's quality, rough

Considerations
1. Apply glazes to add warmth to the snow and to reflections in the water.
2. Paint a few rocks and tufts of grass in the foreground to improve the composition.
3. Add some fence posts to break up the long length of bank.

Payne's Gray

Cerulean Blue

Alizarin Crimson

Raw Sienna

Burnt Umber

FACT FILE

FIRST STAGE

Complete an outline drawing and apply a pale Raw Sienna wash, then paint a darker tone of Raw Sienna in the centre of the sky area.

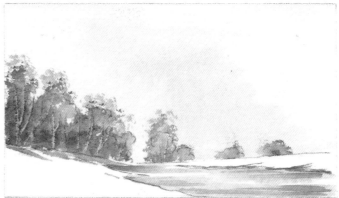

SECOND STAGE

Paint the trees and water using a Payne's Gray/Alizarin Crimson mix. Add some shadows under the left-hand trees. Take care to paint the water using horizontal brush strokes, leaving areas of the paper uncovered. Scratch in some tree structures.

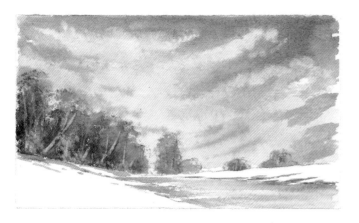

THIRD STAGE

Paint the sunset sky using the process described in the introduction. Wet the area with clean water and add Cerulean Blue to the top of the sky. Once dry, re-wet the area and add a mix of Alizarin Crimson/Raw Sienna. When it is dry, re-wet the area and add the darker Payne's Gray/Alizarin Crimson clouds, using the hake.

FINAL STAGE

Paint the posts and the rocks in the water and on the snow-covered river banks using the rigger and a mix of Payne's Gray/Burnt Umber. Stipple white paint on the trees to represent snow. Apply a Raw Sienna glaze to selected areas of the bank and water.

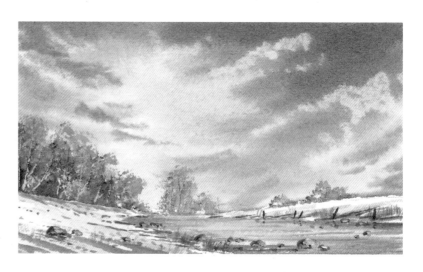

LESSON 13: PAINTING IN EARLY MORNING

INTRODUCTION

River scenes are a favourite of mine. Such scenes can be found nationwide, providing the artist with abundant and varied subject matter which can be painted over different seasons and at different times of the day. Early morning is one of my favourite times to paint: the light is soft, the birds are singing and, if I'm quiet, the local heron will keep me company.

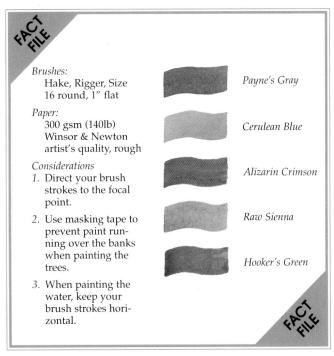

FACT FILE

Brushes:
Hake, Rigger, Size 16 round, 1" flat

Paper:
300 gsm (140lb) Winsor & Newton artist's quality, rough

Considerations
1. Direct your brush strokes to the focal point.
2. Use masking tape to prevent paint running over the banks when painting the trees.
3. When painting the water, keep your brush strokes horizontal.

Payne's Gray

Cerulean Blue

Alizarin Crimson

Raw Sienna

Hooker's Green

FIRST STAGE

For this quick sketch, complete a rough outline drawing and paint the wet-in-wet sky with the hake loaded with a Payne's Gray/Alizarin Crimson/Cerulean Blue mix. Note how the diagonal brush strokes are arranged to lead the eye to the focal point: the dark, middle-distance trees left of centre.

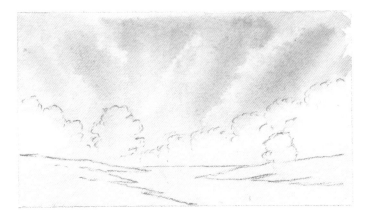

SECOND STAGE

Apply a Raw Sienna wash to the foreground river banks and, when they are half dry, paint in some darker tones using a Payne's Gray/Raw Sienna mix. Spread the tip of the round, pointed brush between your fingers to fan the hairs and paint the tufts of grass by flicking the brush upwards.

THIRD STAGE

Position masking tape to block out the river banks and water. Then, paint the trees using the pecking action described on page 72, using the 1" flat brush and mixes of Hooker's Green/Payne's Gray. Use Cerulean Blue/Alizarin Crimson for the lighter tones. Scratch in some tree structures and gently remove the masking tape.

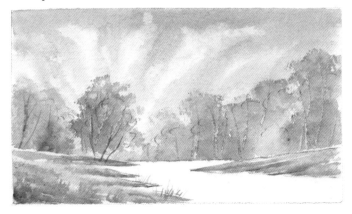

FINAL STAGE

Use the side of the round brush and horizontal strokes to paint the water, taking care to leave some white paper showing through. Paint the fence with the rigger. To balance the painting, paint bushes on the right-hand bank.

LESSON 14: PAINTING ON A CLOUDY DAY

INTRODUCTION

I painted this simple sketch in only eleven minutes to capture the atmosphere and mood of the sky. It's the type of sketch I produce continuously on my travels, to capture a particular aspect of nature. I find the spontaneity exciting, and such sketches provide useful source material for the future, in this case a cloud study.

FACT FILE

Brushes:
Hake, Rigger, Size 16 round, 'Unique'

Paper:
300 gsm (140lb) Winsor & Newton artist's quality, rough

Considerations
1. Produce a tonal study to clarify where the paper is to be left white.

2. Paint the clouds as quickly as possible (under two minutes) to achieve a soft natural look.

3. Use a light touch and minimum strokes.

Payne's Gray

Burnt Sienna

Raw Sienna

FACT FILE

FIRST STAGE

Do a quick tonal study (see Final Stage). As for the painting itself, the only drawing undertaken is the horizon line. Complete a Raw Sienna under-painting. Paint the trees with the 'unique' brush, using mixes of Burnt Sienna/Raw Sienna adding some Payne's Gray for the darker tones. Scratch in the tree structures.

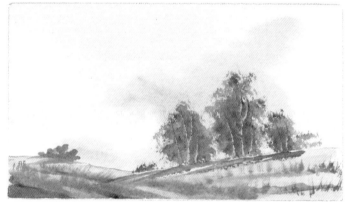

SECOND STAGE

Paint the foreground with the round brush using the above mixes. Use the fanning and flicking technique to paint impressions of tufts of grass. Paint the left-hand bushes using a dabbing action.

THIRD STAGE

Paint the fence with the rigger, using a mix of Payne's Gray/Burnt Sienna, then paint in the structures of the dead trees. Add some darker tones (Payne's Gray/Burnt Sienna) to the foreground to provide more depth and detail.

FINAL STAGE

Paint the storm clouds with the hake by re-wetting the sky area with clean water and using mixes of the three colours. Take care to leave areas of white paper showing through. When painting such a sky, doing a tonal study before applying colour is a prerequisite for determining where the white paper is to be left uncovered.

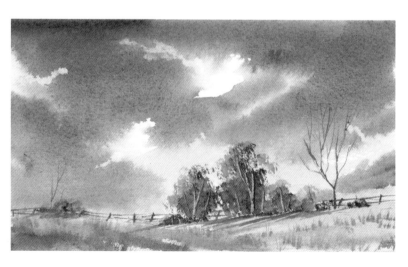

LESSON 15: PAINTING AN EVENING SCENE

INTRODUCTION

This is a view of the old boathouse on Lake Derwentwater. I painted this quick sketch late in the evening whilst people were having their evening meal. This is another one of my favourite times, as there are few people out and about and it's very peaceful.

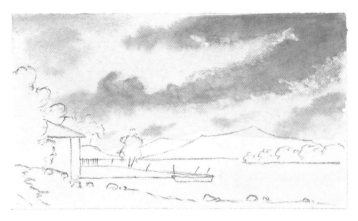

FACT FILE

Brushes:
 Hake, Rigger, Size 16 round, 'Unique'

Paper:
 300 gsm (140lb) Canson Fontenay artist's quality, rough

Considerations
1. Draw your horizon line one third up the paper.
2. Apply glazes to bring out the sky colours and to add sparkle to the water and foreground.
3. Remember: don't paint square fences.

Payne's Gray

Cerulean Blue

Alizarin Crimson

Raw Sienna

Hooker's Green

FACT FILE

FIRST STAGE

Use the viewfinder to determine the best composition and complete a drawing using a water-soluble crayon. Paint the wet-in-wet sky using the hake loaded with a Payne's Gray/Cerulean Blue mix over a pale Raw Sienna wash.

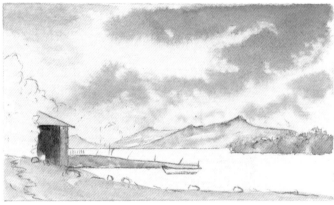

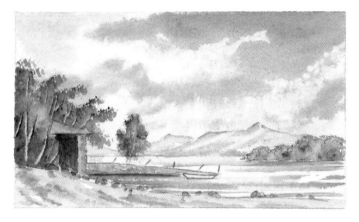

SECOND STAGE

Paint the distant mountains with the round brush using a Payne's Gray/Alizarin Crimson mix. Make sure the brush strokes follow the structure of the mountains. Dab in the trees using Hooker's Green and Raw Sienna. Add the boathouse, landing stage and shore line.

THIRD STAGE

Use a mixture of Hooker's Green and Raw Sienna to paint the left-hand trees, stippling with the 'unique' brush. Using the round brush and horizontal strokes, paint the water simply. Add texture to the shore line.

FINAL STAGE

Paint the boat using the rigger loaded with Raw Sienna. Also use the rigger to add the gate and fence posts and to improve the foreground detail. Allow the sketch to dry completely. Apply various glazes made from Alizarin Crimson and Raw Sienna to create the soft evening colours (see page 107).

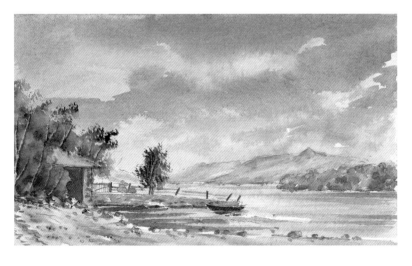

CORRECTING MISTAKES

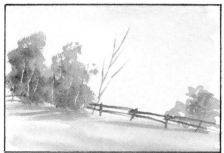

The composition on the left is out of balance: the bushes are on one side only and the fence has been drawn horizontally and is too square and even. The composition on the right is much better: smaller bushes have been introduced to balance those on the left. The fence has been drawn at an angle and not as neatly.

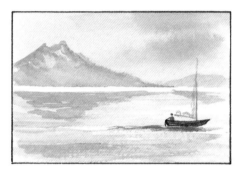
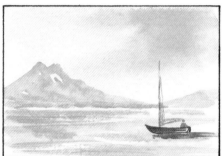

The left-hand composition shows the boat moving out of the painting and the water line is too high, whereas the right-hand composition has a more suitable water line and the boat is shown moving into the painting.

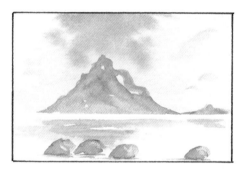
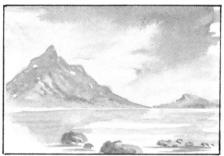

On the left, the mountain is situated too near to the centre and the foreground rocks are too similar in size. The right-hand composition is better: the mountain has been moved off centre and the rocks have been painted in various sizes and shapes.

The left-hand composition is poor: the trees to the left and right are of a similar size and a smaller tree has been placed between them. The bases of all three trees are on the horizon line. The right-hand composition is much improved: the left-hand tree is balanced by the two bushes on the right and a small bush has been added. The fence and foreground add interest.

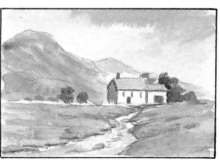

In the left-hand composition, the track takes the eye past the farmhouse and out of the painting. The right-hand composition is much better. The track leads the eye directly to the farmhouse, which is the focal point.

TO GLAZE OR NOT TO GLAZE

In this section, I will introduce you to another method of painting, that of establishing tonal values and colour harmonies gradually, by applying a number of glazes until the painting is in balance. As discussed on page 45 and elsewhere, glazes are extremely important considerations for the overall success of your painting.

WHAT IS A GLAZE?

A glaze is a transparent layer of colour which is applied over another layer of paint once it is dry. It is made by mixing a small quantity of paint with a larger quantity of water or glazing medium. With watercolours, the former would be used. The level of transparency achieved depends on the properties of the chosen colour and the amount of water or glazing medium used.

Acrylics are particularly suited to glazing techniques. With traditional watercolours, the glaze can soak into the under-painting, lifting the paint, resulting in undesirable hard edges and a loss of brilliance. There's no risk of this happening with acrylics as, once the under-painting has dried, it cannot be removed. This allows any number of transparent glazes to be applied without the worry of lifting colour.

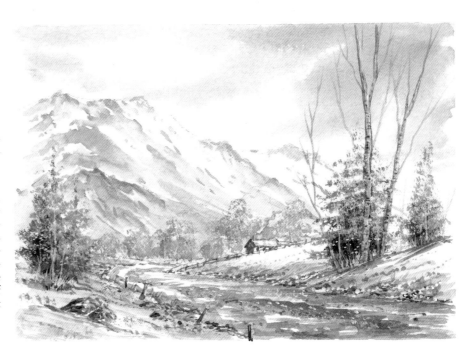

ADVANTAGES OF GLAZING

Glazing can produce exciting atmospheric effects and can be applied as a flat wash, a graded wash of a single colour or a graded wash using several colours. Glazes can aid you in creating atmosphere and mood (see page 96) and can assist you in achieving the correct levels of tone, counterchange and colour harmony. You can relax in the knowledge that, if these considerations are not quite right first time, applying glazes can restore the balance. For instance, if you apply your glaze over your painting as a whole, it can assist in achieving colour harmony. After all, what you've done is to paint one colour over every other colour in your painting.

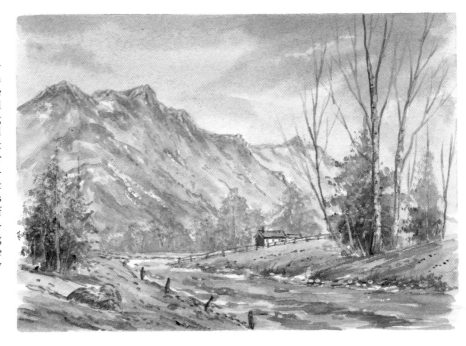

To demonstrate the versatility of glazing, this snow scene has been glazed to turn it into a summer scene. This is the kind of demonstration I enjoy giving to art societies: seeing the painting change in front of their eyes in a few minutes always guarantees an audience's attention.

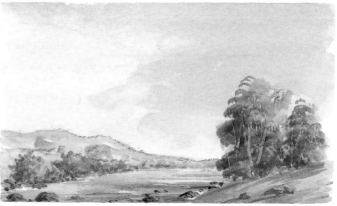

I felt the sketch on the left lacked warmth, so I applied a Raw Sienna glaze to part of the sky, the foreground land and the trees. I also painted a mauve glaze made from a Cerulean Blue/Alizarin Crimson mix over the water. The finished sketch on the right was the result.

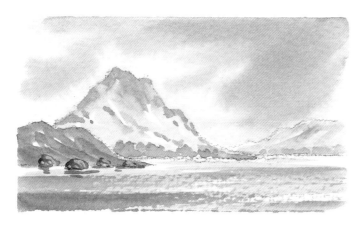
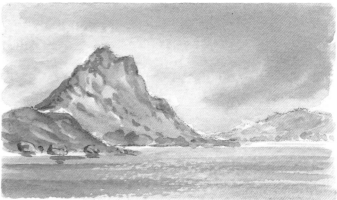

To improve the left-hand sketch, I applied a Cerulean Blue glaze to the sky and the water. When that dried, I added a Raw Sienna glaze to the mountains and middle-distance land and a Raw Sienna glaze to areas of the water. The resulting right-hand sketch exhibits more sparkle and depth.

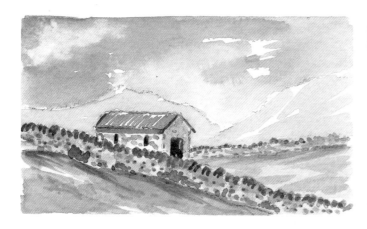
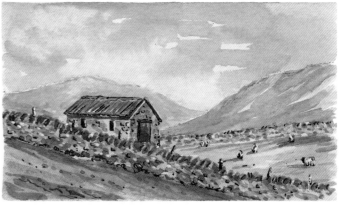

This old barn and stone wall are typical of those the Lake District. There's little colour in the left-hand sketch, so I applied various glazes to the mountains. I also glazed the grass areas with a pale green and painted in a few sheep. When dry, I glazed the whole sketch with pale Raw Sienna to add warmth.

ADDING SPARKLE TO YOUR PAINTINGS

Glazes can be applied to a large area, such as a sky, or to smaller areas, such as buildings. When areas of the painting appear cold, warm-coloured glazes will restore sparkle; and when areas appear too colourful or bright, a cool-coloured glaze will restore the balance.

All artists have their own method of working. Some pre-mix washes, whilst others prefer to mix their colours on the paper; others still prefer to test their colours first on a scrap of watercolour paper. My approach is to look at a painting over a few weeks and to apply such glazes as are necessary to improve the painting before framing it. I apply my glazes using the hake or a sponge brush, moving from left to right, top to bottom. When applying a glaze, your board should be tilted at an angle of approximately 10 to 15 degrees to encourage the glaze to run slowly down the painting. Remove any build up of paint at the bottom with a thirsty (nearly dry) brush or a tissue.

It can be difficult to predict how a painting will look after glazing, so it's important to experiment by applying a number of glazes, using Raw Sienna, Burnt Sienna, Alizarin Crimson, Cerulean Blue or a Payne's Gray/Alizarin Crimson mix, for example, over an unwanted sketch. Keep the glazes light in tone; you can always apply a further glaze to achieve a stronger, more sparkling effect. You will be surprised at the potential of glazes.

USEFUL COLOUR COMBINATIONS

A glaze made from Payne's Gray/Alizarin Crimson is suitable for clouds, distant mountains and moorland heather.

Applying a Raw Sienna glaze to one side, Burnt Sienna to the other side and allowing the two to blend together is useful for lake or seashores.

Trees exhibit a wide range of greens and ochres. Raw Sienna, Burnt Sienna, Cadmium Yellow and Hooker's Green glazes provide variation in the foliage.

To add depth to your foliage, try Payne's Gray/Alizarin Crimson, Payne's Gray/Burnt Sienna and Payne's Gray/Hooker's Green glazes.

For interesting shadows, don't use black; instead, try 20 per cent of any other colour mixed with 80 per cent Payne's Gray. You will be able to create a lovely range of warm and cool greys.

Several glazes made from Cerulean Blue, Burnt Sienna or Payne's Gray/Alizarin Crimson applied over a Raw Sienna/Burnt Umber under-painting will add sparkle to your stonework and rocks.

Experiment with your glazes, they can transform your paintings.

This sketch of an early-morning scene was painted using cold colours.

To add warmth and depth to the scene, a Raw Sienna glaze was applied overall and, whilst it was still wet, a Burnt Sienna glaze was added to the foreground.

EXERCISES

1. Use an unwanted sketch and draw vertical lines 3" apart to divide it up into strips. Apply a different coloured glaze over each strip. Observe the transformation.

2. Paint a grass area a dull green, leaving some areas of the paper uncovered. Apply a Raw Sienna glaze overall to add sparkle.

3. Apply a Raw Sienna glaze over a snow-scene sky to see how it brings out the white.

CONSIDERATIONS

1. Use warm-coloured glazes to add sparkle to your painting. Use cool-coloured glazes to dull an over-bright area.

2. A glaze applied over the whole of a painting will assist in achieving colour harmony.

3. Pre-mix your glazes in small pots or large wells in your palette.

4. Glazes can help to revitalize an unsuccessful painting.

BALANCE AND TEXTURE

I consider **BALANCE** to be one of the most important principles of design as poor balance can destroy a painting. In this section, I will return to the three primary types of balance: **TONAL**, **COMPOSITIONAL** and **COLOUR**. While each of these elements of design has been discussed in detail in its respective section as I regard them as significant, they are included here to refresh your memory.

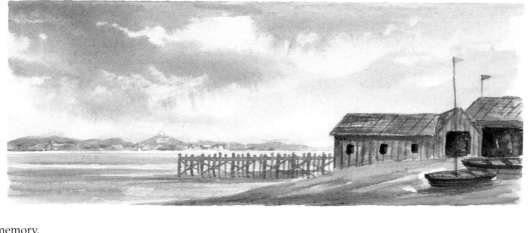

Before I do so, however, I feel I also need to say a few words about **TEXTURE**. Artists tend to use three basic textures. Although we have discussed various aspects of each of these at various places earlier in the book, it is useful to review them all together.

SOFT TEXTURE

If the brush is very wet and paint is dropped into a wet under-painting, a soft-textured shape will occur, as with clouds in a sky, for example. As we know, this technique is called 'wet-in-wet'.

If the paint on a quite dry brush is painted into a wet background, a shape that is still soft but is more controllable will result. To reiterate, this technique is called 'dry-on-wet'. A good

example would be when one is painting fir trees in the mist (see pages 56 and 98).

SMOOTH TEXTURE

Imagine the texture of a watercolour paper to consist of mountains and valleys. Remember how I suggested you achieve a smooth texture? You need to brush over the paper with a well-loaded brush of wet paint. As described earlier, the paint will cover the mountain tops and run down into the valleys, resulting in a band of solid colour or smooth texture. Your brush stroke must be slow and your brush held almost vertical to push the hairs into the valleys. This is the technique used for broad washes and glazes.

ROUGH TEXTURE

To achieve rough texture, the brush needs to be less wet and moved quickly across the paper, held at an angle as flat to the paper as possible. The aim is to deposit paint across the peaks of the mountains, not allowing time for the paint to run down into the valleys. This is the technique used for creating sparkle on water, texture in tree foliage, or when painting rocks.

Artists are entertainers, they use texture to create illusions in paint and to balance a painting. A rough-textured foreground helps to balance a soft-textured sky, for example. Now, on to the three types of balance.

TONAL BALANCE

The first thing to realize is that artists don't necessarily paint what they see. As entertainers, through their painting they must convey an impression to the viewer. They must make the viewer think and stir his or her imagination. This is where I used to go wrong when I first started painting. Being an ex-chief draughtsman, I wanted to paint exactly what I saw, rather than represent the landscape in a way that would be convincing to the viewer.

Look at the tree/river sketch. The trees on both banks have been painted in the same tones and colours. We haven't used our skills as artists to lead viewers into the painting and to guide them round the corner behind the left-hand tree grouping. We can rectify this by taking advantage of tone.

In the bottom sketch, the left-hand trees have been made darker than they actually were. The trees on the right-hand bank have been painted slightly lighter in tone in the foreground and painted gradually growing lighter still as they vanish into the distance behind the dark trees on the left-hand bank. The mountains have been re-shaped somewhat to improve the composition. The river banks have been glazed with Raw Sienna to add warmth. In other words, we've used artistic licence and the technique of tonal balance to create a more pleasing sketch.

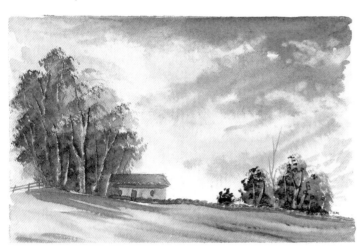

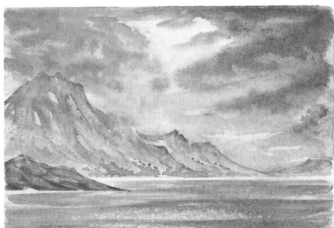

COMPOSITIONAL BALANCE

How we arrange the elements in a painting is also important. We don't have to move them, we simply view them from a different vantage point. In the sketch above left, the trees and farmhouse have been placed in the centre of the composition and the darker clouds have been painted directly behind this grouping: not a good composition.

To improve the composition, the trees and farmhouse have been moved to the left, as you would see them if you stood approximately thirty yards to the right of the original vantage point. The darker cloud formations have been moved to the right to balance the left-hand trees, and a smaller group of trees painted in darker tones has been added on the right to balance the painting. This is known as diagonal balancing.

COLOUR BALANCE

The mixing of colours, their use and their relationships in the painting have been discussed earlier in the relevant sections, but please keep these three attributes clear in your mind:

❍ HUE: how we distinguish between colours, i.e. blue, yellow, green, etc.

❍ CHROMA: the brightness or coolness of hue, also known as colour intensity or strength, not to be confused with tone or value.

❍ TONE/VALUE: the darkness or lightness of any hue, i.e dark green versus pale green.

All three attributes are used to achieve colour balance. In the top sketch above, the chroma is too garish. Colour subtlety achieves a more relaxed and pleasing effect, as in the lower scene.

PAINTING IN MORE DETAIL DEMONSTRATION 7: PAINTING BOATS

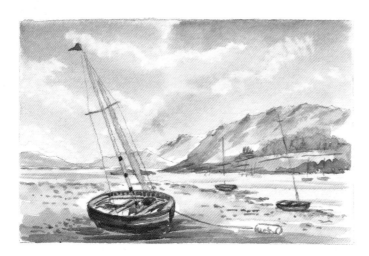

MATERIALS

Brushes:
 Hake, Rigger, Size 16 round

Paper:
 300gsm (140lb) Canson
 Fontenay artist's quality, rough

CONSIDERATIONS

1. Take care when drawing and painting the centre of interest, the foreground boat. If your proportions are incorrect, the boat and finished painting won't be acceptable.

2. Paint the background simply, as it's only supportive.

3. Don't forget to paint shadows under the boats.

INTRODUCTION

Plockton on the west coast of Scotland is featured in many holiday guides and books. Because of its many hidden bays, groups of old cottages, mountain ranges and mild climate, it is a popular painting spot with artists.

The most difficult feature in this painting is the foreground boat which must be drawn with great care. The rest of the painting is simply supportive. I painted this scene sitting next to the harbour wall.

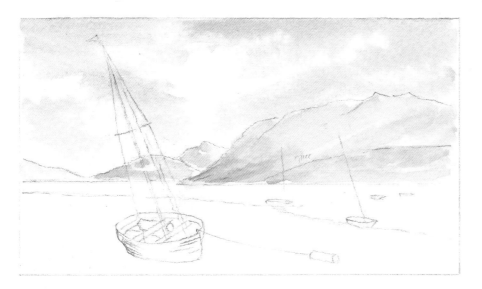

FIRST STAGE

Complete the background drawing with a 4B pencil, as, on this occasion, you don't want the outline of the boat to be washed away as the painting progresses. Take great care to capture the correct proportions of the boat, which is the centre of interest. Paint the wet-in-wet sky and the distant mountains using the hake and a Payne's Gray/Cerulean Blue mix. Paint the middle-distance mountains in a pale green.

SECOND STAGE

Use the hake and a mix of Raw Sienna with a little Burnt Umber to paint the first wash, representing the shore. Then, use the round, pointed brush to add some foreground rocks and the shadows under the boat.

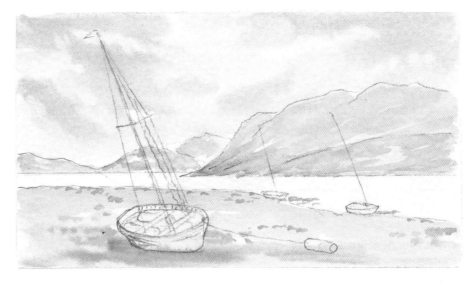

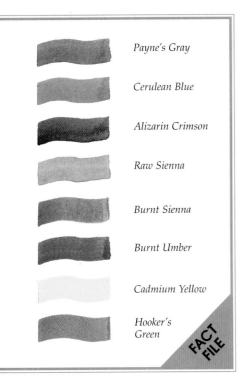

Payne's Gray

Cerulean Blue

Alizarin Crimson

Raw Sienna

Burnt Sienna

Burnt Umber

Cadmium Yellow

Hooker's Green

FACT FILE

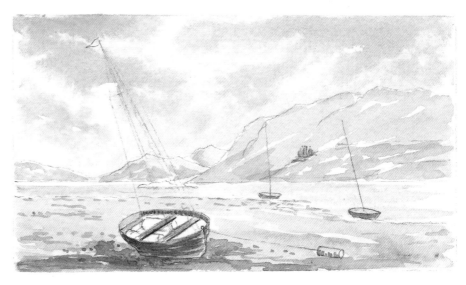

THIRD STAGE

Use the rigger to paint the boats in a medium-toned Raw Sienna. Use the round brush with Burnt Umber to add depth to the shadows under the boat.

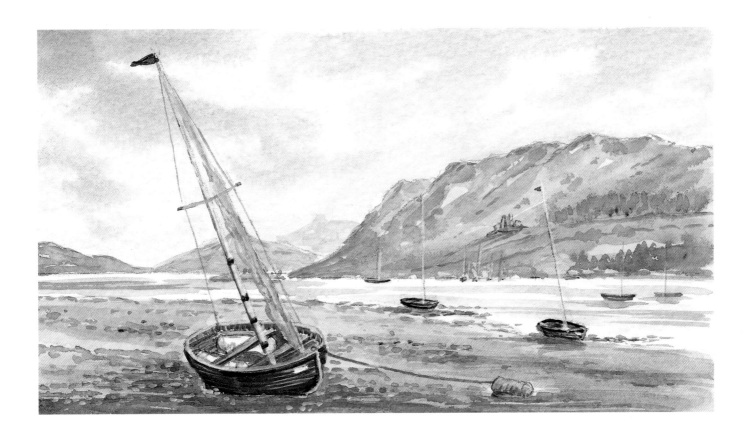

FINAL STAGE

Complete the boats; finish them using the rigger loaded initially with Burnt Sienna with selected strokes of Payne's Gray/Burnt Umber to add definition. Use various green mixes to paint detail in the middle-distance mountains. Use the rigger to add foreground detail and to paint the red flags. Remember to take care when painting the foreground boat.

DEMONSTRATION 8: PAINTING A WOODLAND SCENE

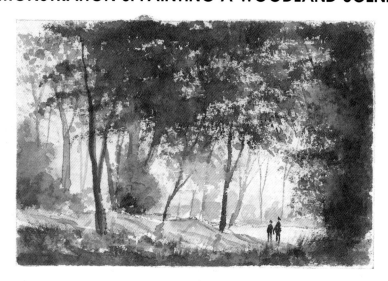

MATERIALS

Brushes:
 Hake, Rigger, Size 16 round,
 1" flat, 'Unique'

Paper:
 300gsm (140lb) Saunders
 Waterford artist's quality, rough

CONSIDERATIONS

1. Tree structures should be lighter
 as they recede into the distance.

2. Take care with your lights and
 darks. They are vital to the
 success of the painting.

3. Don't paint your figures too
 large – the rigger is the best
 brush to use.

INTRODUCTION

This was a scene I came across when walking in the Lake District. The sun was shining through the foliage which cast shadows over the ground. This is quite a tricky subject, as I had to take care to capture the effects of the light which made the sketch appeal to me in the first place. I added the figures to indicate scale and also to give life to the sketch.

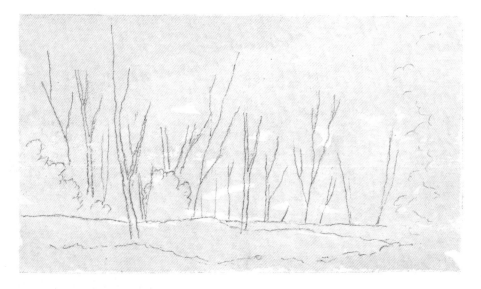

FIRST STAGE

Carefully draw in the outline of the tree structures with a 4B pencil. Then, paint in the background using a weak Cerulean Blue/Payne's Gray mix and apply a Raw Sienna wash to the rest of the painting to seal the pencil lines (which have been drawn much darker here, for printing purposes).

SECOND STAGE

Paint the basic forms with a 1" flat brush, using various mixtures of green made from Payne's Gray and Raw Sienna. Paint the tree structures in the distance using a weak Payne's Gray, adding Burnt Umber for those in the foreground. You should use the rigger for both.

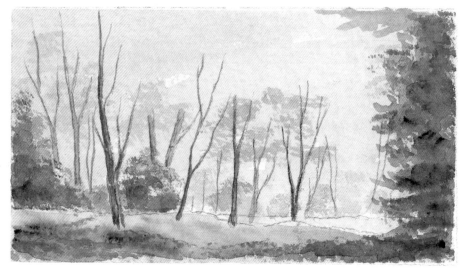

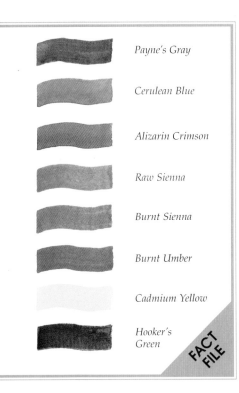

Payne's Gray

Cerulean Blue

Alizarin Crimson

Raw Sienna

Burnt Sienna

Burnt Umber

Cadmium Yellow

Hooker's Green

FACT FILE

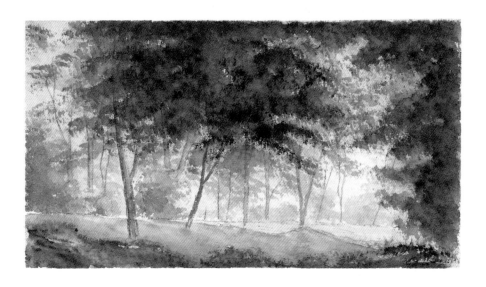

THIRD STAGE

Block in the groups of foliage with the flat brush and a stronger mix of Hooker's Green/Raw Sienna, using a pecking action. Take care to stand back and look before progressing further. (To leave the light effects that inspired the painting in the first place, the foliage should not be overdone.) Then, add some texture to the foreground and selectively apply a Raw Sienna glaze.

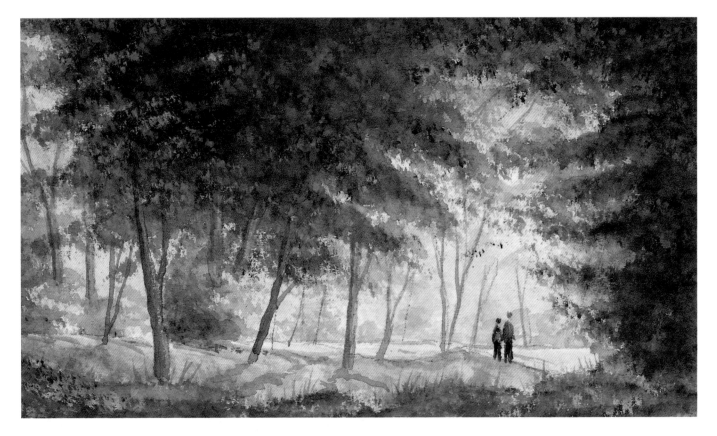

FINAL STAGE

Add texture to the trees and, using the rigger, paint in some shadows. Finally, paint in the two figures in Cerulean Blue and Alizarin Crimson. To help with recession, add texture to the foreground trees and give them more definition by darkening their trunks. The addition of figures in a woodland scene adds life to the painting.

DEMONSTRATION 9: PAINTING A MOUNTAIN SCENE

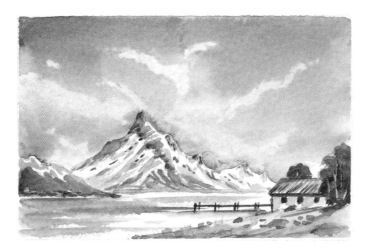

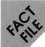

MATERIALS

Brushes:
 Hake, Rigger, Size 16, 1" flat

Paper:
 300gsm (140lb) Canson
 Fontenay artist's quality, rough

CONSIDERATIONS

1. Take care when painting the snow-capped peaks – they can be so easily overworked.

2. Use several colours in the foreground to achieve variation.

3. Don't paint the boat and figure too large.

INTRODUCTION

Snow-capped mountains provide a lovely background to a scene. In this winter landscape the rusty, corrugated roof of the old landing stage provides a dash of colour in contrast to the snow-capped range, which in turn required a dramatic sky.

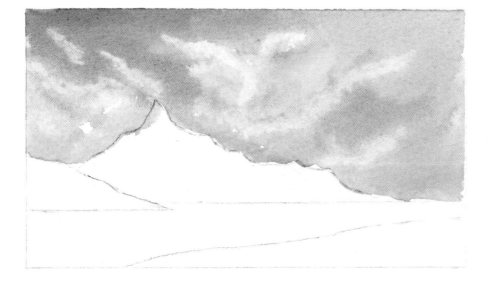

FIRST STAGE

Complete an outline drawing of the mountains and foreground, taking care to draw the water line one third of the way up. Paint the wet-in-wet sky with the sky brush by wetting the area with a very pale Raw Sienna wash and adding the cloud formations in mixes of Payne's Gray/Burnt Sienna. Use tissues to soften the edges of the clouds.

SECOND STAGE

Paint the distant, snow-capped peaks with the round brush using mixes of Payne's Gray/Alizarin Crimson. Make sure the brush strokes follow the structure of the mountain. Leave some white paper uncovered to represent the snow. Use the rigger to paint finer detail using a dot/dash technique, following the fall of the mountain. Apply a Payne's Gray/Burnt Sienna glaze to the base of the mountains.

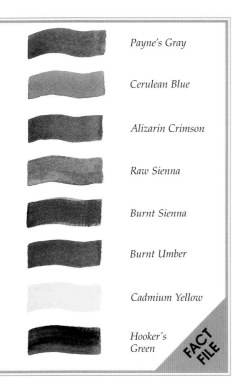

Payne's Gray

Cerulean Blue

Alizarin Crimson

Raw Sienna

Burnt Sienna

Burnt Umber

Cadmium Yellow

Hooker's Green

FACT FILE

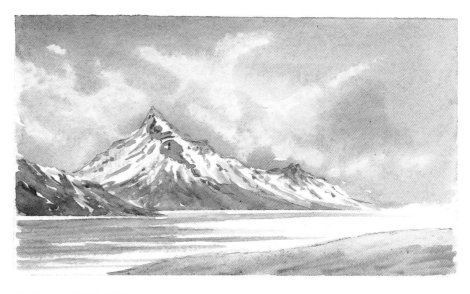

THIRD STAGE

Use the side of the brush to paint the water, taking care to keep the brush strokes horizontal and to leave some white of the paper uncovered. Paint the fore- ground grass by initially applying a Raw Sienna wash and, when the under-paint- ing is half dry, over-painting with darker tones of Hooker's Green/Raw Sienna.

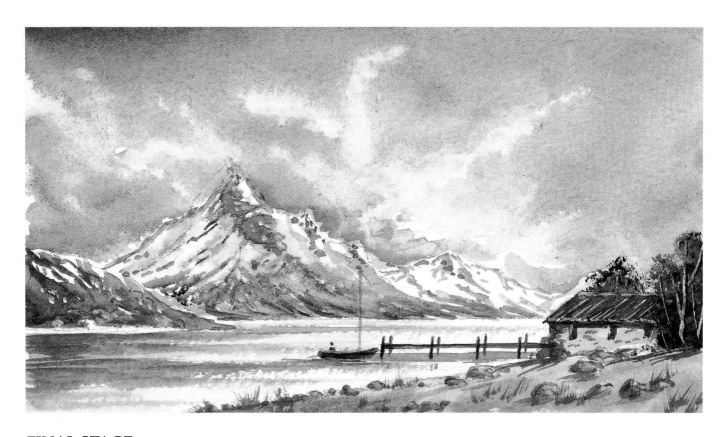

FINAL STAGE

Use the 1″ flat brush to paint the old boathouse and the landing stage. There's no need to draw, just move the brush every inch. For the roof, hold the flat brush vertical with the hairs inclined at 45 degrees and dab from left to right. Here, the building has been painted in Raw Sienna, the windows in Burnt Umber and the roof in a Burnt Sienna/Alizarin Crimson mix. The trees were painted using the pecking tech- nique. Finally, add the rocks (Burnt Umber) and the boat to indicate scale. Aim to achieve a dramatic sky to high- light the snow-capped mountains.

DEMONSTRATION 10: PAINTING IN THE YORKSHIRE DALES

MATERIALS

Brushes:
 Hake, Rigger, Size 16 round,
 'Unique'

Paper:
 300gsm (140lb) Canson
 Fontenay artist's quality, rough

CONSIDERATIONS

1. Paint a simple sky – there's
 sufficient detail in the fore-
 ground.

2. Vary the heights of the trees and
 bushes.

3. Never paint a stone wall with-
 out a gate or an opening. It
 keeps the viewer out of the
 painting.

INTRODUCTION

This old barn is typical of many to be found in the Yorkshire Dales. Its characteristic stone buildings and walls are a pleasure to paint. The group of trees provides counterchange with the old barn and the rusty, corrugated roof provides a welcome splash of colour.

However, by this stage you should be able to recognize the deliberate mistake in this composition.

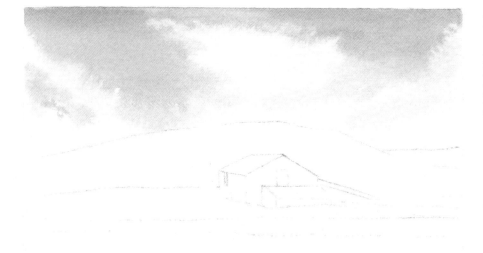

FIRST STAGE

Having completed the drawing, use the hake loaded with Cerulean Blue to paint the wet-in-wet sky. Keep it simple and light to provide counterchange with the dark tree grouping.

SECOND STAGE

Paint the background mountain using Hooker's Green. Paint the grass areas using gradually darker tones of Hooker's Green, adding a little Raw Sienna as you progress to the foreground.

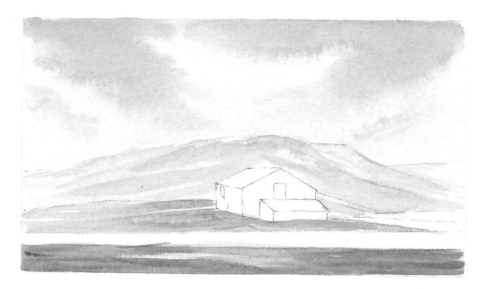

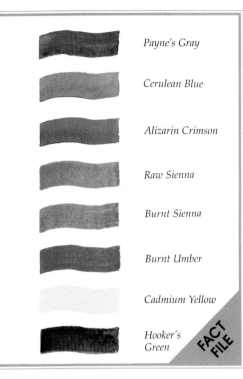

Payne's Gray

Cerulean Blue

Alizarin Crimson

Raw Sienna

Burnt Sienna

Burnt Umber

Cadmium Yellow

Hooker's Green

FACT FILE

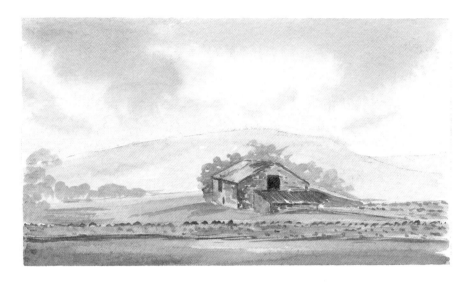

THIRD STAGE

Paint the building and stone wall using the round brush with a wash of Raw Sienna/Burnt Umber. Paint the roof using a mix of 80 per cent Burnt Umber/20 per cent Alizarin Crimson, as this mix is ideal for painting both corru-gated roofs and pantiles. Paint the loft opening and windows using the rigger loaded with a Payne's Gray/Burnt Umber mix. Add a few individual stones and some shadow effects using the rigger loaded with Burnt Umber.

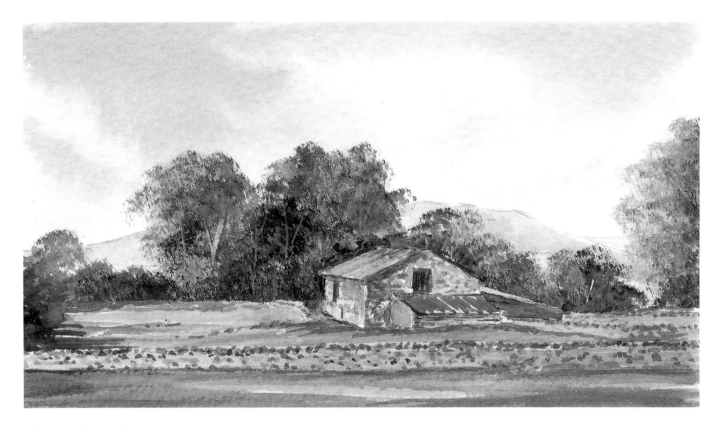

FINAL STAGE

Use mixtures of Cadmium Yellow, Raw Sienna and Hooker's Green to paint in the background trees and bushes, following this with a Payne's Gray/Burnt Sienna mix to add darker tones to the trees. Use the 'unique' brush to paint the foliage and your thumbnail to scratch in some tree structure.

Well, have you spotted the deliberate error in the composition? (See consideration 3.)

DEMONSTRATION 11: PAINTING A SUNSET

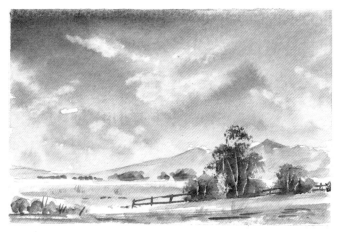

INTRODUCTION

This is a scene I came across on one of my outings in Wales. The foreground is basic; it's the evening sky that attracted me. Snow shimmering on the trees has always fascinated me and, if you close your eyes slightly to create a blurred image, you'll be surprised at the range of colours and tones you can see in the snow-covered fields. Remember: don't paint your sunsets too bright and garish – stick to subtle pastel shades, they look more natural.

MATERIALS

Brushes:
 Hake, Rigger, Size 16 round, 'Unique'

Paper:
 300gsm (140lb) Canson Fontenay artist's quality, rough

CONSIDERATIONS

1. Don't use bright, garish colours when painting the sunset.

2. Use the 'unique' brush to stipple some white paint representing snow on to the foliage.

3. Paint the fence simply, the distance between posts being approximately twice the height of the fence.

FIRST STAGE

Stretch a piece of masking tape across the paper approximately one quarter of the way up to represent the horizon line. Take care to ensure the tape is perfectly horizontal. Using the hake, paint a Raw Sienna wash down to the level of the tape and allow it to dry. Then, simply paint in the distant mountains and a few bushes. When it is dry, gently remove the tape.

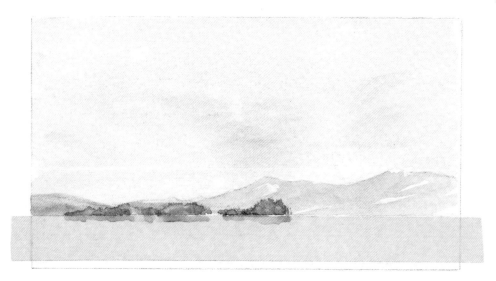

SECOND STAGE

Using the masking tape again, position a piece at a slight angle to represent the bottom of the foreground hedge. Stipple in a few bushes using a Payne's Gray/Burnt Sienna mix. Scratch in some structure with your thumbnail or a knife. Paint in the fence using the rigger loaded with the same mix. Make sure the distance between the fence posts is approximately twice the height of the fence.

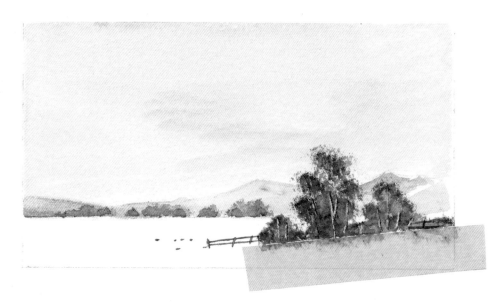

Payne's Gray

Alizarin Crimson

Raw Sienna

Burnt Sienna

FACT FILE

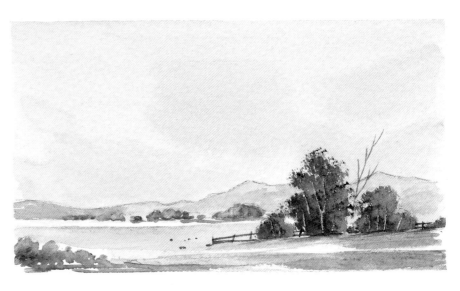

THIRD STAGE

When this is dry, slowly remove the masking tape. Paint in the young saplings with the rigger brush. Using the round brush, paint the reflections in the snow. Apply a Raw Sienna wash for distant reflections and a mixture of Payne's Gray/Alizarin Crimson with a little Burnt Sienna added for those in the foreground. Take care to leave some white paper to represent the snow. Using a dabbing action, paint in the small bushes on the left.

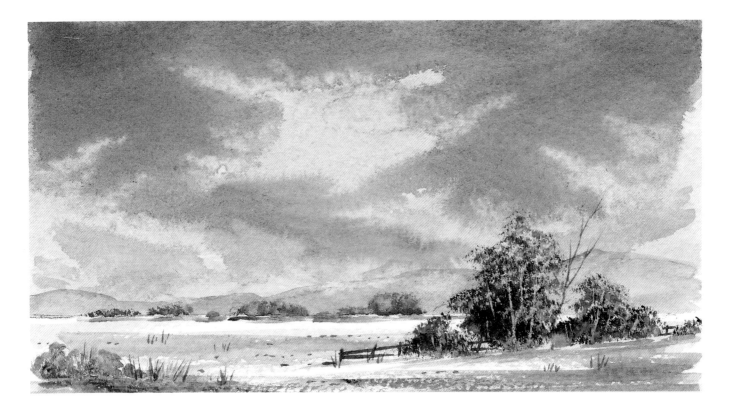

FINAL STAGE

Initially, apply a pale Raw Sienna wash. Paint in the higher, darker-toned clouds using a Payne's Gray/Alizarin Crimson mix, adding more Alizarin Crimson as you work your way down the paper. Rinse the hake clean and paint a deeper Raw Sienna above the distant mountains. Soften the edges of the clouds with tissues. Using the 'unique' brush, stipple in some white paint representing snow on the foliage. Use the rigger to add detail to the foreground.

DEMONSTRATION 12: PAINTING A SCOTTISH RIVER

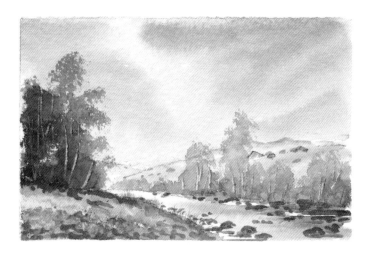

INTRODUCTION

Glen Etive in the western Highlands of Scotland is one of the more beautiful glens to paint in. I always include it in my annual expeditions to Scotland. The glen boasts many exciting waterfalls and offers the artist numerous inspiring river compositions. This exercise is such a scene. The river Etive opens out into a sea loch. There are hundreds of rocks in this river, an attractive feature, but time consuming to paint. A more detailed composition can be seen on page 42.

FACT FILE

MATERIALS

Brushes:
 Hake, Size 16 round, 'Unique'

Paper:
 300gsm (140lb) Canson Fontenay artist's quality, rough

CONSIDERATIONS

1. Paint a simple sky.

2. Paint the left-hand tree cluster in darker tones.

3. Paint simple trees on the right-hand bank in lighter tones.

4. Paint rough texture on the foreground bank.

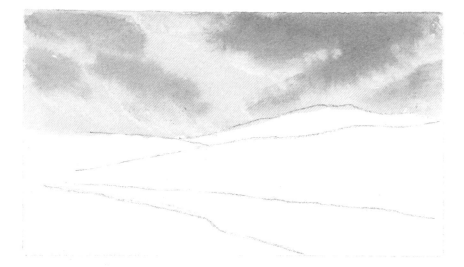

FIRST STAGE

Draw the outline with the water-soluble crayon. The foreground is quite detailed in this landscape, thus it requires a simple, uncluttered sky. Using the hake, paint a wet-in-wet sky with a Payne's Gray/Alizarin Crimson mix over a pale Raw Sienna wash.

SECOND STAGE

Using the hake again, complete the under-painting for the distant mountains and grass areas: use a Payne's Gray/Cerulean Blue mix for the mountains and Raw Sienna and a Raw Sienna/Payne's Gray mix for the grass.

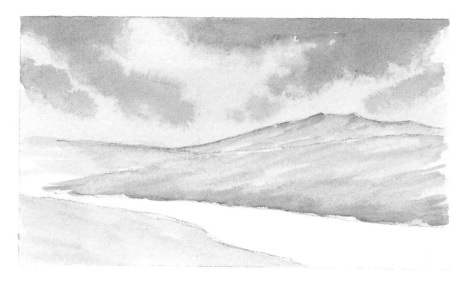

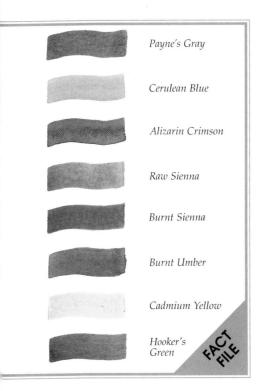

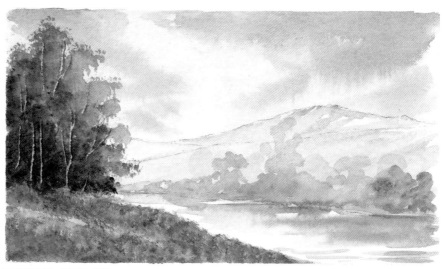

THIRD STAGE

For the left-hand tree cluster, use a pale wash of Burnt Umber with a little Hooker's Green for the under-painting and, when it is half dry, apply a drier mix of Payne's Gray/Burnt Sienna to add depth. When this second layer is also half dry, scratch in some structure. Paint the simple shapes of trees on the opposite bank using a paler mix. Stippling to create texture, paint the foreground bank using various mixes of Cadmium Yellow/Hooker's Green.

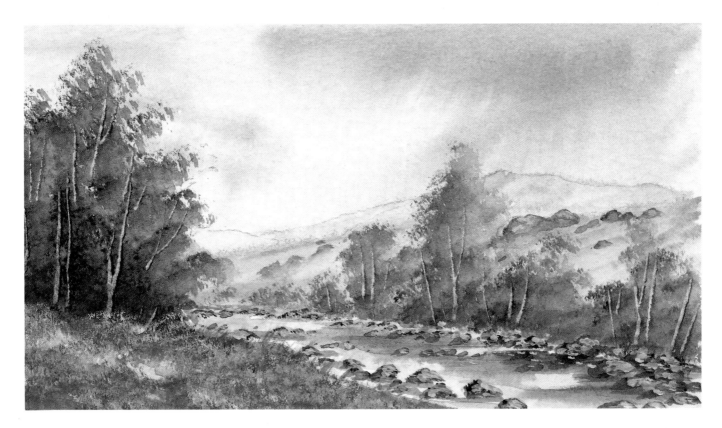

FINAL STAGE

Paint the trees on the right-hand bank using a Hooker's Green/Raw Sienna mix, adding a little Payne's Gray to the mix to create depth. Finally, paint the water and, when it is dry, add the numerous rocks, taking care to vary their size, shape and position. Endeavour to achieve gradation and variation in the foreground.

CREATIVE MARKETING

Artists are not generally good at promoting themselves. It's no good sitting back and expecting the world to come to you. Life isn't like that, it's up to you to create a market for your painting.

When I first felt my work was of a reasonable standard, I approached my local art shop and they accepted several paintings on a sale or return basis, with a commission on sales being paid to the shop. These sold, and the shop began to accept works on a regular basis. It was good to receive the occasional cheque and satisfying to know that someone had liked my paintings sufficiently to purchase them. There's a lot of wall space about, it's just a matter of persuading the person in charge to let you hang your paintings for a trial period. You'll be surprised at the response. Why not try the local pubs, cafés, library or doctor's waiting room? They're all places where people gather in large numbers. Why not join the local art societies? They normally hold at least one exhibition each year where your work can be seen and, who knows, you may even sell a few paintings. The British Watercolour Society and the British Society of Painters also accept paintings on a commission basis, as do many other societies. Additionally, throughout the country there are many shows where you can hire a stand and display work.

I remember a few years ago caravanning in Scotland next to an elderly oil painter. He used to set off on his travels each day and return in the evening with several paintings of local views. These were displayed outside his caravan each evening and the word soon got around. He couldn't produce enough; his paintings sold each evening. He informed me that he spent his time travelling around the country, paying for his holidays by selling his paintings: holiday-makers always wanted a souvenir of the area to take home and were eager to purchase his paintings. That's initiative for you. He enjoyed his painting and obtained great satisfaction in knowing people appreciated his efforts.

As your standard improves, you may like to consider hiring a room in the local library, church hall or hotel to mount a one-person exhibition. You will need about sixty paintings to display. Some halls have strips of wood round the walls to hang your work, but most don't, so you may need to hire some stands from the library or a local school or college. Some local authorities provide this service, but even so, the cost of hiring the hall, stands, posters, mail shots will have to be taken into account. Posters can be produced on the local photocopier, most libraries have one, and distributed in the regional libraries and local shops. Remember to keep them to A4 size, as space is always at a premium.

In addition to the costs above, the cost of framing can be considerable. It goes without saying that your work should be presented professionally, with no badly cut mounts and using only quality frames. The framing can have a significant effect on first impressions of your work. If you are worried about the cost of framing, one alternative is to dispense with frames and just mount your paintings. Either way, it's a good idea to standardize the colour of your mounts and, if you use frames, not to use ones that are too fussy. You wouldn't believe the number of times I've heard people say that they like the painting, but the mount or frame would clash with their wall decorations. So, choose a light, stone-coloured mount which will go with any colour or pattern of wallpaper and a simple frame.

Also, limit the size of your frames to two sizes: if your paintings don't sell, you can keep changing the paintings in them.

Fortunately, in my previous career, I was director of publicity for a large organization and became competent at writing and issuing press releases. A good tip is: advertising costs money – editorial doesn't.

Send out a press release, but restrict it to one side of an A4 sheet. If they accept it and want more, it's no problem. Head it PRESS RELEASE and think of an imaginative, eye-catching title for your text, which preferably should be typed and double-spaced.

When I was asked to teach three total beginners to produce a landscape painting in under an hour for the BBC's *Eleventh Hour* programme, I headed the press release 'Artist's TV Challenge'. The press release was circulated to several local and national newspapers (address them to the news department) and was accepted by most. Some even sent along a photographer to photograph me at work.

Whatever specific methods you are using, it's important to be business-like: don't forget to send your PR out in plenty of time before the publication deadlines.

Once your paintings have reached a standard worthy of being on show in professional galleries, do your homework. Visit the galleries on a few different occasions to observe the kind of paintings on display. If you're a representational painter, it's pointless approaching a gallery that specializes in abstract paintings. Make a note of the prices being asked for the paintings on show. It can be embarrassing when asked how much you want for your work and you ask too little or too much. If you ask too high a price they will tell you. Don't forget that most galleries expect 30–60 per cent commission and your price must reflect this. Ask their advice, they know their market. I remember being told by one gallery owner that some of his customers wouldn't look at a painting priced less than £1000. Needless to say, I was quite pleased, especially when I sold more paintings than any other artist.

Your approach to the gallery owner or manager is important. An initial letter and telephone call will establish whether they want you to submit slides representative of your work, or to take some paintings along for them to see. Approaching the more prestigious galleries can be a daunting experience. I usually go along for an initial visit and, if I strike it lucky, have a chat with the gallery owner or manager at the time, gradually introducing into the conversation the fact that I'm an artist and inquiring whether he or she would be prepared to have a look at my work, with a view to displaying it. I usually take along six paintings, just in case.

If accepted, you'll find that most galleries will expect you to display your work alongside other artists until they establish that your work sells. The one-person exhibition is some time away, I'm afraid. At this point, it's important to clarify the hidden costs. Professional galleries will print a programme, send out mail shots, place advertisements, provide wine and nibbles for the opening night, etc. and you will need to know if these costs are covered by their commission or if you are expected to contribute in part or in full.

At whatever level you start, it's important that your paintings are seen. Use your initiative, don't let opportunities pass you by.

Good luck with your endeavours!

KNOW THE JARGON

ALTERNATION is one form of variation (see below) and is an important design principle for avoiding boredom within your compositions. For example, try to avoid having a row of equally spaced trees which all have trunks of a similar girth. Instead, alternate between trees of different heights and widths.

BALANCE is the use of composition, tone or colour to bring the painting together, to make it appear as a pleasing whole. Examples would be using rough texture in the foreground to offset soft texture in the sky, darker clouds on the right to balance a mountain peak on the left.

COMPLEMENTARY COLOURS are those placed opposite each other on the colour wheel (i.e. red opposite green, purple opposite yellow, orange opposite blue) and are used to create contrast. A good example would be a red top on a figure placed in front of the green foliage of a tree. This technique was often used to great effect by masters such as Constable.

COMPOSITION is the process of arranging all the elements of a painting together into a whole. Composition is concerned with placement, size, shape, form, line and the centre of interest, or focal point.

CONTRAST is an abrupt change or juxtaposition. It can be represented by tone (light against dark), colour (warm against cool), line (straight against curved), shape (round against square) or size (large against small). It is used to achieve variety.

COUNTERCHANGE involves contrasts in tone. Examples would be the placing of a light object, such as a figure, against a dark object, such as a building, or a dark object, such as a tree, against a light-toned sky. Counterchange is used to achieve sparkle and vitality in a painting and to highlight the focal point. It is very important to a painting's success.

DRY BRUSH is one of many brush techniques used to create sparkle on water and texture on rocks and in foregrounds. It involves dragging or pushing a brush loaded with a semi-dry paint across the surface of dry paper.

GLAZING is a technique used to warm or cool a painting, to add sparkle where required or to create atmosphere and mood. It involves adding a large quantity of water or glazing medium to a small amount of paint, mixing it thoroughly in a pot or on the palette and applying it, usually with a large brush, to selected areas of the under-painting, which must be perfectly dry.

GRADATION is the gradual transition in a painting. This is the opposite form of transition to contrast and, like contrast, can involve tone, colour, line, shape or size. For example, the sky may gradually change from one shade of blue to another and from a light to a dark tone. The shape of a group of rocks may change from round to angular or change in size, receding from large rocks in the foreground to smaller ones in the distance.

HUE is the characteristic by which we differentiate one colour from another, i.e. red, blue, yellow, etc., as distinct from tone (see below).

MASKING FLUID is a rubber solution used for masking areas of the painting, allowing broad washes of colour to be applied. Once the paint is dry, the solution can be removed with a finger or eraser to restore the white paper surface.

MEASUREMENT is the process used by the artist to determine the relationships between the elements in the painting. Usually the artist's thumb, a pencil or brush is used, held at arm's length to determine how far the base of the tree is from the farm building or how high the tree is in relation to the height of the buildings, for example.

PERSPECTIVE takes two forms. Linear perspective is a method of establishing distance by reducing the scale of objects as they become further away. It is based on the fact that receding parallel lines appear to meet at a vanishing point in the distance. The best example would be the tracks of a railway line converging on the horizon. Aerial perspective is the method of establishing distance by painting warmer and darker tones in the foreground and cooler, lighter tones in the distance.

PRIMARY COLOURS are colours which cannot be created by using mixtures of other colours. The primary colours are red, yellow and blue.

RECESSION is the sense of distance in a painting. One of the main ways it is achieved is through aerial perspective (see above).

SECONDARY COLOURS are colours which are made by mixing together two primary colours, i.e. red and yellow make orange, blue and yellow to make green and red and blue to make purple.

TERTIARY COLOURS are mixes of three colours, one primary and one secondary.

TONE (VALUE) refers to the lightness or darkness of a colour and, if used effectively, can play a vital role in the success of the painting.

VARIATION is the changing of size, shape, colour or tone of an element in a painting to add interest. For instance, when painting a harbour scene we wouldn't want to paint the boats all the same shape or size, as it would be boring.

VIEWFINDER is an aperture cut out of a piece of mount card through which the artist looks, with one eye closed, to view the landscape. It is used to determine possible compositions.

WET-IN-WET refers to the technique whereby the paper surface is wet with clean water or a wash of colour and, whilst it is still wet, further colours are added to achieve a soft texture. This technique is often associated with the painting of skies and grass areas.

WET-ON-DRY refers to the technique of applying wet paint to a dry paper.

INDEX

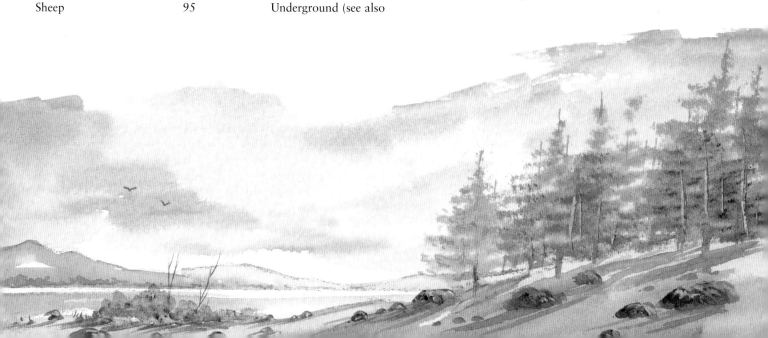

ACKNOWLEDGEMENTS

In producing this book I have relied on the help, guidance, encouragement and efforts of a team of people.

Thanks to my editor, Sheila Murphy, for believing in me and giving me the opportunity to produce this book. To my wife, Dorothy, for putting up with my highs and lows, and for typing the initial draft. To my daughter, Allison, and son, Martyn, for their contributions, help and guidance. My grateful thanks to my good friend Rita Scrafton for typing the final draft onto disk and to all my students who have tested the demonstrations and lessons and informed me what they expected from a book on painting landscapes. My thanks, also, to Don Macpherson for putting the book together – no mean task – and to Anica Alvarez for her help and advice.

To all these people and to the general public who continually ask, 'When is your book coming out?' my grateful thanks.

LIST OF SUPPLIERS

Col Art Fine Art & Graphics
Whitefriars Avenue
Harrow
HA3 5RH England
Tel: 0181 427 4343
Fax: 0181 863 7177
Website: www.winsornewton.com

Tollit & Harvey Ltd
Oldmeadow Road
Kings Lynn
Norfolk
PE30 4LW England
Tel: 01553 696 600
Fax: 01553 767 235
Website: www.tollitandharvey.co.uk

Inveresk Ltd
St Cuthberts Paper Mill
Wells
Somerset
BA5 1AG England
Tel: 01749 672 015
Fax: 01749 678 844
E-mail: stc-sls@inveresk.co.uk

Specialist Crafts Ltd
P.O. Box 247
Leicester LE1 9QS England
Tel: 0116 251 0405
Fax: 0116 251 5015
Website: www.speccrafts.demon.co.uk
E-mail: post@speccrafts.demon.co.uk

COMPLEMENTARY VIDEO

Videos of this same title have been produced to complement the book and are available from the artist. The 'unique' Derwentwater and Ullswater tree and foliage brushes, complete with an explanatory brochure, are available from the same address:

KEITH H. FENWICK
'Watendlath'
42 Laurel Drive
South Wirral
L64 1TW England